Rosegarden and Labyrinth

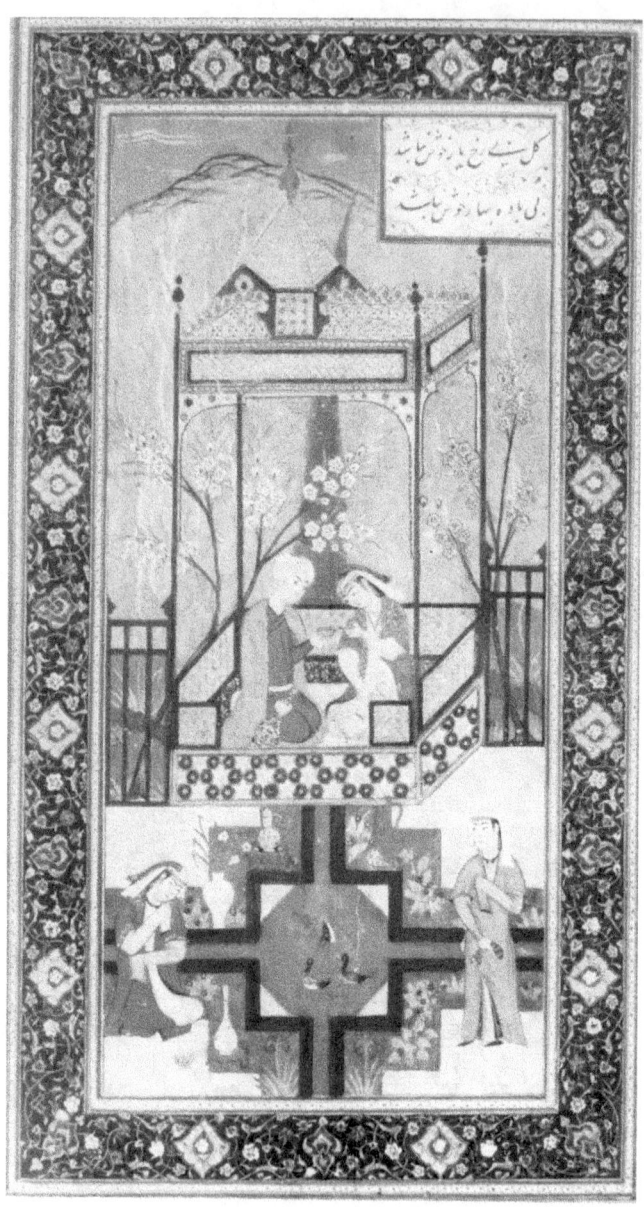

FRONTISPIECE Persian Garden Miniature
 15th century
 Österreichische Nationalbibliothek, Vienna

Seonaid M. Robertson

Rosegarden and Labyrinth

A Study in Art Education

With forewords by
Sir Herbert Read
and Peter Abbs

SPRING PUBLICATIONS
THOMPSON, CONN.

Published by Spring Publications
Thompson, Conn.
www.springpublications.com

First published in 1963 by Routledge & Kegan Paul Limited

Third, revised edition 2018

Cover image:
Labyrinth at Chartres Cathedral
13th century

All images reproduced with permission

Library of Congress Control Number: 2018941822

ISBN: 978-0-88214-001-8

This act of self-indulgence
is dedicated to
enlightened administrators
in education,
especially
W.R.N. and D.R.C.

CONTENTS

ACKNOWLEDGMENTS

I wish to express my gratitude to the teachers who took part in the investigation, many of whom will be surprised to see where it led; to those whose work is described or illustrated here; to Sylvia Fairman who helped in the preparation of index; to Elizabeth McKee and Charity James who did their best to rescue readers from my scotticisms; and to those friends, and in especial Arthur Justin Creedy, who by discussion stimulated me to turn the next corner.

Acknowledgement is gratefully made to the following for permission to reproduce images: Österreichische Nationalbibliothek, Vienna; Trustees of the British Museum; Staatsgalerie, Stuttgart; Musée des Arts Décoratifs, Paris; Biblioteca Estense and Umberto Orlandini, Modena; Staatsgalerie Frankfurt; Alinari Fratri, Florence; Caisse nationale des monuments historiques, Paris; Mansell Collection, London; and Mr. Blackett of the University of Leeds for photographing many of the children's artworks.

The revolution that has taken place in the teaching of art in the past half century has perhaps created as many problem as it has solved. Ms. Robertson mentions three "large questions" in the first paragraph of her book, and she gives some convincing answers to them in the pages that follow. But she does not mention the greatest problem of all—how to find teachers with sufficient knowledge of psychology to enable them to guide the delicate process of integration that is involved in the unfolding of the creative activity in children. Art, she is convinced, has a social as well as a personal function, for what the individual creates is not merely an expression or resolution of its own internal necessities but, above all, a mode of communication: a statement that is intended to have significance for other people, above all for the ever-expanding circle of the "other people" within the child's immediate range of experience. At its minimal significance, art is a signal of distress thrown out by a lonely and possibly shipwrecked soul; but we learn, the more we study such signals, that they belong to a universal language of symbols, and that they come from an individual who represents the collective fears or fantasies of the human race itself; its affirmations, too, of hope and joy.

It is precisely at the moment of transition from childhood to adolescence that these "signals" acquire an unusual urgency, and unless they are picked up by sympathetic adults, the psyche of the child is in danger of shipwreck—by which metaphor we mean some degree of permanent psychic disorder. In this book, Ms. Robertson studies with extraordinary sympathy and insight two such psychic signals or images, and this leads her to a general discussion (with the experience of other teachers to aid her) of the significance of the symbolizing

activity in children generally. The investigation ranges widely over the history of symbolism in art, always returning to the pictures made spontaneously by children, and to a meditation on the meaning of those two universal archetypes of the rosegarden and the labyrinth that occur so frequently.

As a whole, the book is much more than an analysis of the significance of children's drawings, and more than one more urgent plea for the recognition of the importance of art in education. It is a work of profound philosophical and, indeed, spiritual value, in which the irreducible symbol, the poetic vision itself, is revealed in all its "almost eternal durability." No teacher (and one would like to say no statesman) can afford to neglect its profound message.

FOREWORD TO THE SECOND EDITION
by Peter Abbs

Given the prevailing instrumental philosophy of education and the present status of the arts, it is not going to be easy to restore the expressive disciplines to their central place in the curriculum. We need to encounter telling theory in relationship to convincing practice. We need to sense a profound philosophy of symbolic form in relationship to actual art-making experience. We need to understand the common nature of all expressive activity, conceive its common source in creative impulse and its common end in illuminating artifact.

I cannot think of a book that intuitively draws the threads together with as much grace and conviction as Seonaid Robertson's *Rosegarden and Labyrinth*. One would like to see it read not only by all art teachers and art students but by all those concerned with arts education and indeed all those concerned with education because the art-making process exemplifies all true acts of learning.

In the present cold climate of education, this seminal book has become quite simply indispensable. With memorable examples it demonstrates the power of art to develop the whole personality. It is an honor to be engaged with the production of this paperback edition.

— University of Sussex
Autumn 1981

INTRODUCTION TO THE SECOND EDITION

We are at the end of an era, both in education and in the history of this astonishing and vulnerable planet Earth. Looking over the two continents I know best, the despoiling of resources, the ever-present threat of nuclear war, the accepted primacy of materialistic standards, not to mention the radical cuts in those aspects of education that seek to develop the human soul, it might seem that all is dark. Dark indeed, yet under the surface there is an extraordinary ferment of activity. I myself feel much less lonely now than when I wrote this book. Driven to question all values by the harsh climate, many people, especially the young, are reaching out towards a new and more deeply rooted life. Tentative, often confused, occasionally "way-out," nevertheless very genuine, this new spirit is finding expression not only in marches and little magazines but in rites and festivals, in meetings, in yoga, and in meditation, and above all in the profound yearning to give our children and young people more firm hold on the eternities of the human spirit. In all this the arts play an absolutely vital role: "Art is to give man a taste here and now of the eternal."[1]

We are seeking a way to the center of ourselves, to the center of reality, and the way lies in symbols through which we enter into eternal verities at any depth we are prepared to plumb at that time.

How can art and craft serve as the vehicle for this experience during the sensitive and formative years? How can the visual arts relate to poetry and drama, to dance and to the study of religions within the harshly segregated departments of our secondary schools and colleges? Teachers' training becomes ever more "academic" in order to measure up to standards of universities geared to measurement in

1. The artist Cecil Collins in a radio interview.

science and technology, where almost none of the faculty will have had extended *experience* of these same arts where such measurement is utterly irrelevant. How can teachers develop that heightened awareness to several arts that would enable them to stir their students' imagination through any medium that appeals to them?

Such large questions, which are crucial to the development of the growing generation, need asking now. This study attempts to tell how exploring one approach to teaching the visual arts within a wider orbit educated me through the very medium of educating.[2]

The opportunity to pursue this study was given to me first by a part-time one-year fellowship, and after I had returned to my job of training teachers for some years by a full-time Senior Research Fellowship at the University of Leeds Institute of Education. I can only express my gratitude that the appointing committee should have seen my tentative ideas and intuitions, supported only by some of the peculiar objects illustrated in this book, as a possible theme for research.

I had felt for some time that a fair amount of study had gone into the art of younger children, and the evidence of their spontaneous painting in a sympathetic atmosphere had been accumulated, and was available for those who wished to study it. About adolescents we knew and still know much less. Especially we do not know how far the outer pressure of academic schooling or of a technological age, the accelerated growth of the rational mind or some unrecognized change within themselves, modifies the nature of their art and their attitude to it. I do not pretend to have investigated all these questions; I explored mainly one aspect of adolescent art and some work of untaught adults that seemed closely related to it. I chose this field because, among the schools of thought on what to do with adolescent classes—"drawing from observation," "useful crafts instead of childish painting," "abstract art because it is of our time," "a basic design course

2. The study of literature, drama, movement, and dance formed no part of my own art education nor my teacher training, and still have no essential place in the majority of contemporary courses—though the more enlightened offer some of these.

because it lays the foundations," a frantic chasing after the passing "ism" of Minimalism, Op art, Pop art, punk, frenetic art, nihilistic vitalism—*this* aspect has been woefully neglected. I am NOT saying that the kind of experience described in this book is the whole of art education, but I am saying that it is the core—to get behind appearances to the spiritual realities. But no teacher should try to use such an approach unless he feels impelled to do so. Teaching is above all an art. Every person who is deeply concerned with education in the arts teaches out of his own insides, in his own style from his own deepest self, that self who has experienced, reacted with enthusiasm, enjoyed and suffered. I can throw out ideas, tell how important this discovery that children spontaneously produce archetypal images has been to me, but each person who wishes to explore it must take his or her own path to the center. If we do not give of ourselves, we cannot hope to operate at that fundamental level from which the archetypes spring.

There are many gaps, many hints not followed up, and I wish that I had been able to study more intensively work with adolescents relating all the arts. Some notable examples of this have been seen in the intervening years,[3] but nearly always outside the state system, in schools for "delinquents," youth groups, or the "disabled," partly because there is more time, sometimes more funds, more scope for risk, but chiefly because some original and courageous people have moved out of the restrictive, rigid timetabling mistakenly thought to be essential in our secondary schools.[4] But since this book is intended as a study in state education, I have not directly examined these fields.

I hope to show how the attempt to understand the significance of certain works led me to a wider understanding and a deeper appreciation of the sources of images in any of the arts. If it encourages other teachers to explore, as true amateurs, in fields bordering on their own, it will have been doubly justified.

3. As, for example, in the annual Myth and Symbol Conferences arranged by the Cockpit Theatre, London, and the Education Area of the University of Sussex.

4. The vitalizing effect of a flexible timetable was illustrated by the work of teachers from the Goldsmiths's Curriculum Laboratory, University of London.

If we explore the mythological images not only in our own but in other cultures, we will find the power of archetypes to revitalize. And we need that power today, starved as the expressive disciplines are of time, funds, and encouragement. We are in a dark tunnel, but we must shield against that draught the small candles we are holding so that we shall be able to offer a flame that can ignite a new age where the life of the spirit is the mystery we serve.

The work described must be seen against the background of art education in those times, and as arising from one person's limited viewpoint. This, as it was at that time, I shall try to set down. Some of it will be very familiar to art teachers—who may wish to skip the rest of this introduction—but because it *is* so familiar perhaps we do not sufficiently examine its implications for the lives of our pupils.

The "rosegarden" described in the first chapter appeared to be very satisfying to the child of eleven who made it, but it did not communicate much to me—though it must have stirred me since it kept recurring to my mind. Must art communicate? If so, to whom? Has such a model anything to do with art? Do we expect what happens in an "art lesson" at least to aspire to being art?

Though I did not expect children to be artists in any except a rather special sense of the term, I believed deeply that the *experience* of the artist, the experience of creating, was something we must offer them. I also believed that communicating their ideas and feelings was an essential part of education, and that communicating in form and color was analogous to communicating in language but even more direct, and less hampered by the mundane practical uses that characterize most of our use of words. So children and adolescents need a language of expression in art, and helping them progressively towards it I considered the job of the art teacher.

With a pencil or a crayon in his hand the very young child scribbles and obviously enjoys the *movement* as much as the marks on the paper. It has been recognized that the resulting scribbles gradually take on a coherent form or consistent relationship of the parts. Each element in his visual "vocabulary" is denoted by a formula, often called a "schema," adopted by the young child or untaught adult, to represent a class of objects. This the child uses much as he does a

word, sometimes practicing it for its own sake, and producing it every time he wishes to indicate a man, a house, or a tree. The first schema for a man or woman (usually undifferentiated at this stage) is often an oval with two dots for eyes and extended mouth, with single lines attached for arms and legs. This schema is soon changed for one that differentiates head from body, which may now be represented as roughly oval, square, or triangular, to which arms and legs (and eventually) fingers and feet are added. Then, often abruptly, he adopts another schema, elaborates that, and discards it in turn. The additions or elaborations made are not necessarily those that are derived from more acute visual apprehension; they are not advances towards a "visual image." The first intellectual grasp of the fact of fingers may result in fingers as long as the arm, or "many" fingers may be represented as seven or nine, not necessarily the same on both hands! The schema may be elaborated in a purely decorative way, as in filling in the whole of a triangular body with nonrepresentational patterns, or executing the hair with flourishes of curls while naming a straight-haired person. So the schema first put down to indicate an *idea* may also be a *shape* elaborated for its own sake.

I have said that his current schema serves every time the child wants to "say" with his pencil or brush "a man," "a tree," or "a house," but there are of course times when the schema is modified. Two particular pressures frequently modify it in this way. One is the emotional importance of this object to the child. Thus, the mother is nearly always drawn larger than other figures in the family. This kind of size-importance relationship represents, of course, a more many-sided truth than the mere "visual representation" does. It is not a primitive concept that is progressively outgrown, as is shown by the return to it in Romanesque art after the relative naturalism of late Greek and Roman art. Among historical examples that come to mind are the Christ in the bas-relief of Lazarus's tomb at Chichester Cathedral, who towers above the other characters, and the Virgin carved at Arezzo Cathedral where she is about three times the size of the Wise Man. There is no doubt that the Italian carvers and mosaicists had plenty of models of naturalism in Roman relics, so it must have been their deliberate choice to represent what they felt to be the true proportion.

The other way in which the schema is modified is shown when physical sensation (probably a large element in forming the original schema) is strongly associated with the idea portrayed. Then part of the body schema may be enlarged or omitted or exaggerated as Lowenfeld has convincingly shown.[5]

When the artist or the child delights in the *individual* quality as seen in what he depicts more than in the general idea, we may then speak of it not as a schema but as a visual image. It has that quality of freshness, the sensuous quality of having been seen by one individual's eyes, which arrests us. Yet, even "drawing from observation" by adolescents looking at the same objects may well produce results more startlingly different from one another than "drawing from imagination" by young children who are manipulating schemata.

How far can we help children to clarify and convey such images? That young children do make images of experience and develop a valid language that is both individual and characteristic of their age—not a poor attempt at adult art—was argued persuasively by the Austrian artist and art educator Franz Cižek,[6] and is now generally accepted. In many—if not unfortunately all—primary schools, children are now given suitable materials and encouraged to paint what they will, and in what way they will. This belief in the *validity* of children's art is reflected in the more informal atmosphere of their room, in the provision of large paper and big brushes (making direct painting possible for young children), in the choice of medium from a wider range, and the recognition of the personal nature of the art produced. Unfortunately, the essence of this freedom was too often misinterpreted by those who, without understanding the positive philosophy behind it, saw the "new art" as a release from the former unsatisfactory position of trying to teach art as a technique. These, confused about the teacher's function, left the children to mess about in a vague

5. Viktor Lowenfeld, *The Nature of Creative Activity*, trans. Oscar Adolf Oeser (New York: Harcourt, Brace and Company, 1939). He gives the example of the grasping arm in being much lengthened while the unused arm is shortened or may even be omitted.

6. Franz Cižek was the founder of the Child Art Movement in Vienna, where he opened his Juvenile Art Class in 1897.

self-expression without guidance in clarifying their ideas or help in exploring their medium. Unfortunately too the striking effect of the spontaneous productions of young children, the undoubted beauty of color and decorative qualities of their work, resulted in these same materials and procedures being adopted uncritically by many teachers of *older* children. Adolescents proved not to be "overflowing with art," not ready, like young children, to pour out naive, direct, exciting paintings. When they did so, the powerful pressures of the adult environment towards sentimentalized naturalism or the crude vulgarity of comics, along with their own developing self-consciousness and criticism of their work by others, often undermined what satisfaction they had in the experience. Cižek had more faith in the younger children and was discouraged by the difficulties of teaching older children, but in the nineteen-thirties Marion Richardson, whose warmth of personality and great concern for the children inspired all who worked with her, surprised educationists by revealing something of what might be achieved with adolescents. She also developed and handed on to her teachers' classes a method of intensifying visual imagery, and, by her own beautiful and precisely detailed descriptions of the scenes they should paint, stimulated her girls to make pictures with a subtlety of color and range of surface texture that had hardly been known before. I would, however, question whether it was not the teacher's artistry, her seizure of a viewpoint on a paintable scene, and her selection of visual detail rather than the children's that are shown in those well-known paintings from verbal description.[7]

Such changes in thought about art education could be accepted because they were in accord with the changes in educational philosophy of the period. By the second quarter of the twentieth century, general ideas on education that go back to Pestalozzi and Froebel and even to Rousseau (apart from their ideas on art education, which were all strangely out of line with their general philosophies) began to filter through and, alongside the investigations of such progressive educators as Dewey and Caldwell Cook, created an atmosphere with

7. Marion Richardson, *Art & the Child* (London: University of London Press, 1948).

which education could flourish. Public opinion of what constituted "art" was widened by the interests of artists in the "Negro" art brought back by anthropologists, and the Bronze-Age and Neolithic excavations of archaeologists. The Postimpressionist painters, who gradually became accepted, extended public interest in the variety of aesthetic experience. The revolt of a number of gifted teachers against a narrow conception of art education as teaching techniques resulted in a breakthrough to a wider range of adolescent art. However, many well-meaning but confused teachers continued to look for the sort of work that came naturally to young children instead of extending the experience of adolescents in ways appropriate to their own stage of development. In secondary schools, the churning out of decorative compositions on abstract themes, e.g., "Power," "Music," or of remote and so supposedly "imaginative" subjects such as "Life on Other Planets" and "Under the Sea," were a symptom of the malaise.

Understandably, there was a counterrevolution, or rather several. On the one hand, some teachers complained that art education was out of touch with life in the twentieth century and thought they were coming to terms with their environment either by a swing towards semi-technical studies of automobiles and airplanes (in which the expressive element essential to art is cut to a minimum) or by a course on "commercial art" such as posters, show cards, and arranging shop windows. This led to a slick advertising style and to concentration on the artificialities of inflated needs created by clever advertising.[8] Is this really the attitude of mind we wish to encourage in adolescents? Surely such ways of coming to terms with the environment are at a level too superficial to be worth discussion.

A more genuine counterrevolution had come from some of the most painterly among art educationists. Deeply concerned about the quantities of sloppy and so-called "imaginative" work in secondary schools, they encouraged a whole-hearted return to work from

8. Much more interesting would be a critical survey of the idealized images used by advertisers and the basis of their wide appeal as is done by enlightened teachers of English or Sociology, so long as it was in addition to practical work.

observation and a careful study of the environment. While this is admirable, they had often, I think, in a wholesome revolt against slovenly self-expression, put too great an emphasis on the *products,* the drawings or paintings themselves rather than on the quality of the experience the children were having, and the great numbers of children's art exhibitions were also a symptom of this emphasis. I believe that while such studies from observation have a great place in adolescent education, they are not an end in themselves. I suspect an *extreme* reliance on drawing from observation is related to a sense of insecurity in the teacher: the visible appearance of things is something stable to hang on to. Moreover, the teacher has a greater skill in the rendering of visible appearances, and so there is no doubt that he is superior in this and can *teach* the child. It may spring from a sincere need to be of use, and a lack of the faith necessary to stand aside at certain times. I would suggest that, however valuable any teacher's knowledge and skill may be, to rely on *that* as the main basis of his relationship with his pupils is to avoid the fundamental core of any fruitful relationship between human beings, the reverence of the unique soul in one another.

There is another school of thought that went so far as to say in effect, "the only thing we can teach children is technique, so let us concentrate on the basic studies of form, color mixing, tone, etc. that are the grammar of our art, and leave feeling and imagination out of it." Such a point of view brought a much needed discipline to the training of young professionals of all kinds in art schools, and may form some part of the serious study of art by adolescents, but it was unfortunately elevated almost to a religion by some of its adherents. This is no more the whole answer to adolescent art than is working from observation, and moreover it leads to a dichotomy between technique and what the technique is developed to say, between language and content, which militates against that "whole" education for which we search. The acceptance of such a narrow limitation for the "ordinary" adolescent must depend on whether we see our job as to instruct or to educate.

I have never seen the acquisition of one more technique (especially one that is of little practical use to most adults) as of any value except

in so far as it enables a person to convey the significance of experi-
ence when a moment of illumination comes. Emotions are clarified for
ourselves and communicated to others *through the expression of them,*
and personal techniques are hammered out in the painful process
of wrestling with this attempt to clarify. But such moments of fresh
vision, which may be the daily experience of the young child with "the
innocent eye," come less often to adolescents and adults—and so are
even more precious when they come.

Therefore I see the actual work to be done in the art "lesson" as
an alternation between the expression of direct spontaneous feeling
(when this is aroused by some incident in life outside the art room
or by the deliberate presentation of something within it calculated
to surprise or delight) with "studies," more objective, deliberately
undertaken exercises to explore the possibilities of the medium, to
perfect some technique of representation, or to become familiar with
the workings of nature in a more analytical way, for instance, how
bodies are articulated, how trees grow, how crystals are structures.
Since this book is concerned with class teaching, it is necessary to
remind ourselves that this alternation would ideally, of course, take
place in a different cycle for each child. One will be bursting with
something to say at the moment when another is heavy and unin-
spired. Not even children can guarantee to be creative at 11:25 am
every Thursday. This is, of course, a strong argument for having a
large enough art room open at all possible hours, with a reason-
able degree of independence for adolescents in the use of their time.
Those who have benefited from such an arrangement can vouch for
its releasing and balancing effect. But since in general we do teach
whole forms and we work within a timetable, the best that can be
done is to encourage opting out of the class activity when that con-
flicts too strongly with a personal urge. All this is not, of course, to
suggest that the careful study of a bare twig or the making of a useful
pot cannot be "creative," or that one mood cannot turn into the other
while one is working. But there certainly are different moods that
occur in different rhythms for each person.

If this is accepted by teacher and pupils then the studies, the tech-
niques to be learned (which are part of art education as much as

of any other discipline) will be seen, not as skills to be mastered for their own sake but as contributing to the act of creation. When, in a moment of vision, an object or an experience is illuminated with significance, not only the innate sensibility but the acquired skill must bear upon the experience to clarify and communicate it. Surely it is for this that the disciplines have been subjected to the techniques practiced in less inspired moments! A child or an adult is no better a human being and contributes nothing to the common good if she can paint but has nothing to say in her painting. What she says should be a personal statement—her own representation of her own experience—not a "good painting" in terms of any particular school of educational thought. Her personal involvement and responsibility for her own statement is one of the most important contributions of the arts to the whole of education. Admittedly, what she says is not likely to be original and creative in the sense of expanding the frontiers of human understanding as do the great artists. But though her painting is individual, it is not in isolation. Only through a sincere study of the masters (both old and contemporary) as people doing the same sort of thing as herself, only far better, who show the variety, the flexibility, the potency of the languages of painting to fix an image, and convey an experience—only through this will she grow from childhood to adulthood in art, with expression and appreciation interweaving. So can a child and an adolescent grow into her own culture and root her present in the past. This much about creative work I understood, I think, when this book begins, but I did not know how far back these roots might reach or how rich was that compost of ages that may fertilize its growth.

With the exception of the opening paragraphs I have found virtually nothing to change in this introduction after nearly twenty years, and I can only greet with joy the present urgency of concern with mythological images, with symbolic forms, and as a spiritual searching. The kind of work illustrated in this book will appear at any time where a sympathetic atmosphere is provided because it arises from the most profound levels of our common human experience.

—Seonaid M. Robertson
Autumn 1981

PART ONE

In Part One I first describe three apparently isolated incidents, illustrative of those that originally drew my attention to the questions this book explores. It happens that these all describe modeling classes—for children and adolescents reveal themselves very clearly in this medium—but much of the material on which this book is based is painting, while poems and dance dramas are also slightly drawn on. The retelling of these incidents is followed by a description of the way in which, from hints and intuitions, a vague idea emerged and was tested out with the cooperation of a group of teachers.

The reader is asked to bear with me in retracing this roundabout approach. It would be natural in a book on education to expect to understand the significance of each incident as one went along. Here I invite the reader to follow the route by which the significance of each incident only gradually became apparent to me and I have no doubt that I have not seen the half of it yet.

I

THE ROSEGARDEN

We had the experience but missed the meaning.
—T.S. ELIOT, "The Dry Salvages"

"O' lovely squelchy stuff, lovely squelchy stuff!" One of the eleven-year-old boys was standing blindfold at his desk, his hair standing on end where he had swept a clayey comb of fingers through it, intoning this to himself as he picked up handfuls of soft clay and squeezed it through his fingers in long gobbets, time after time. He made nothing the whole lesson, and when at the end he uncovered his eyes, he cheerfully surveyed the mass of clay eels on his desk with a surprised grin. This did not worry me at all, as he was able to enjoy his fun. Apart from all kinds of other satisfactions, this boy had reached the first prerequisite of the artist—the positive enjoyment of his material.

One little girl, faced with clay for the first time that day, had moaned at the sight of it, "O, I don't want to touch it, horrid stuff, I shall get dirty. I'm sure I shall get dirty." I persuaded her to put on her pinafore and told her she could easily wash her hands afterwards, promising her that if she did not enjoy it she need never use clay again. Then I tied the bandage over her eyes and, taking her hand in mine, gently laid it on the grapefruit-sized ball of clay I had put in front of her, and left her alone with it.

This was my first meeting with those thirty youngsters,[1] and I had brought along quantities of plastic clay and large handkerchiefs (to cover their eyes) for this first occasion. I had quietened the group who

1. These were boys and girls of eleven to twelve in whose school I had been invited to take a few sessions of clay work.

were bubbling over with engaging excitement at the prospect of using clay and told them to blindfold themselves.

So with a great deal of chatter the boys and girls tied on their own and one another's bandages. There were some who, during this manoeuvre, managed to find their way to a completely different part of the room and had to be led back to their own desks and a few who were convulsed with laughter at the sight of their friends so bandaged. After a few moments I managed to see that each child was quietly settled at his own place, and I suggested that they should start. "You need not think about something to make," I said. "Here is a piece of clay and you've never had the opportunity to play with clay before. Just get to know this piece of clay; push your fingers into it, pull them out, thump it, bang it, roll it if you like—discover what it will do and what it won't do. If you push your finger far, it will go right through; if you pull the clay out in your hand it will eventually break, and if you want to go on just exploring and enjoying the clay itself for the whole lesson, that's quite all right. You don't need to make anything, and if you do make something you can squash it up again and make something else. But if you find that, as you feel the shape you are making beneath your hands, an idea comes to you of what it *might* be, then perhaps you would like to bring out that idea a little more, to shape it into the form of the thing that is in your mind. There is more clay at your right-hand side, which you can feel for, and I shall come round and see what you are doing. Do not worry about the other people in the room—perhaps you can imagine that you are quite alone with this piece of clay. So it would be a good idea if we were all very quiet. At the end of the lesson we will take off our bandages."

I myself would hardly have believed the way in which the burble of excitement died down in a few moments. First of all the bright eyes of the children, which were what had particularly struck me about this new class, disappeared beneath their bandages, and then the excited jigging limbs, the hands constantly thrust up to attract my attention, and the feet that hammered on the floor or kicked at the desks in childish desire for movement were all stilled. The whole activity in each of those little bodies became concentrated in the hands—those hands that were pushing and pulling and forming the formless lumps

of clay in front of them. I was intensely interested in their very first movement and wished that I had a hundred eyes to see what was going on in every corner of the room. One of the most unexpected things was the great number of pillar shapes pulled up from the lumps and later elaborated with "decorations." I could not watch at the same time the transformation of every one of these and could only in a few instances follow their change into lighthouses, candlesticks, and pistols (PLATES 2*a-c*). At the end of this lesson, there were more recognizable lighthouses than any other single object.

I watched the little girl who had moaned about getting dirty, and at first she laid one single and tentative finger cautiously on the clay, clutching her thumb and other fingers in her palm and holding her left hand clenched in her lap. After a few tentative pats or strokes with the tip of her finger she drew back and shuddered a little. Then the clay drew her again, and the same pink index finger, with its smooth soft nail, crept out and this time pushed at the ball of clay, making an imprint in it. After a momentary shiver she pushed that finger further and made a hollow in which she slowly twisted her finger, then again she quickly withdrew it and clenched her hand to her chest; however, the other hand came slowly up from her lap and then with two forefingers (but with the other fingers still curled in her palm) she started again to pat and press and eventually to poke the surface. For the whole of that lesson she could not give herself up to the clay; she could only push a finger at it and then hastily withdraw as though attracted while being afraid of the attraction. She had made nothing by the end of the time and still sat with her ball in front of her—only modified by those pierced hollows and proddings that were all she had allowed herself. However, at the end, I just smiled at her and pointed out reassuringly that her overall was still quite clean and sent her among the first group to wash her hands.[2]

2. I did not yet know whether she would refuse to use the clay next week, a feeling I had promised to respect, and I had quite anticipated that even though she did not refuse it, I might have to use a certain amount of persuasion to get her to make anything with it. In fact, the next week as I drove my van up to the front door, the children were out enjoying their playtime

As I walked quietly about the room I tried not to disturb the children in their absorption, but murmured occasionally, "That's fine!" or "It's lovely stuff to feel, isn't it?" or I left alone some whose whole movements expressed intense concentration. Then I saw, towards the end of the lesson, one little girl working by herself in a corner of the room almost with her back to the rest of the class. She was laying out on her desk by touch, a string of "sausages" of clay, which she rolled and placed with great devotion, feeling their position in relation to one another. When I saw her at work she had completed one oval of such sausages and was making another inside it. She seemed to be working to some intense inner dictation so, not wanting to disturb her, I waited until the end of the session and went back to discuss her work with her when the others were clearing up. Inside the inner oval she had placed three upright pillars, of which the middle one was larger, more squat, and hung with fruit-like appendages. When, a little later than most of the children she took the bandage from her eyes, she looked at her work for a few moments, then ran to the front of the room where I had provided a bag of white powdered flint to dry up the clay, which was a little too damp on this occasion. She came back with a handful of this and, laughing, scattered it over the pillars (PLATE 1*a*).

Looking at this curious arrangement of sausages so laid out, which conveyed nothing to me and might so easily have been swept up and put back in the bin as no sort of achievement to keep, I asked her what it was she had made. A superficial glance would have suggested

in the courtyard. To my astonishment this little girl detached herself from her friends and came flying across the asphalt to me, saying, as she helped me to open the back doors of the van, "Are we going to use clay again this week?" eyes shining and cheeks bulging with the stretch of her smile. Something seemed to have happened in the meantime. Perhaps just the fact that her tentative playing with clay had brought no dire results from any quarter overcame her inhibitions so that she could dare to enjoy it. That week she attacked her ball of clay in a completely different way, and though she was always one of those who early seized on an intelligible idea and gave herself assurance by working on that, she did, I think, find a material responsive to her handling and courage to widen her experience.

it was the work of a lazy child or one of low intelligence. "It's a rose-garden," she said, only letting her eyes glance at me before they were brought back to her model. "It's a rosegarden, and this is the wall round it. You come in here," she indicated an opening in the outer wall with her finger, "but you cannot get into the garden. You have to come round that way" (between the outer and the inner wall), "and then you come into the garden this way." The opening of the inner oval was at the opposite side to the outer one and now, with her forefinger, she traced the path into the inner garden. "And here," she said, "there are fountains," and again she lifted a little of the white powdered flint, and scattered it—perhaps as the drops of water might fall from the fountains? "There are fountains and there are flowers and rose trees and lovely smells." The contrast between the barely formed pieces of clay lying on the desk and the vision that was obviously in her mind, this *contrast* was so great that I knew I was in the presence of some-thing very puzzling. Here was an intelligent twelve-year-old who was capable of drawing a reasonable picture, of representing the visual appearance of the world to a normal extent, obviously happy and sat-isfied for a whole session in the experience of placing together two ovals and three pillars of clay. This was no instance of compensating for inadequate skill of the hands by dressing it up in skill with words. I later discovered that this little girl could model reasonably realisti-cally, but today there was a dreamy in-turned expression in her eyes, as with great satisfaction, if a hint of reserve, she murmured to me, "This is a rosegarden."

I managed to preserve the "rosegarden" by telling her that the oth-ers had all cleared away and that she also must go now and wash her hands. So I was able to photograph it. I knew I was in the presence of something strange that must be explored, but how to set about it I did not know, so in the need to get on with the business of teaching and of everyday living, I did nothing.

II

THE MINE IN THE CLASSROOM

The mystery of the hole—the mysterious fascination
of caves in hillsides and cliffs.
—HENRY MOORE, "Notes on Sculpture"

The contrasting group of which I now write were boys in a secondary modern school in a rather decrepit building in one of the uglier mining areas of the West Riding, where the lads were tough and truculent in their Yorkshire independence.[1] Lacking pocket money, they found weekend playgrounds in the cindery wastes and foul pools around the tips, and gratis amusements in lounging outside the smelly pubs or staring at the vulgar posters outside the cinemas. I was invited to teach in this school once a week, and the class I faced that first day were fourteen-to-fifteen-year-olds, several of whom would be working men very soon. Most of them were restive and contemptuous of school, longing for independence and the dignity of bringing home a pay packet. They were unused to a woman teacher. I wondered what I had taken on.

However, when I saw the thirty-odd youngsters gathered in the room, some rough, some slinky with plastered hair, some weedy looking with blue-tinged faces, almost all in clothes neglected by overworked mothers, I reminded myself how restricted their sense experiences had been in these bleak surroundings, and I was filled with confidence in the clay to give them an experience they might otherwise miss.

1. I had at this time taught for several years in girls' schools and in a mixed training college and deliberately chose this school to refresh my teaching as one of the toughest in which our students practiced.

The craft master in the school gave me the utmost coopera-tion—the use of the clay, complete freedom with the room, which was finished with rough tables and chairs, and the feeling of being wel-comed by him. He seldom put in an appearance during my lessons but he was always interested in the boys' products. They had a good tradition of pottery in the school, but this form had not done much modeling, which was the work I proposed to take with them. I gath-ered them round one of the big tables, sitting on stools or perched on one another's knees, until we were all close enough to talk in an informal fashion. Telling them briefly how I had come to be a pot-ter, I asked them about what they were going to do when they left school—which for some of them would be in a few weeks. As coal mining was the predominant local industry most of them took it for granted that they would go "down t'pit," although some admitted that their mothers didn't want them to. When I asked why their mothers objected, among the chorus of "It's dirty" and "Me mum wants me to have a job you don't get so worn-out" came also the sombre stories of pit accidents. One boy had an uncle killed, many had brothers or fathers injured in the pits, and in that first ten minutes with them I sensed another sort of life from that I had known, a life overshadowed not only by the heavy gray skies, which the soot and dirt suspended over the town, but by this threat in the background. Yet the inevitabil-ity of working down the pit shut them within this cultural waste as the circle of pit tips blocked every vista of the streets.

Nevertheless, this sombre side emerged only occasionally in such discussions, and on the whole they took it for granted and got on with their lives like other adolescents. I suggested that on this morning we should all model a miner. I also told them, as I do with almost every class, that whatever subject for a picture or model I put to them was only a suggestion, and if they felt strongly against using it, or if they had some other idea crying out to be expressed, they should never feel themselves forced to work on the subject given. This proviso is I think, essential, and it has often proved very interesting to watch which subjects certain boys, or the majority of a class, opted out of. It has also proved just as illuminating to see what subjects they chose to do when they *did* make the definite decision to work on one of their

own choice. On this day nobody opted out; everyone modeled a miner or some aspect of mining.

I asked them whether any of them had ever been down a mine, but none had, nor had I at that time—but they had heard exact descriptions from their fathers and brothers. They described what they thought it would be like when they finally went down there; they spoke chiefly of the darkness, the confined space, and the feeling of the whole earth over one's head. It would obviously have been much better if I could have gone with those boys down a mine, as indeed I did later with my own students,[2] but since it was not feasible on that occasion I proposed to them that we should build ourselves a mock mine in the classroom and give ourselves up imaginatively to the experience. They thought this rather peculiar, but after agreeing to humor me, they set about it with a will. So we darkened the windows so far as we were able. We constructed a kind of tunnel in the class-room, starting by putting the large tables together end to end, leading through to the chairs all set end to end, and then the stools so that our construction narrowed in the final part. We made the tunnel wind about the room and turn round corners, and we hung the sides with a collection of coats and waterproof table covers to get the feeling of darkness and constriction. Just before we started to crawl through the tunnel one hitherto silent boy pointed out that the miner usually carries his pick over his shoulder down the mine and this seemed an authentic addition. So we all searched about the room for something to represent a pick—a broom handle, a long piece of wood, a ham-mer, or something of the sort, and imagining we had just come out of the down shaft, we filed into the "mine." I did wonder if this would seem rather childish play to those boys of fourteen, but as soon as we started off through our constructed tunnel we all became so absorbed in our physical sensations that these at least were intensely real. One became acutely aware of angles, of the angles of one's elbows and one's wrists and one's knees in the effort to avoid knocking them against the legs of the tables and chairs. One's forehead became like that of a caterpillar, the forward-pushing part of oneself that must

2. An account of this is given in Chapter IX, "The Visit to a Coal Mine."

take all the bumps and knocks. It was fairly dark in the tunnel, and we had to feel our way along and round the corners and meet obstructions such as crossbars with our doubled-up knees. We crawled very closely, one behind the other, the last boys tumbling to get in and hustling the others on, so that one was always afraid of kicking the face of the boy behind or being kicked by the one in front. I found then how very much more difficult it is to crawl carrying a pickaxe; it is a relatively easy thing to crawl on hands and knees across the floor, but on *one* hand and knees it is a different matter. The pressure on every bony part seems more than doubled. Progress was rather slow through the labyrinthine construction, and I was acutely conscious of the unprotected protuberances of my kneecaps. My shoulders became stiff, so I thought it would be a relief to change hands and tried to transfer the "pickaxe"—an old mallet for woodcarving—to my other shoulder, but I found it impossible in the restricted space, and the boy behind me was pushing and breathing and muttering, so I had to press on. It seemed a surprisingly long journey round that dark classroom, and when I finally emerged at the end of the tunnel, it was an intense relief to stand up and stretch; as the boys tumbled out one after another they lunged into a vacant spot and stretched themselves in real enjoyment of the space.

At this point there occurred an incident that endeared those boys to me on this my first meeting with them. I had brought an overall for this clay lesson but in order to make a good appearance on my first day at the school I had put on my best nylon stockings. At the moment before I started to lead them through the tunnel I became aware of the foolhardiness of this but since there was nowhere to slip away and take them off, I ruefully took my nylons through the tunnel with me. When we emerged, and I was looking at the ladders running down from each knee, the boys also noticed and gathered round me with anxious solicitation: "Oh, what a shame, Miss." "You can't do nothing about mending that, Miss, it's too far gone," they exclaimed. They knew from their experience at home with sisters and mothers how it might sap self-confidence and ruin a date to be without a pair of perfect nylons.

However, I was anxious for them to hold the image of their recent experience in their minds, and so we hastily stripped the coats and covers off the tunnel, righted the chairs, and with an enormous double-fistful of clay each settled down at a table. At this point I said nothing to them except, "Now let us model what it *felt* like to crawl through the tunnel. Do you remember where it hurt? How cramped we were? Think yourself back into the experience and from that imagine the closeness and darkness of a real mine, and model a miner at work." Silence immediately shut down on the group, and everyone started modeling. Most of the boys chose to model a miner crawling on his hands and knees, but one or two showed the miner hacking at the coal face. Almost all the models had an extraordinarily earthy sturdiness (PLATES 3*a-b*).

After remaining in the background for the first ten minutes to let them become absorbed in what they were doing, I started quietly going round. Without being "correct" in proportion or finished in detail they were truly clay representations of our experience. To look at them recalled bodily the constricted movements. The figures usually showed very large hands and feet, and shoulder muscles, of which we became acutely aware, were prominent. These boys would see their fathers stripped for bathing at home, and there was nothing of the idealized he-man in what they modeled. Many of the figures had a curious look of a blind, burrowing animal about them. I began to ponder the effect of mining on miners: whether in expecting men to go down into the earth to get coal for us, we are asking them to become less than men. It is a known fact[3] that mining towns produce a very harsh type of patriarchal society—might this be due not only to economic factors but to the need for men who have felt at the mercy of their environment when at work to dominate powerfully at home?

On my way round I paused to talk to Bert whose miner was a beetle-like creature with a small flat face emerging from a huge body, one

3. This emerges clearly from a sociological study of a town close to this school: Norman Dennis, Fernando Henriques, and Clifford Slaughter, *Coal is Our Life: An Analysis of a Yorkshire Mining Community* (London/New York: Tavistock Publications, 1969).

little hand thrust out in front feeling its way. Most of the boys had represented the great heavy clogs the miners wear and had, if anything, exaggerated the feet in their consciousness of the morning tramp of miner's boots. But Bert's little figure was heavy and sturdy in the shoulders, thighs and knees, and then the legs tapered away to small insignificant feet, almost without a representation of the heel. Before I had realized what I was doing I said, "Bert, haven't you ever *looked* at anyone's feet? Legs don't just taper away to a point like that. There is a heel, a right angle, which we have developed to stand on and which we lift from the ground as we walk." He lifted his eyes from the model and looked up at my face with an almost dazed, unfocused look, still sunk in what he was doing. Into his absorption, in which for the moment no one else existed, I had intruded. Instantaneously I realized my mistake. I was standing above him and in that moment of realization I had dropped instinctively on to my haunches beside him.

I suggested that we should both try on our hands and knees to feel once more the position he had chosen to represent. Bert "came to" slowly, parked his spare clay, and we both crouched on the floor at the side of the table on our hands and knees. For a moment we gave ourselves up to recapturing in our bodies the image of our progress through the tunnel. Then meeting his eyes level with mine that foot or two above the floor, I could only nod my head humbly at him and say, "Yes, I see what you mean." For the extraordinary thing was that when I got back into that position and tried to *feel* the length and shape of my leg instead of *looking* at it, I was almost unaware of my heels. Sensation followed the tensed muscles of the leg and the tactile sensation of the skin of the foot arch pressed on the floor, but I was not conscious of having heels unless I thought about them. "Yes," I said, as we rose from the floor, "I see what you mean, you are perfectly right," and fortunately Bert settled down at his work again, I hope only a little the worse for my interruption. For I had been, of course, completely in the wrong. In asking those boys to crawl through the tunnel with me, I had deliberately cut out as much light as possible so that we would not be relying, as we usually are, so much on *visual* as on *kinaesthetic* sensations, those feelings of being crowded in a narrow space, of being bumped by jutting prominences, or feeling one's bodily

movements within a very restricted alley. Bert had, in fact, offered a representation of just this experience, and here I was asking him if he had *looked*! I was shocked into being more patient and more cautious before I made a comment to any of the other boys. I tried to take to heart again my own advice to my students, to wait until, by observation and perhaps questioning, they had felt their way into what aspect a child was trying to represent, before they commented or criticized. We have to lie down, as it were, beside the child and take his point of view before we can say anything helpful.

I had been so interested and so absorbed in the miners all round me that I had not noticed that at the other end of the room two boys were working on something rather different. When I made my way to them I found that after the others had taken as much clay as they wanted from the clay bin, these two had helped themselves to all that was left. On the end table they had piled this huge mountain of clay with which they were constructing, they said, a mine. The great heap was riddled with tunnels that went in at one point, turned corners and emerged somewhere else, crossing and doubling back, sometimes dividing into two. The clay was pitted with the hollows thrust by a prodding finger, but when I came up to them, these two were thrusting their arms up to the elbow into the bigger tunnels, feeling their way forward with the clenched knuckles of one hand and withdrawing their arms again from the clinging clay, which made a sucking noise. The blissful content on their faces as they pushed into the hollows, their independent silent play on opposite sides of their clay mountain and yet their acceptance of each other's presence and each other's pleasure in the same activity, was very thought-provoking. Their intense satisfaction and enjoyment in the simple act of thrusting in and pulling out of one orifice after another is something that I shall never forget.

If I were asked to justify the device of the mine in the classroom, I would say first that the basis of all art lies in sensation, but that the kinaesthetic and tactile sensations that are the foundation for making or enjoying sculpture, pottery, and many other crafts are sadly neglected in a predominantly visual, aural, and intellectual education. Since I was going to take this group for modeling and pottery I

wanted to establish this basis from the beginning, and I deliberately made an effort to isolate and emphasise bodily sensations—by darkening the room, by using less familiar muscles, by an imaginative heightening of the situation. As for the precise choice of subject for these boys, I wanted on my first day to meet them on ground where they were at an advantage, where I must listen respectfully and sympathetically to their tales of the mines and share in the anticipation of their future jobs.

The next week we were mountaineers, stretching and reaching up to grasp. We climbed on one another's shoulders, we hung on to any firm projections we could find. We talked about Everest and about why men climb mountains. Although this provided an extreme contrast of the physical sensations—stretching, reaching, staring upwards, after creeping, crawling, crouching downwards—and gave to such common expressions as "reaching after proof" and "burrowing for facts" the new vividness of bodily sensation, I found that this was not such a good subject for modeling. It lost too much through lack of color and was much more satisfying when worked out in painting.[4]

So far, the models had usually consisted of *one* figure with which the boy, by this approach, was induced to identify himself. Because of the degree of abstraction needed to represent even the simplest three-dimensional form on a flat surface, it is easier to be objective in drawing, and being objective is of course another necessary facet of art education. But for the many weeks when we pursued this more subjective approach (without necessarily "going through the motions" as a group every time), they had realized that if you take up the physical attitude of the character you are "feeling yourself into," you are likely to get a fuller realization of his situation. From then on, boys could be seen unobtrusively getting themselves into all kinds of queer positions, "to know it from inside," as one said, as well as asking their friends to pose briefly for them while working on a model.

4. When I suggested mountains later as a painting theme, I noticed that mountains were then always represented from a distance, and often fantastically peaked. It was the idea of the unattainable, not any actual incident of climbing, that was chosen.

Where one teacher can teach movement or dance and drama as well as art, as is more possible with primary class teachers, such interaction between one and the other is very natural. Many of my students who have gone in for secondary teaching have also managed to follow through themes in several different arts in this way, each contributing to expression in the other. Since this particular line of development was not open to me with this particular class of boys, I went on instead to explore the relationships of *groups* of figures using eyes as well as haptic sensibilities.[5]

Miners' families are keen keepers of pets, and when these were welcomed at school they proved fascinating models for drawing: hamsters, tortoises, greyhounds, or goats. I used this interest to bridge the chasm between the single-figure and double-figure models. The boys told me about their pets, so we talked of animals and of the differing relationships of men to animals; of hunting them (with reproductions of cave paintings to look at), of taming them for milking and breeding, remembering the pastoral Old Testament stories, and then of the harnessing of animals to help in agriculture. I remember telling them one day, as we did the more mechanical work of preparing the clay, about Briffault's theories of the change in these earliest societies in the status of men and women resulting from this.[6] He believed that the early communities were matriarchal, closely attached to one spot, the women owning and largely working the land, the husbands going

5. A description of the complete reliance on touch and haptic sense is given in an article on blindfold modeling in *The New Era in Home and School* (1954).

I had for as long as I can remember been aware that emotions may be *expressed* by certain attitudes—I suppose a child early learns to interpret the postures and gestures of others for its own protection. But it was something of a shock when I first consciously recognized the converse—that emotions can be *evoked* by movements and postures, and this was largely through coming to know Rudolf Laban and his students. I recognized that, just as marching and drilling could be used to evoke one kind of emotion in the participants, and dancing together a different kind, so adopting an upright posture and bold step could help me to get over nervousness before entering a room or mounting a lecture platform.

6. Robert Briffault, *The Mothers: The Matriarchal Theory of Social Origins* (New York: Macmillan Company, 1931).

to join and live with their wives on marriage rather than the other way round. But the domestication of herds, entailing grazing circuits, which was men's province, had put economic power in the hands of the men, who, moreover, then wandered off taking their wives with them, as Jacob took Rachel and Leah, and so gradually a patriarchal society became more general. Where however agriculture had developed on an important scale into historical times without an intervening pastoral stage, the matriarchal setup has been reinforced and survives strongly in some primitive societies, which the boys themselves knew from films or television. As well as entertaining us through the less creative stages of clay work, perhaps Briffault's ideas would suggest to this generation in flux that the extreme patriarchy they experienced in their own homes was not the only possible form of human society.

So they modeled "men with animals" in whatever relationship they chose: men fighting tigers, breaking in horses, milking goats, nursing cats, or fondling those pigeons (PLATE 4*a*) that are the commonest associates of miners and perhaps represent a freedom they, more than most of us, are denied—

> winging wildly across the white
> Orchards and dark-green fields; on—on—and out of sight.[7]

In these models they explored the ideas of various relationships expressed in the *stance* of man and animal. This led on to the two-figure groups that were made next—boys wrestling, grandfather dandling a baby, the lovers shown in PLATE 4*b*, a model that, though made quickly by a loutish boy out of the coarsest brickwork clay, is tender and delicate in feeling. When we came on to the technically much more difficult problems of relating three or more figures in a model, I got led away, I remember, into talking about the sudden opening of fresh possibilities in Greek drama when the third actor was introduced, but they kept me down to earth, discussing the difficult situations that do arise when three friends or three in a family are together, and all the myriad ways in which they may react to one another. Their

7. Siegfried Sassoon, *Collected Poems* (New York: The Viking Press, 1949), 124.

models revealed and fixed in telling form some of these situations and attitudes: the rejection by a pair of the third person; awareness by two of the presence of the third, which somehow forbids pairing off and holds all three in uneasy congress; the glad acceptance of the third, perhaps in veneration—as seen in one boy's model of two small children at their grandfather's chair—or protectively, as in the Henry Moore family groups that some of them knew, since he was born near here. Consideration of these models interwove with discussion of the complex ties that exist between three people. The resulting image arises not only from the visual memory of such situations, nor from the imprint of haptic sensations of cowering, stretching towards, or embracing, but also from a human understanding of such relationships. The practice of an art is an opportunity for pondering such things, and many children ponder more deeply with plastic material between their hands. The material in its turn suggests images and modifies those that arise in the mind. The discussion of why a model will not balance may lead to a discussion of the physical properties of clay or to the human situation of falling over backwards to avoid rushing in "where angels fear to tread." The two planes cross here in a clay model illuminating each other, and this is one of the reasons for including art in education. An illustration of how the *material* may lead the thought rather than the other way round is given in the next chapter, "Eddie's Woman."

Children and students were often invited, either by me or by a colleague in consultation, to record their response to a subject or a situation in a piece of original writing. This helps those who do not feel that they have successfully communicated their feeling in clay or paint to search for the appropriate medium for what they have to say. It helps others to come to a more full and complete response through exploring many facets of the theme. Two such poems (on the theme of the mine by members of the class) follow.

THE PIT

The grimy filthy pit
The men struggling with giant machines and others just
hacking with hand picks.
The pit ponies who have never seen the earth above,
struggling with giant loads.
The pit, held up by mere logs, and the danger that lurks there,
round any corner, anywhere it comes unexpected in the pit.

At last the day's work is ended and the miners are making
their way home, up, up, and up the sheet face of the pit, dripping
dark and still.

Into the light once more we came, the sun a startling con-
trast to the pit.

THE MINE

The mine is very deep and long
and very frightened too
I heard the echoes of the deputy
shout so long and shrill
as it meant a frightened ghost
to me. You could hear
the explosions of the coal
beside, behind you
It is a very frightened pit and very lonely too.

III

EDDIE'S WOMAN

When the "charming woman" shows herself in all her splendor, she is a much more exalting object than the "idiotic paintings, overdoors, scenery, showman's garish signs, popular chromos," that excited Rimbaud; adorned with the most modern artifices, beautiful according to the newest techniques, she comes down from the remoteness of the ages, from Thebes, from Crete, from Chichén-Itzá; and she is also the totem set up deep in the African jungle; she is a helicopter and she is a bird; and there is this, the greatest wonder of all: under her tinted hair the forest murmur becomes a thought, and words issue from her breasts.

— SIMONE DE BEAUVOIR, *The Second Sex*

Children and adolescents will from necessity, in order to preserve themselves, turn what we offer them to the service of their own needs and desires. In an atmosphere where there is any degree of freedom at all, we are able to observe the inner pressures and needs emerging even through work that is not, in the usual sense of the term, "free expression." Some instances from different age groups will illustrate what I mean.

A keen young student had prepared a lesson during her teaching practice on painting cats. When she talked to her group of eight-year-olds, she asked them if they had a pussycat at home and told them about her cat and tried to engage their enthusiasm for a subject she felt was very suitable for their age and on which she had expended considerable preparation. But when she gave out the paints, and most of the children were eagerly starting their pictures, one little boy ran up to her in great excitement. "Miss, I was at a cowboy film last night, it was thrilling; they had them big hats on, and they were galloping after one another on horses. Miss, can I paint a picture of cowboys?"

The student, perhaps feeling that they ought to respond to the subject she had prepared with zest, said firmly, "No, Tommy, today we are painting pussycats," and Tommy went dejectedly back to his seat. However, when the work came to be collected at the end of the lesson, Tommy proudly displayed a picture of cats, wearing cowboy trousers and hats, riding horses!

Another instance is that of a much older boy, an overgrown, slouching lad of fifteen in an East London slum. Often he announced that he was bored with art, but just occasionally he would get absorbed in painting. On this day, the teacher, one of a group working with me on a series of themes, suggested to the class the subject of "The Sea." She may have talked about the moods of the sea; the sea when it was wild and angry and dangerous; the sea when it was calm and translucent with little waves lapping on the beach; the sea as one looked down through its depth to all the wonderful creatures who lived within it; or the sea as we knew it from all the great stories of history, wrecking St. Paul, casting up Jonah from the whale's belly. She also talked about the sea as those boys and girls might themselves have experienced it during a day at Clacton-on-Sea or Brighton, and of their enjoyment of the sea in paddling and bathing, calling to mind her own and their experience of water in all its characteristic moods. Now, though Fred, this morose, overgrown youth, knew, as did all the others, that he could opt out of any subject suggested and do another of his own, he did not choose to opt out of it and presented his finished picture with "The Sea" written proudly on the back (PLATE 5a). A rich orange sand covered the whole of the background right up to the top of the page, on which, in fact, no sea appeared, and on this beach reclined some very large, very plump, extremely pink and quite naked ladies. There was no need to ask the direction of Fred's thoughts at that time, and while he could reveal them in this frank way he had some hope of bringing them into relationship with the rest of his life. Whether it was in any sense a work of art is another matter, but certainly to try to judge it as a work of art without taking account of the pressing reason for which it was painted, would be beside the point.

Another picture on the theme of "A Family Group" shows how space relationships in a picture may be determined by the emotional

situation far more than by any conscious attempt at composition. The children, a class of twelve-year-old girls, had been shown old Victorian photographs of family groups by their teacher. She then asked them what their own family did together, in what circumstances one would see them all together? Did they go out together for picnics or for outings, did their mother take them shopping with her, or was the only occasion on which the family was seen together round the meal-table? She asked them to paint a picture of "My Family." Doris painted the picture shown in PLATE 5c and she herself is represented in the right-hand corner. One has no need to ask who is the dominating personality in this family, and the pathetic little scrap who paints herself as almost pushed out of the picture (not even troubling to finish off the details of hair and clothes as she has done in the other figures) is seeing herself, as it were, through her mother's eyes. In the presence of a picture like this, something given with sincere feeling, it seems to me it would be pointless to criticize this child for the composition of her picture, to point out that it is unbalanced, one large figure crushing another up against the side of the page. This child would feel that what she had given had not been accepted and, although she could not put this into words, she might know that the lopsided truth she had spoken was more true than the well-balanced composition we might be tempted to ask from her. But if the "image" that is called up in response to the suggestion of a certain subject owes much of its personal form to the inner pressures (as in "A Family Group") and to the driving interests of the moment, it also owes very much to the material in which it is formed. Painters have recently been rediscovering the power of the material to inspire (and some have almost abdicated from control of it), but craftsmen have always known this. Not only does a material of character modify a half-formed image in the artist's mind; it may be the very source of images itself.[1] Henry Moore has written of keeping pieces of wood in his studio for years waiting for *them* to suggest to him what is to be made from them. In

1. I have written a personal account of this in the chapter "On Being a Potter" in Seonaid M. Robertson, *Craft and Contemporary Culture* (London: G.G. Harrap, 1961).

the chapter on the relationship between the idea and the material, this will be further explored.

I have many personal accounts from students starting with a lump of clay but no subject, and of how the ideas arose from working the clay. It is not only that activity stimulates the mind and that there are always certain fundamental "ideas" or themes latent in our minds. Certain materials draw out, as it were, certain sorts of ideas. Yet that same clay, which evokes or provokes the kind of work done by the eleven-year-olds when Margaret was quietly modeling her "rosegarden," is also the stuff of Sung pottery, one of the most austere and spiritual forms of art that the world has seen and handled, yet one that has a human warmth and an acceptance of the physical base of human experience. When clay is used, this keeps breaking through the veneer of superficial sophistication and prudery, often assumed as self-protection.

Among the subjects that had produced some strange works, remote from any visual portrayal of the subject, had been that of "Mother and Child." I had used it, as I have written in Chapter II, as one of a number of suggestions for a two-figure group to encourage children to see how the different relationships between people were thrown into relief in a spatial relationship to one another. I used this subject with the group of boys described in the last chapter when I had been working with them for about five weeks. I was emboldened by a good relationship with those fourteen-to-fifteen-year-old boys but, even so, it turned out that with this group I had approached this difficult and very personal subject too soon. On this occasion more of them opted out than on any other, and it was interesting to see what they chose to do instead. As I walked round the class discussing the models with them, Eddie—an undergrown scrap whose ash-fawn hair tended to stand up straight above his pinched face—was modeling a standing woman. She had not yet any clothes on, but since quite frequently children attempt to model the figure first and add some indication of the clothes afterwards, I waited to see what he did. There was no sign of a child, and I did not remark on this but discussed the need to balance a standing figure so that it did not fall over sideways or backwards. The next time I came round to Eddie, his woman was still

unclothed, and she had now a well-developed bosom and exaggerated hips. As I looked at the figure I sensed a certain tension in Eddie and in the boys around, their heads bent over their own work but their ears cocked for my reaction. I pointed out to Eddie that a clay figure needs rather strong, sturdy legs and that ankles as fine as he had given here were tending to crack with the weight above. I mentioned that if he wanted to make such a shapely girl with a small waist and neat ankles in the current ideal, then he would have to work in some other material, but with clay the weight of damp clay above was bound to bear down on the legs, and therefore they must be strong enough to support her full figure. How far was it the damp clay and how far Eddie's own perhaps unconscious wish that kept modifying his magazine girl into a buxom maternal woman? The next time I came round to Eddie, he had indeed made the legs thicker and stronger, but the breasts and buttocks were now built out in an almost grotesque fullness. It was a primitive earthy woman, no more beautiful than Jacob Epstein's *Genesis*. Again I sensed Eddie's rather fearful expectancy and the watchful silence of the other boys, who were working either on their own choice of subject or on rather conventional mother and child groups, many of animals. Regarding Eddie's woman as any other piece of modeling, with careful appraisement, I congratulated him on managing the legs better, and asked if there was any part that did not satisfy him. Without raising his head, he muttered something about the hair, and I fetched a piece of clay and putting it beside him suggested that we should use it to try out different ways of treating hair, scratching it, adding small pieces of clay, or simply treating it as one large mass, demonstrating as I did so with this extra piece of clay, which I then rolled up and gave to him to practice on. There were many other models in the room that demanded discussion, so it was only at the end of the lesson that I got back to Eddie. By this time his woman had a great protruding belly and obviously it was indeed a mother and child. She was now quite grotesque, not because of her condition but by the crude and overexaggerated way in which he had modeled her. This time I did no more than smile at him and comment appreciatively on what he had done with the hair that did give

the model more variety[2] and interest, because now the face was sunk
between her breasts, and Eddie's tension seemed to ease with relief at
this acceptance. It was as though he *must* do this model, yet he hardly
dared. He sat back on his stool and stared and stared at his woman,
turning her this way and that way, and patting her with his hands. By
now the time had come to clear up at the end of the lesson. The boys
knew it was never possible to preserve all the models that had been
made; only some of them could be kept and fired and the rest must
be broken up to go back into the supply of clay. As a rule, those to be
kept were decided in discussion but, in addition, they knew that if any
boy particularly wanted to keep his model he could put in a special
plea for it. So after accepting their suggestions about which should be
kept, I started the boys on breaking up the rest into the clay bin and
in tidying up the room. In the busy atmosphere of movement and talk
while this was going on, I went over and sat on the stool beside Eddie.
I had intended to say casually, "She is going to have a baby soon, isn't
she, Eddie?," but in the presence of Eddie's intensity and fierceness of
possession, casualness seemed out of place. So I just sat down beside
him and smiled at him to let him know I was happy in what he had
done and left the rest unspoken between us. "Eddie," I said, "do you
want to keep your model this week?" I would not have been a bit sur-
prised if he had wanted his woman kept, so that he could take her
home and smuggle her into his bedroom and brood over her. I would
gladly have accepted it if this had been so. But Eddie looked at her
and looked straight at me with solemn eyes and looked back at her,
in a long silence. Then a slow smile curled up into the corners of his
eyes and brought vitality to his peaked face, and he gave a pat to her
bottom. "No," he said with tremendous satisfaction, "I wanted to do it
and I've done it," and suddenly he picked up his woman and fiercely
breaking her up, threw her with great feeling into the clay bin. He
had obviously been tempted to keep her, perhaps because he loved
her for her own sake or perhaps to boast about having dared me. I
believe that he recognized in the act of destroying her something of

2. The model had by now changed from a lithe pin-up type to something
very like the Paleolithic figure illustrated in FIGURE 3.

the crudeness and vulgarity of his portrayal and that he could go on from that point of understanding. In this case, the breaking up was as important in his education as the making. How much I would like to have had a photograph of that woman to preserve. But it would have been quite wrong to have disturbed Eddie at work to take one. Still less could I make an excuse to keep her just long enough to photograph. A man on good terms with the boys might have teased Eddie gently and asked to keep the model, with this in mind. I sensed that my function was a different one. What I did was to put a few handfuls of clay in a tin, and as Eddie was going out of the door after the rest of the boys that afternoon, I called him back and said, "Would you like some clay to take home, Eddie? You might make some more models." If there were any more models I never saw them, but then regrettably my relationships to those boys was only that of a weekly visitor.

Eddie's woman, no work of art, went like so many human phantasies, back into the bin where she belonged, but his sacrifice of her must, I am sure, have contributed in the long run to his maturity. No other material offers quite the plastic responsiveness of clay, nor invites perhaps so much to sensuous phantasy. Yet this same lump of clay, which was shaped a week or two before to the aspirations of a mountaineer, embodied Eddie's adolescent yearnings, and, broken up, re-emerged the next week, not to stop a bunghole but as a flower-vase offering for mom's birthday!

IV

HOW THE THEMES EMERGED

We shall not cease from exploration
 And the end of all our exploring
Will be to arrive where we started
 And know the place for the first time.
—T.S ELIOT, "Little Gidding"

I have described in the introduction how I believed for some time that in adolescence there should be a greater stress on visual observation—an objective study of the world around. I had also come to see how an imaginative participation in the life of other people might be induced by vivid sense impressions, as in our mimic crawl through the tunnel. I accepted that the images formed would be modified by emotional pressures, as in Fred's bathing belles and the relative sizes of Doris's family. These modifications of the visual image would be accepted by most thoughtful art teachers today. But this belief in the importance of sense impressions and the imprinting and "fixing" of an experience through painting or modeling it threw no light on Margaret's rosegarden. I could not forget that model, so remote from visual or haptic experience yet so satisfying to the child who made it and so haunting to me. It seemed to belong to another order of works and chimed with a different pattern that still eluded me. These were echoes of it, however, in the fragmentary hints of another way of working that began to emerge.

It was one of those dark, dirty, foggy evenings familiar to the West Riding of Yorkshire, and I had come back from a forty-five-mile round of teaching practice in the industrial areas, from Rawmarsh to Barnsley, from Barnsley to Pontefract, from Pontefract to Heckmondwike,

and back to the training college where I taught.[1] All over the college
other tutors were sitting in their little tutorial rooms to which a stream
of students came to discuss their work of the last few days. This often
went on until quite late, but the enthusiasm of the young students,
even though they too were tired, always enlivened and reinvigorated
me. Apart from discussing his work in literature and perhaps move-
ment or religious education, each student would bring one hundred
or more drawings or paintings and spread them out on the floor as
we relaxed on the easy chairs that were the essential furnishing of my
tutorial room. Thirty or a hundred paintings of the same subject by
secondary modern children might seem boringly the same to a casual
onlooker, but to the student, each one was the work of an individual.
These paintings, spread out like great fans or hands of cards across
the floor, were the starting point of our discussion.

On this particular evening I was cold with driving in fog all day,
tired with hurrying from school to school, and when the last student
arrived my head was swimming with this succession of pictures of
floods, volcanoes, vases of flowers, pit tips, and portraits. Despite my
genuine interest, it was in a dreamlike state that I looked at another
hundred or so paintings. As these paintings passed before my eyes
almost as blobs of color and shapes, some recurring rhythm, some
special kind of vision seemed to emerge from the series. I cannot
at this point describe what it was, only hint at a vague feeling that
the same sort of thing was happening again and again. My rational
mind told me that all the children in the class were often, though not
always, painting the same subject, however it was not the repetition
of pit tips or waterfalls but, rather, some way of seeing it that seemed
to jump out at me from this particular set of paintings. When I say
this I do not mean to suggest that these children all drew the scene
from a particular viewpoint or used the same composition. No, it was
rather like a mood that emerges from the hidden structure of music.
I stopped the student in his commentary on the day's doings, to stare

1. My students were resident two-year students training to be teachers who
were taking art as their principal or specialist subject though they would also
be teaching English and perhaps another subject.

and stare at a painting of a cave in which this hidden meaning seemed almost emerging. I say "emerging" because the picture itself looked superficially a mere daub, nothing in it was fully worked out, the boy who did it seemed hardly to rely on his knowledge or memory of the visual world at all. It was without detail or verisimilitude, only a series of swinging curves in beautiful contrasted colors of blue, blue-green, gray, violet, dark green that hollowed back into the center of the paper, drawing one in. Robert, the student, exclaimed over this painting, saying that the boy had seemed quite unnaturally absorbed in something apparently so simple and undemanding. Of another cave picture where I detected this same evocative simplification of form, Robert volunteered that this boy normally wandered about the room unable to paint, trying to distract the others, but that on this occasion he had sat down and worked rapidly and thoughtfully and produced this picture on which he brooded in a satisfied manner till the end of the lesson. Robert obviously appreciated this "strange" work. Perhaps if I had been feeling fresher I might have urged him, as I had urged other student-teachers on former occasions, to "take the work further," to incorporate more detailed observation of the known world. Fortunately, some other quality in the work silenced any such suggestion. Was it possible that Robert's appreciation of its quality—though he could define that no more than I—had "provoked" its appearance? By what means did he entice this strangely moving work from secondary modern children of the drab towns of the industrial West Riding?

Through the following weeks, the idea kept recurring that something unexplained was conditioning those forms, that they were not intellectually planned by these children. The notion that there was something to investigate was so vague, so tenuous, that it was a temptation to dismiss it as nonsense, yet it remained with me.

At the end of the teaching practice, when the students covered every available wall of the college exhibition space with the children's work, and hundreds of paintings were pinned, often unmounted, touching edge to edge, I hoped that from the sheer number and proximity there would emerge some clue to that which had attracted my attention.

Formulating some questions, I spent hours in that room trying to *see* the answer with my eyes. The questions I asked myself were these:

DO THESE SHAPES OR "WAYS OF WORKING," WHICH SEEM TO ECHO ONE ANOTHER, OCCUR REPEATEDLY IN THE WORK OF ONE CHILD?

Knowing the predilection of some artists for certain shapes and rhythms, and knowing my own tendency to explore a limited range of shapes at one time, it seemed likely that this might be the explanation. There were only about five or six productions from one child in a seven weeks' teaching practice, yet I could see from this survey and from my records of previous years of my own teaching that the answer was certainly not an unqualified "yes." My knowledge of movement study, gained from contact with colleagues trained by Rudolf Laban and from opportunities to join dance groups myself, suggested that certain individuals would tend to use the same physical rhythms repeatedly and therefore reproduce the same forms, but these strange forms seemed to turn up in the work of whole classes on one day rather than in the serial work of one child. So, since I had first been particularly struck by this quality in the work shown me by Robert, the next query was:

DOES THIS WAY OF WORKING ALWAYS APPEAR IN THE WORK DONE UNDER ONE TEACHER?

The influence of the teacher in setting the atmosphere and encouraging one aspect rather than another must always be allowed for, and it only becomes dangerous when all the children are beginning to paint in one style. On going through all the work again, it seemed that the thing I was looking for was quite absent from the work done under a few student-teachers, but was frequent in that of others who were yet not open to this charge of encouraging only one style. Yet the influence of the teacher did not wholly explain it because, even with these last, it was sometimes quite absent for weeks.

There seemed nothing to come to grips with. There were altogether too many variables. Pinning up hundreds of paintings in different ways, I searched for a clue, selecting first on one count, then on another. On one occasion I pinned up together all the work in which any student-teacher had made the comment that the children

appeared to have been absorbed to an unusual degree. Suddenly it struck me that the *subjects* portrayed in this group were very often the same as the subjects in the group where I thought I detected these elusive simplified forms, which had for me the same evocative, haunting quality as Byzantine art. Now obviously, some subjects would be more meaningful to them and so be treated with greater intensity by some individuals. But could it be that there was some *general* relationship between the subject and the degree of involvement over whole groups?

Here it is necessary to explain that these students often find themselves on school practice teaching classes of from thirty to forty-five in a room that may serve as a classroom for general subjects before and after the lesson. They work for periods ranging from a whole afternoon down to that bare forty minutes that is no more than time to give out and take in painting materials and discuss the subject, and therefore virtually cuts out any value painting may have. Because of these conditions, I encouraged them, particularly on teaching practice in an unfamiliar school, to treat one subject with the whole class. The ideal art lesson for adolescents as much as small children may be the one in which children come into the studio, get out their own materials, and work quietly, each on his chosen job, coming to the teacher for individual help. But this situation presupposes a well-equipped studio not used as a classroom, so that tools can be left available; sufficient room for children to move freely at all times without disturbing others; and classes about half the size of those we generally have *or* a long unbroken session to allow for the time necessary to get out many kinds of equipment and to give sufficient attention to explore with each child the subject he has chosen. Another condition, a *tradition* of independence in individual work, can be built up by a teacher but hardly by a student working for a few weeks in an unfamiliar school.

So, as a general rule, a subject is suggested verbally or presented in the form of actual objects. It is discussed and is either drawn or painted "straight" or used as an incentive to explore further. Children may always "opt out" to do something they have an urge to paint.[2]

2. Since there is no generic term covering to draw, to paint, to sculpt, to

But some boys will merely draw airplanes every time, and some girls will simply repeat schematic houses or fashion plates. If this is not mere laziness or timidity, it means that they have become fixed or frozen in their emotional relationship to this object. The house or airplane is, as it were, a mummified image, serving as a channel for emotion perhaps, but not offering fresh experiences. They may be liberated from its constriction—and support—in at least three ways. One of these is the challenge of a new material, such as stone, or a new tool, such as a graver rather than brush, which demands a new form. Another is the introduction of something that will give a visual shock of delight and startle a child into wanting to convey this with the materials ready at hand. The third and perhaps most important is the reaching towards a more flexible attitude to the obsessional subject itself by looking at new aspects of it with genuine observation and allowing what he actually sees to lead the child towards a wider relationship with it. This does not of course completely deal with the inner pressures that produce such an obsession—that needs skilled treatment—but although she cannot give this, the responsibility of the ordinary teacher with all ages, especially with adolescents, is more than merely providing the materials and "letting them get on with it."

So, it is in exploring together a chosen subject that most of these students met their classes.

To return to the question that intrigued me—I asked myself, could it be the *subject* that evoked this way of working? I could not yet define to myself what I meant by "this way of working," but I felt quite sure that certain arrangements of forms resulted in pictures that were powerful beyond the usual work of these children, and that did not depend on draftsmanship or painterly qualities. This whole study is subjective and, being organized within the normal school routine, makes no pretence of using strict control groups or strictly controlled conditions. Even so, there was no need to rely on my response alone. I asked a group of my friends (men and women, mostly housewives, teachers and training college lecturers in other subjects) to pick out

model, I shall use "to paint" unless another is specifically called for. The greatest number of illustrations I use are in fact of painting.

from hundreds of pictures presented to them those that seemed to be evocative or "haunting," as one of them described it, beyond what the skill of the child would lead one to expect. From their choice I made a list of the subjects of these pictures.[3]

Next I asked my students (men and women taking art as one of a number of teaching subjects but with whom I was pursuing many different issues and who had no idea then of the question in my mind) to bring to me those pictures, of whatever "merit," which had appeared to absorb with an unusual intensity the children making them. I made a list of the subjects that had inspired *those*.

I added a third list from a number of "queer" inexplicable objects, which had been made in my classes from time to time over many years. It seems strange to me now that I had kept them, carried them round with me from one dwelling place to another, but they had compelled me to hold on to them until I could relate them to something else. These objects were mostly in clay, and, as they were made in small-group classes where I had time to discuss his idea with each modeler separately, no subject had been suggested. Their makers, often people of above normal intelligence, administrators, youth leaders, teachers, brought them to me at the end and named them spontaneously. But they named something to which they bore little actual resemblance. Nevertheless, they seemed quite different from the unsuccessful attempts at naturalistic representation, which of course I also met. I have brought them into this study because they were similar to the adolescents' work in two ways: I had observed the unusual concentration, the intense personal *involvement* in their making, and the *final satisfaction*, which hardly seemed justified by the results; and secondly, they used *forms* that were strange or unexpected to represent the idea and were yet evocative of it. Adolescents and untrained adults (unless they have long been encouraged by an appreciative teacher) are usually diffident about their work, and sensitive to the

3. I presented material mainly from my students, from a few friends, and from my own teaching days, so on the whole these children were aged from eleven to fifteen, occasionally up to seventeen, and were mostly from secondary modern schools.

criticism of their fellows about a result that does not *look like* the thing they portray. What other more powerful force could be transcending this diffidence to give them such pleasure and satisfaction? The man who made the model in PLATE 7*a*, blindfold and at his first attempt at clay, said, "I don't know what I've made, but I know I have not been so happy for years as I have been this afternoon."

I made a list of the "subjects" of those that had been named, which included "The Hollow Madonna" (PLATE 8*b*), "A Woman" (PLATE 8*c*), "The Calyx of a Flower" (PLATE 7*b*). But just as interesting were those in which I thought I recognized clearly traditional shapes from the art of cultures less bent on the representation of appearances than European art since the Renaissance has been, or shapes with an unconscious physiological basis such as PLATES 8*a* and 7*a*.

In some cases, as in the sets of the student-teacher Robert's work, the subject had been suggested by the teacher. In a few cases they were chosen themselves by children who opted out of other subjects set by the teachers. In the case of many of the "queer objects" they were spontaneously named by the makers, but I do not think they always started with this idea or subject; it often emerged in the course of the work, as will be described in the chapter on "Relationships between the Idea and the Medium."

These three lists, arrived at in different ways, proved to have a surprising number of "subjects" in common. This overlap of subject was a complete surprise, and a simple, straightforward explanation must first be looked for.

In the first place, it may be argued that all the teachers of these groups were apart from myself, my friends, or my students. Naturally we would have interests in common, and I even suggested subjects for the students to use with their classes. But the majority of subjects I had suggested and had myself used lay quite outside this list. To give examples at random, subjects from their environment ("Washing Day in the Back Streets," "Cats at the Dust Bin"); subjects likely to be of special interest to adolescent girls ("A Dressing Table," which we actually set up in the classroom; "At the Manicurist's"—two contrasting types of hand lying on a dark red cushion with all the fascinating paraphernalia); subjects that involved concentration on different shapes

("Mechanic's Shop," "Bottles in Sunlight"); or on textures ("A Breakfast Table," which again the class and I actually laid in the classroom with things I had brought from my flat).[4] *Although it was my custom with adolescents, to use more than others those subjects that relied chiefly on immediate visual stimulation or on visual memory, such subjects did not occur in our lists.*

In the second place, if my personal responses and predilections seem to dominate the work too much, it ought to be pointed out that several of the subjects did not originate with me at all. "The Cave," one of the most evocative of all, it had never occurred to me to use. It was used with his classes by a student who came from Derbyshire that, of course, is steeped in cave lore, and his results suggested that the children had had an experience so striking that I later used the theme myself and found it produced some of the deepest concentration and evoked some of the most interesting pictures.

In the third place, once the significance of these themes is seen, it may be argued that the list covers neither a full range nor is perhaps the most evocative that could be drawn up, but the element of chance enters in here. When I tumbled to the importance of the subjects but was not yet fully aware *why* these subjects were important, I used for the list of "enquiry" subjects only those we had in fact discovered. *I did not invent or add any more.* Since we none of us had been working

4. How far does art education involve us in social education? Almost any school study does, I suppose, but we teachers of art should be able to give these children a wider range of experiences without setting up artificial standards of taste or convention. For instance, on this occasion, I had brought bright earthenware and several different tablecloths from home, but the boys' first action was to put a newspaper on the table. When I asked if we would not put the milk in a jug (I had planned this because it was a nice shape to paint), one of them seized the implication and said, "More work for my mom." So we compromised with milk in bottle, but we used a tablecloth because I urged that it was clean whereas the table or a newspaper might well not be. They took great trouble over choosing which dishes to go with the table cloth, and exclaimed with pleasure over the final appearance of the set table, yellow dishes on a blue check cloth with brown bread, butter, and oranges in a dark blue bowl. We ended by eating the breakfast after four o'clock when we were cleaning up!

with this in mind, many that could have been productive of the sort of work that had this haunting quality just happened not to have been used. The final list of subjects is given below and will be discussed in the next chapter. The word "investigation" is more appropriate than "research."

It may surprise those not educated at an art college to see how reluctant I was to pin much importance to the subject. But I was brought up on the dictum that "the subject does not matter, the art lies in the way it is painted." The aesthetic value of a work of art certainly does not lie in the subject—but that is part of its power to move the artist. When we have searched for subjects to interest adolescents, we have been, it seems, too apt to look to their surface interests, machines, clothes, events of excitement, neglecting a deeper level about which even they cannot tell us.

When I had reached this stage in my own thought, I did not know how much to put down to my own influence, and though I had already hundreds of paintings from student-teachers, it seemed that a larger number from different teachers was necessary to test my suspicion that the key lay in the subjects. At this time I was asked to run a weekend refresher course for art teachers of the neighborhood, and on the last day I told them that I had been struck by the evocative power of certain themes and asked for volunteers to work through a year, using such subjects. There were about eighteen volunteers of whom six for various reasons dropped out, and the final group consisted of twelve teachers working with ages ranging from eleven to seventeen in grammar and secondary modern schools.

Therefore the teachers selected them themselves. I did not select them. I myself, freed from my training college work for a time by a Research Fellowship from the University of Leeds, taught in four schools, one boys' and one mixed secondary modern, one boys' grammar and one mixed private, using themes from the same list as the teachers.

In addition, as a sort of check, I asked three not very close friends working in secondary modern schools in other parts of the country, each to use with one class our list of themes. They had not seen the pictures that provoked the inquiry, and they were given no explanation

of what we might expect (PLATE 28*b*), and others omitted for lack of space came from this "outside" group.

So the final list (which I call "the list of themes") was drawn up from the three following lists.

One was the subjects of those pictures and models that had induced a complete involvement of their makers, an intense concentration and satisfaction not usually evident among the less skilled of secondary children (the more skilled are likely to enjoy art and to be more absorbed anyway).

The second was the subjects of those pictures that seemed to have some specially compelling quality to us as spectators (to the group of colleagues and myself) and seem subsequently to have had this appeal for a wider audience.

The third and much smaller list was from those objects and drawings of strange inexplicable shapes that had absorbed and delighted adults and adolescents in my own classes and obviously induced an exceptional degree of absorption. Some of these I had kept for years from some dim notion that they were significant; I did not know of what (PLATES 6*a*; 7*a-b*; 8*a-c*; 25*a*; 30*b*).

The actual form of suggestions to guide the teachers—which we had agreed together, is given below. The question of *why* these themes might be evocative had barely been raised with them, and according to their own greater or lesser understanding they might be aware or not of the significance of the themes they were using. It will be seen from those suggestions that we agreed together during our preliminary discussion to reduce the introductory talk at the beginning of the lesson to a minimum so as not to make direct suggestions—beyond the theme itself—to the children. This is *not* advocated as the way to conduct every art lesson, but it was necessary in this research so that the teacher's personality and associations should not be too dominant, so that the theme itself, the thing we were all using in common and whose potency we were investigating, should be given full scope. For the same reason we agreed to give only encouragement, not specific suggestions or criticism to the work in progress, as most of these teachers would have been in the habit of doing. In spite of accepting this agreement, several of the teachers were distressed by

the *apparent* passivity of their role. They felt it was their job to "help," to "improve," the work. They had not fully grasped that this help might best consist not only in providing an encouraging and sympathetic atmosphere but by questions that enabled some children to visualize more clearly the image they sought. The formulations of such questions, both in the introduction to the whole class and to the individual child at his precise phase of clarification, is one of the most delicate and subtle exercises in the art of teaching, The rapid adjustment, as one moves from one child to the next, in entering into the spirit and sensing the direction of his work is one of the most wearing aspects of teaching. Far from being passive, it requires a response as immediate and accurate as a compass needle.

About 3,400 paintings on these themes (approached in this manner) were studied and compared with many thousands on other subjects approached in other ways from the same age groups. But if this enquiry has any value, it lies less in the numbers—though these appeared to suggest a common underlying pattern of response—than in the close observation of individuals at work. If an attempt had been made to conduct this investigation objectively within strict limits which permitted only one of a number of planned responses, the whole point would have been lost. I could not foresee what the children might do with the themes, nor did I wish to eliminate the "accidental" or apparently irrelevant. In addition, one would not wish to tie down so narrowly the art work of large groups of children over a critical year of their lives.

FACSIMILE

IMAGINATIVE PAINTING THEMES SUGGESTED TO TEACHERS
TAKING PART IN GROUP INVESTIGATION

NATURAL OBJECTS
> CAVES, CAVERNS
> SEA (other water subjects)
> WOODS
> MOUNTAIN PEAKS

MAN-MADE OBJECTS
> HARBORS
> TUNNELS

MINES

LIGHTHOUSES

MEN AND GODS

KINGS, QUEENS—THEIR CEREMONIES

PRINCES AND PRINCESSES

MOTHER AND CHILD SUBJECTS

FAMILY GROUPS

GIVING OF GIFTS (e.g., THE THREE KINGS, HARVEST FESTIVAL)

HEROES, GODS, AND GODDESSES

ANIMALS AND BIRDS

BULLS

HORSES

COCKS

MYTHICAL CREATURES

PHOENIX

UNICORN

DRAGON

MONSTERS

Note: The garden theme does not occur in the list because at the time I had not come to see its significance, and though children had spontaneously used it I had never given it as a subject.

FACSIMILE

SUGGESTIONS TO THE TEACHERS WHO OFFERED AT THE WEEKEND CONFERENCE TO JOIN THIS GROUP

The purpose of this study we are undertaking together is to find the forms that arise naturally in the work of adolescents under the stimulus of imaginative themes such as those in the attached list. Because of this emphasis on what arises naturally, the direction by the teacher should, *in these lessons only,* be kept to a minimum as we agreed together. The creation of a quiet encouraging atmosphere, in which, after the introduction, the children can work quite individually, and an acceptance of the finished work without pressure to take it further or "work over" it much, will be sufficient. Above all, the atmosphere should be kept as natural as possible, and any slight variations from the procedure usually adopted explained as "the way we are doing it this time."

But although the minimum of actual instruction to the class or individuals is suggested, it cannot be emphasized too strongly

that the teacher is not being encouraged to subdue his own personality during the introduction but, rather, to draw fully on his own and on the children's experiences. The subject can be explored as fully as possible between teacher and children, as is probably usually done, with a discussion of their ideas on their experience of their associations with it. No one style is emphasized as being more desirable than others. The children can be urged to clarify their individual vision for themselves before they begin.

We agreed, you will remember, that we must avoid *in this particular series*, giving suggestions about the form of the objects or the arrangement on the paper. Naturally, any previous teaching in arrangement or composition will emerge if it has been absorbed by the children, and any knowledge of the appearance of figures or natural objects from previous experience may be apparent. But if this is not so, it need not be commented on, and unusual forms can be accepted without correction and without the children's being directed back to look at such objects again. Nevertheless, we must guard against looking for certain forms rather than others.

We shall all be fully aware that under these circumstances some children will not take their work as far as it is possible for them, or finish their paintings as fully as we might wish, but if a genuine statement has been made, we must accept that danger for the first few weeks until the individual language emerges clearly enough for us to be sure the help we offer is in the same idiom. Pictures or books normally available may be left about as usual, but no special pictures or illustrations of sculpture should be shown directly in connection with these lessons.

It is suggested that this series of subjects should be worked through with one class or two classes and not used indiscriminately with any group in the school. It would be most illuminating to see work in clay and in paint by some children, but where this is not possible the clay series[5] might be used with one group, and the painting series with another.

5. So few teachers managed to use the clay series that no general conclusions could be drawn, and it was dropped from the investigation.

MATERIALS

The materials should be those generally used in the school, but painting with little or no preliminary drawing will often be found to have a releasing effect on the children's ideas. It is suggested that wherever possible, the choice of size and color of paper be left to the children, and large and small sheets of different colored paper, powder color, perhaps Indian ink, watercolor, pastel should, if possible, be available.[6]

The preparation of materials, which is noisy and disturbing, should be done before the subject is explored so that when the moment of stimulation comes, the children can immediately get to work.

When I first tried out some of these themes with children (in my own return to school teaching that year) I used to introduce the day's subject with a general discussion, asking the children to contribute their experiences or ideas to us all before settling down to work—encouraging the "active participation of the class" as it is called in books on teaching method. But I soon discovered that with these themes this had a disturbing rather than a settling effect, and that the children *did* participate to the full when they were painting. There was no need to enrich their ideas by the contribution made by others. Even the less imaginative had that richness of association in themselves if one could only tap it (as pondering on these themes so often did). I was trying to help each to draw on his *own* evocations by pointed questions, and it only pulled him away from his personal image to hear others discussing theirs. The vociferous, lively atmosphere, desirable in some lessons, was not the one needed here but rather a tranquil, more contemplative attitude, a quiet acceptance of whatever images came. Sometimes this was induced by using movement if that seemed appropriate (I wish now that we could have combined these sessions with dance), sometimes by reading a poem, an incantation, always by my quiet roaming in talk round the theme itself but softly enough to allow those ready to start to do so undisturbed.

6. Oil paints were unfortunately not used in any of these classes in these schools, and while I was experimenting elsewhere with having powder colors available for mixing either with water, oil, or egg for tempera, it seemed better not to introduce the complication of a new medium or attention would be focused on the medium rather than the subject.

The kind of questions I myself asked my class, in for instance the Cave subject, were such as these: "Is *your* cave in a mountain or on the seashore? Is it high and light so that you can see everything clearly, or is it dark, and if so, what colors are the shadows?" "Can you see in your mind's eye the shapes, one against another? What shape are the hollows through which you see the further recesses?"

I never asked the children to answer their questions in words but to sit quietly and let the answer for *their* caves rise in their minds. In this way, each child could build up his own image without being distracted by other people's ideas.

I then found, in fact, that the children often worked with great speed, not pausing for intellectual planning or criticism on the way, and nearly always with extreme concentration. They usually finished their pictures in one double period, often in much less, and I never suggested they should return to them the next week. Sometimes they finished them in a much shorter time, though occasionally someone would do the same subject again immediately. Sometimes we worked on several aspects of a theme at once, choosing for instance from the subject of "Water" whatever mood they wished to treat. On the other hand, with one class, after using "The Sea" one week, I suggested that we should all do "Rivers"—slow and calm or rushing and wild—the next week, and "Pools and Harbors" the week after. They then went on to the subject of "Fire." (By chance, this obvious theme had not presented itself in time to be incorporated in the list, but it seemed a fitting contrast to the water themes, so I used it.)

Some of the themes and the adolescents' response to them will be described in the next chapter.

The teachers were visited in their schools occasionally during the year to see the classes at work, and most of them met again during the year and finally for a residential weekend to look at the work and to discuss various approaches to art education.

One of the twelve, a teacher in a grammar school, produced work that lacked almost completely the sense of power and "haunting quality" that had first suggested the subjects, and on the other hand his children did not show the fresh, visual images they might have gained by working from direct observation. I think, in that case, this scheme

was probably a failure because the underlying idea was unacceptable to one too insecure to trust the themes themselves. Its success relies on the teacher's permissiveness and a confidence in the theme to carry the children along on its tide, as it were. These teachers varied greatly in personality, training, and experience. In all other cases, work of great interest was produced. Though I can speak from direct experience only of the children I taught, many of these teachers said that the children had been absorbed and produced "better" work, though they could not define (and I did not yet try to do so) what the essential difference from their former teaching was. In the case of one woman at least, her headmistress told me that participation in this scheme had transformed that teacher.[7] She had "taken on a new life" and "the atmosphere in the art room was completely different"; "she seems to have found herself in this scheme." In the case of one student-teacher working in an approved school, the headmistress believed that this clay work had provided an invaluable outlet, especially for one girl with strong homosexual tendencies. It is true that instead of reclining in her friends' arms all her free time she took to clay work and produced countless masculine models, and that her general outlook improved greatly during this period, but it would be impossible to *prove* any causal connection. These approved school girls frequently said that their happiest hours in the week were those with the clay; they could "be themselves" with it.

One can only estimate the effect of any aspect of education on any particular child when one knows her intimately and when one also knows all the other influences bearing on her at that time. Perhaps no one ever does know this about any human being. I can make no extravagant claims for the idea I put forward. I shall only say that in the hands of teachers who themselves are temperamentally fitted to use it—and these proved to be not of one but of many types—this does appear to offer adolescents a profound experience of a kind that is singularly lacking not only in their education but in the rest of their lives today.

7. It is possible that any kind of stimulus and periodic discussion of work might have this effect on a teacher in a culturally barren district.

Seeing the list of subjects arrived at by the empirical method described, I confess to a hesitation in using it because it seemed to include an insufficient number of the subjects I would have thought specially appealing to adolescents of the mid-twentieth century—no bicycles, no airplanes, no jets, or space men—though there were some subjects, e.g., tunnels and mines, that belonged rather specifically to our industrial age. Yet though they were free to opt out, those that did so did not often turn to jets or space men.

Although the teachers stressed that any style or treatment was acceptable, what struck me most in my own classes, and in visiting theirs, was the fact that even when one was aware of intense activity, there was a brooding, contemplative quality about the atmosphere. The pictures and models seemed to confirm this.

It will be seen that many of the suggested themes lie not far from the normal range of subjects used in art lessons. Why then, out of scenes of commercial activity, should a harbor more often result in pictures of compelling quality than a railway station? Why did the suggestion to draw a tree often encourage the children to draw more objectively, relying greatly on their *visual* memories while a wood or a forest (PLATES 6a-b) produced pictures in a mood of mystery often with overtones of fear? Yet if one looks for an aura of mystery living on from the past, a tree has been a focal idea associated with worship since prehistoric times and was carried into Christian iconography. For me, as teacher, "The Tree" had more conscious associations than "The Wood"—which seems to argue against the determining influence of the teacher's associations. But even in the specific form of the "Tree of Life" it appears to have, for most people, lost since the Reformation its deep significance, whereas the "Dark Forest" theme has been kept alive not only through the Grail legends in their changing forms but also for children through fairy tales (especially those of German origin such as *Hänsel and Gretel*).

Of course, all the themes used—except the fantastic beasts—could be interpreted factually, as memory pictures from former observations. A few children always did this. Many of these children had been taught deliberately to recall memories and to use earlier sketches from observation in their "imaginative" work. I myself have encouraged children to do this in many fields of art. But during these

sessions I found they seldom stopped to refer to sketchbooks. I tried only to ensure that the teachers should *accept* whichever of many approaches the pupil chose, not insist on one.

I found myself more prepared to accept the idea that such themes might be very important to younger children (who have always received much of their education through the fairy tales or their equivalents) but it was difficult to accept in adolescents. (It would have been interesting to study the way in which such suggestions are used by children during the latency period, but I have not been able to do this systematically. I would hazard a guess that the treatment would be less evocative and more objective than either before or after.) I have explained that my previous practice of art teaching with adolescents had stressed the necessity of objective studies, in the disciplined exploration of their medium, and in an appreciation of their environment, especially perhaps the industrial environment that often demands of those who live in it a perceptive eye to make its squalor bearable. All these persist *but I have come to see that they are only a part of the whole.*

Some of the themes on the list were used by all of the teachers—some by only a few. We had intended to work right through this list during the year but for various good reasons this was not always possible. The choice of those they used was left to the teachers and would probably be influenced by their own response to them. This is inevitable and even desirable in art teaching.

Some themes proved more evocative than others in all the schools, and since it is not possible to describe the treatment of them all, here is a selection of these, introduced by the kind of thoughts that arise in my mind in response to this theme. At the end of each section are some of the poems written by the children either at the end of the class or at home after these lessons, or under the inspiration of a colleague, Paul Haeffner. While I was teaching temporarily in one of the secondary modern schools he became interested in this research, and he and a drama tutor and I agreed together to use these themes in the three arts with the same group of thirteen-year-old boys and girls. Their drama it was impossible to capture, but some of their poems and pictures are reproduced in the next chapter along with those from my own and the classes of the participating teachers.

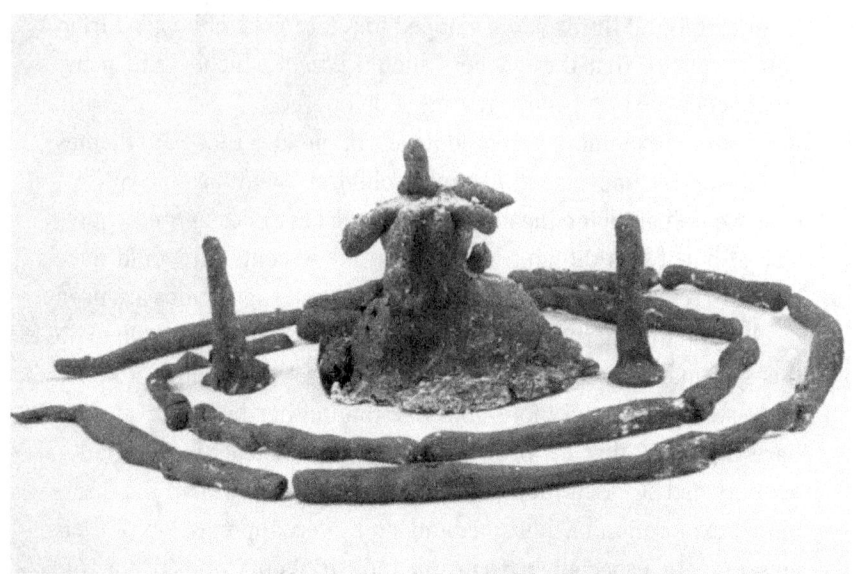

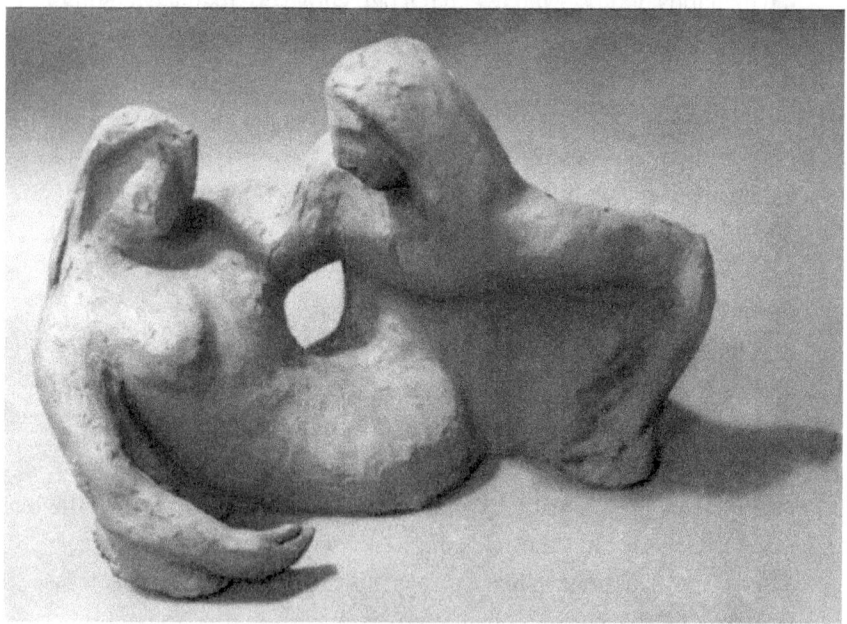

PLATE 1*a* Margaret's "Rosegarden," which started the whole enquiry (*Girl, age 12; first clay experience; blindfold session*)

PLATE 1*b* "Man and Woman," suggesting the range of clay experience (*Female adult*).

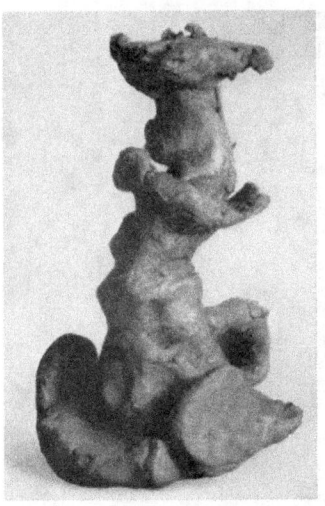
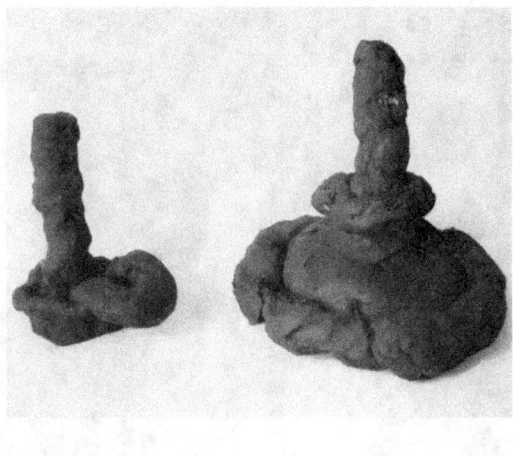

PLATE 2*a* "Candlestick Carriage"

PLATE 2*b* "Two Candlesticks"

PLATE 2*c* "Two Pistols." All transformed from original pillar shapes
(*All by boys, age 12, first clay experience, blindfold session*)

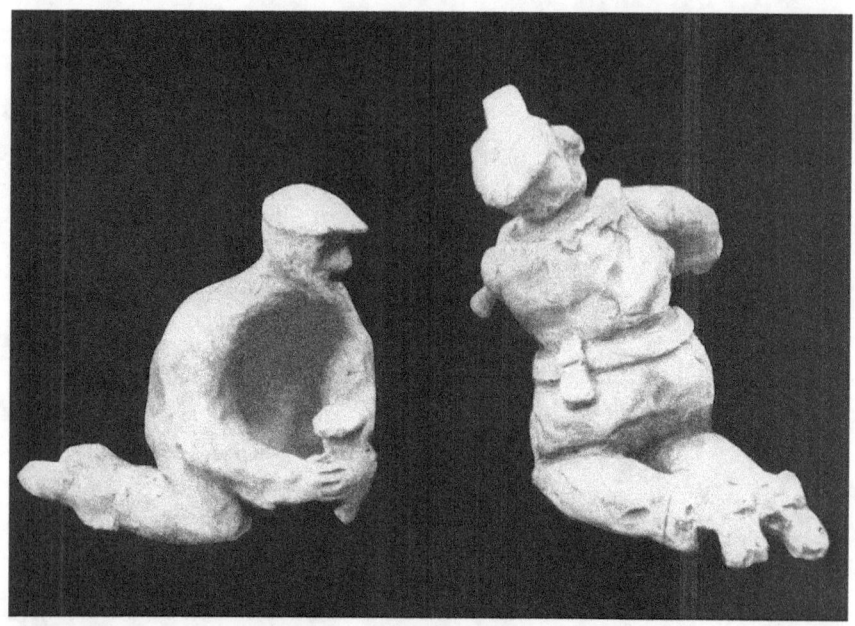

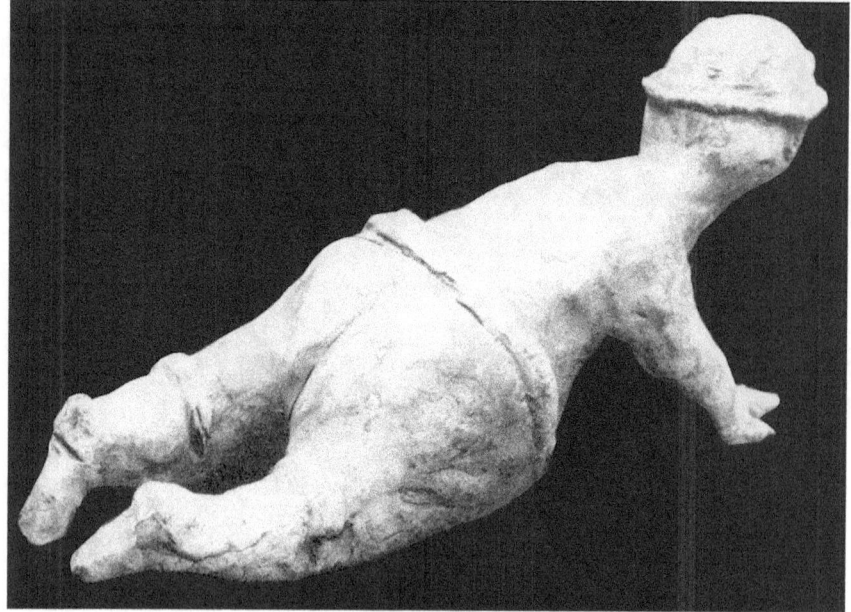

PLATE 3*a* "Two Miners"

PLATE 3*b* "Miner Crawling" (*Boys, age 14; both from "The Mine in Classroom" session*)

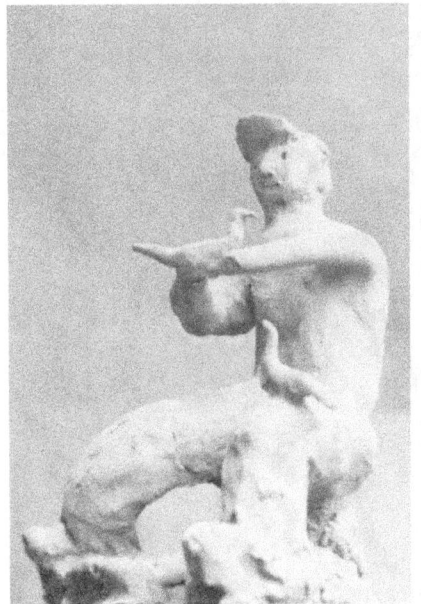
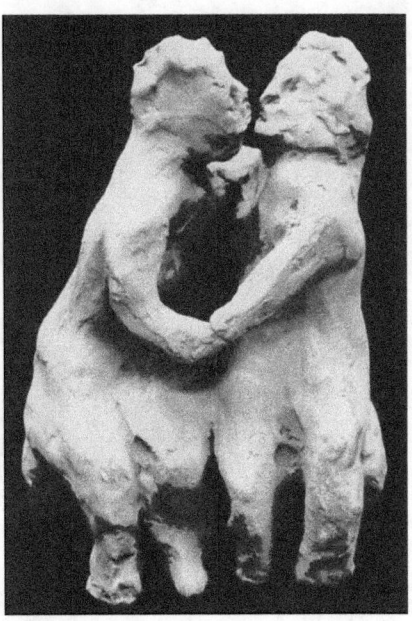

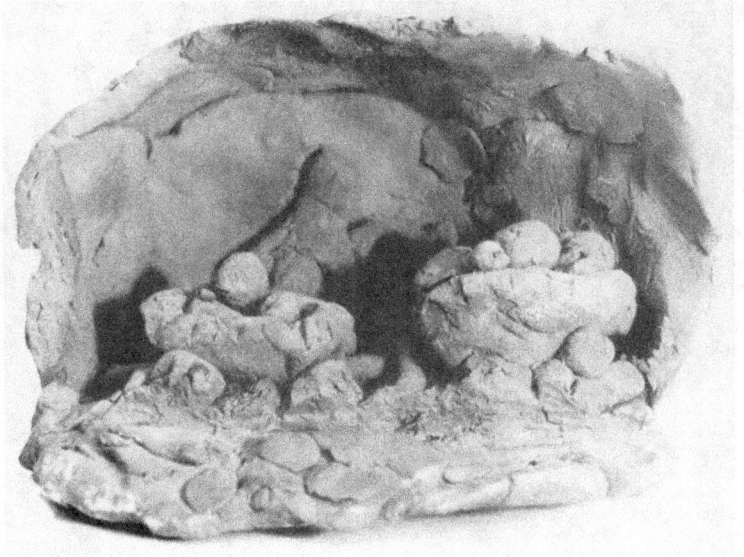

PLATE 4*a* "Man with Birds." Miners families are great keepers of pets (*Boy, age 14*)

PLATE 4*b* "Lovers." An adolescent's interpretation of the subject of "Two People" (*Boy, age 15*)

PLATE 4*c* "Miners Pushing Cars." A cave-like enclosing mine, three inches high (*Boy, age 14*)

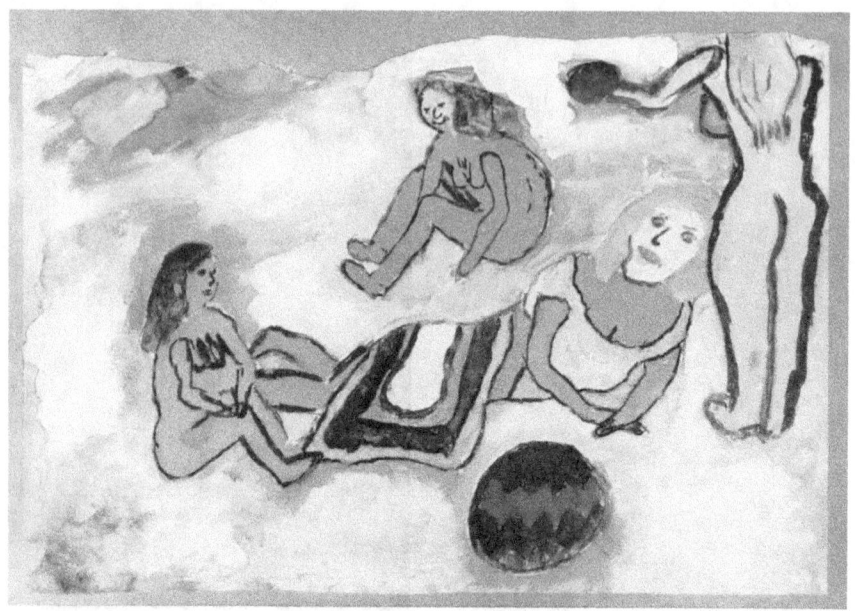

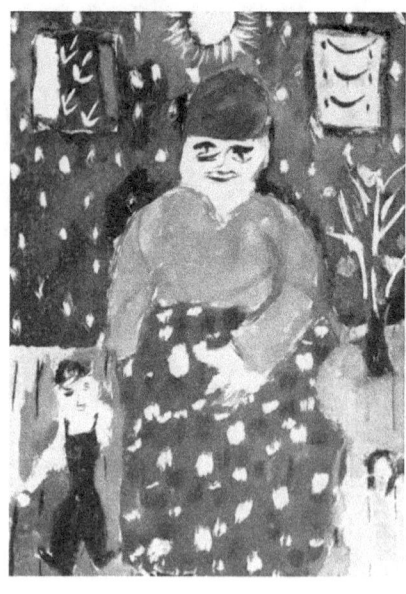

PLATE 5*a* "The Sea." An overgrown adolescent's interpretation, no sea in sight (*Boy, age 15*)

PLATE 5*b* "My Family." The painter is on the right, her young brother on the left (*Girl, age 13*)

PLATE 5*c* "My Family." Using round shapes and subtle warm colors (*Girl, age 13*)

PLATE 6*a* "A Wood." She worked alone in a corner for two sessions (*Girl, age 13*)

PLATE 6*b* "A Forest." One of a number who put a house enclosed by trees (*Boy, age 14*)

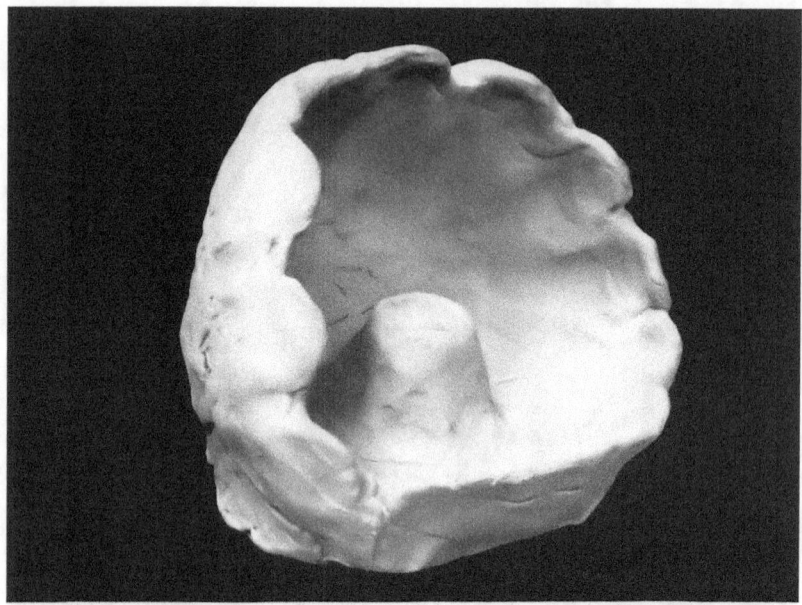

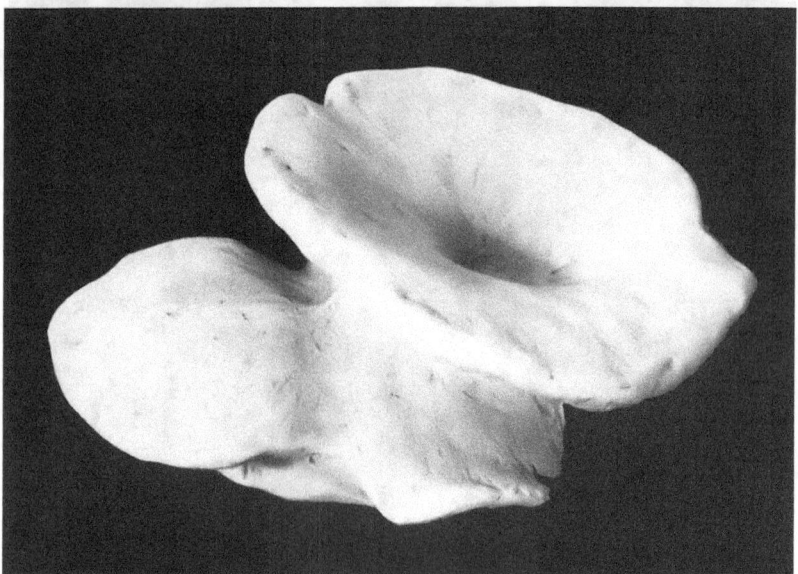

PLATE 7*a* "Shell Form." This youth leader said, "I enjoyed myself so much" (*Male adult; first clay experience; blindfold session*)

PLATE 7*b* "Calyx." This primary teacher said, "I was thinking of my wife" (*Male adult; first clay experience; blindfold session*)

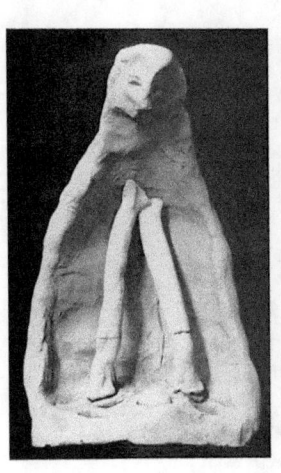 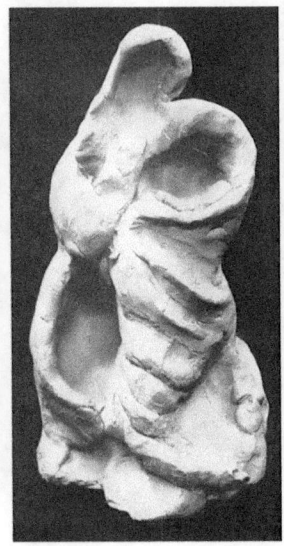 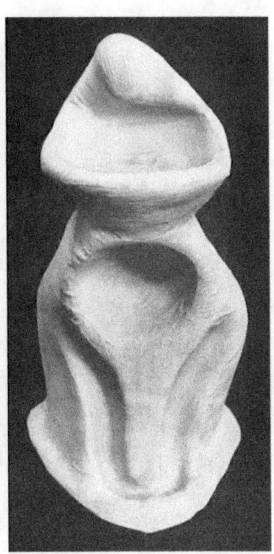

PLATE 8*a* "Hollow Woman." Straps join breasts to base where three balls nestle (*Girl, 14*)

PLATE 8*b* "Hollow Madonna." The blob of a child nestles in shell-like hollow (*Female adult*)

PLATE 8*c* "Abstract Woman" (*Female student; after two blindfold sessions, made open-eyed*)

V

THE THEMES THEMSELVES

(1)

SOME ASSOCIATION WITH THE THEME OF WATER

The second verse of the first chapter of the Book of Genesis runs as follows:

And the earth was without form and void; and darkness was upon the face of the deep. And the Spirit of God moved upon the face of the waters.

On the first day God said, Let there be light, on the second He made the firmament, and divided the waters which were under the firmament from the waters which were above the firmament.

And on the third He gathered the waters under the heaven unto one place, and let the dry land appear; and the gathering together of the waters called he Seas.

Similarly in one of the Greek cosmologies, the beginning of everything was when Eros issued from the egg of Night which floated upon Chaos.

The sea, or the great waters, that is, are the symbol for the primordial undifferentiated flux, the substance which became created nature only by having form imposed upon or wedded to it. [...]

Its first most obvious characteristic is its perpetual motion, the violence of wave as tempest; its power may be destructive, but unlike that of the desert, it is positive. Its second is the teeming life that lies hidden below the surface which, however dreadful, is greater than the visible.

— W. H. AUDEN, *The Enchafèd Flood or The Romantic Iconography of the Sea*

Tides are fundamental to our lives. There were tides on the molten earth before there was water, and their motion was inherited by the seas as they formed from streams of rain falling on the cooling earth. At some point, the critical degree of temperature and saltness was reached, developing borderline forms of life, not quite plant, not quite animal, barely living. But when the clouds of steamy atmosphere rose, and the sun penetrated that dim world, organic substances that could use sunlight to manufacture chlorophyll developed, and other organisms who could not do this devoured those, and so the whole complex food chain on which we now rely for nutrition was initiated.

All these eons the sea creatures lived in accordance with the tides, and there is some evidence that minute sea creatures, and possibly some fish, still have their breeding times in accordance with the tides. During all this time the continents had no life. It is fascinating to imagine the world of those days as described by Rachel Carson:

> There was little to induce living things to come ashore, forsaking their all-providing, all-embracing mother sea. The lands must have been bleak and hostile beyond the power of words to describe. Imagine a whole continent of naked rock, across which no covering mantle of green had been drawn—a continent without soil, for there were no land plants to aid its formation and bind it to the rocks with their roots.[...] For there was no living voice, and no living thing moved over the surface of the rocks.[...] So, for more than three-fourths of geologic time, the continents were desolate and uninhabited while the sea prepared the life that was later to invade them and make them habitable.[1]

The land could not become habitable until the bare surface had been clothed with plants—with mosses, ferns, and seed plants. In time, a few of the sea species developed lungs that could breathe air and learned to drag themselves across the mud or survive in dried-up pools. In course of time, they became independent of the sea, which had been their birthplace, and developed legs and wings and began to evolve the ancestors of our present forms of life: "When they went

1. Rachel Carson, *The Sea Around Us* (New York: Oxford University Press, 2003), 10-11.

ashore the animals that took up a land life carried with them a part of the sea in their bodies, a heritage that they passed on to their children and that even today links each land animal with its origin in the ancient sea."[2]

Rachel Carson is speaking of the salty stream we carry in our veins, but there are other evidences in human life of our origin and relationship with the sea, not only in physical traces such as the moon cycle of women, but in our social institutions as in the observance of a seven-day week, which can be traced back through pre-Jewish times to the lunar cycle, still observed in some primitive societies today.

But if the tides give to our lives a certain element of pattern, the unpredictability of the sea is part of its terror. Even within the enclosed basin of the Mediterranean, the storms for which Jonah was blamed and which wrecked St. Paul are part of our history. The *Odyssey* is full of the sea, and the sea encompasses the islands of its separate episodes—the island of Calypso, the sea nymph, where we first meet Odysseus dallying; Circe's Island; the island of the Phaeacians (the Minoans) of whom Homer wrote, "Poseidon has made them a sailor folk and these ships of theirs are as swift as a bird or as thought itself."[3]

To the landward Greeks the sea was a thing of mystery (Hesiod the farmer said, "Go to sea if you must, but only from mid-June to September—and even then you will be a fool"[4]), and the place of many mysterious births. Aphrodite, the Goddess of Desire, rose naked from the sea riding on a scallop shell. It was held that she sprang from the foam that gathered about the genitals of Uranus when Cronus, his rebellious son, threw them into the sea. *His* son, Zeus, dethroning him in turn, is credited with begetting children in many quarters, and Leto bore Apollo to him on the Sacred Island of Delos, which floated, so they said, on the sea. To this day, no one is allowed to be born or die there.

2. Carson, *The Sea Around Us*, chap. 1.

3. Quoted in H.D.F. Kitto, *The Greeks* (London: Penguin Books, 1991), 43.

4. Ibid.

The sea is also a way of escape, as it was to Leto from Hera's jealousy; and when Daedalus fled from King Minos's anger (for having helped his wife to couple with the Bull and produce the monster Minotaur), it was on wings across that sea, into which Icarus fell—as Bruegel painted it. Since the sea separates, what comes from over it is strange, perhaps precious. How foolish was King Mark to send Tristram across the sea to fetch his bride! A journey across the water changes people, effects a transformation, even a rebirth. This is typified in baptism, which was first performed by wading waist-deep into the water, then in sunk baptistries built on river banks, and only later by a token sprinkling.

The transformation through death by water is elaborated in

> But doth suffered a sea-change
> Into something rich and strange.[5]

It recalls to our minds the sea-wasted Palinurus episode of T.S. Eliot's *The Waste Land*, relating desert and sea waste.

The sea, as an undifferentiated chaotic element against which man must pit his strength, is a challenge that must have moulded the thought and character of an island people. Strangely enough, perhaps the deepest expression of this in England came from Joseph Conrad, a central European, born far from the sea. He uses the revelation of the power and terror of the sea as a symbol for the recognition of the depths and alien elements in our own nature. Melville, the other sailor-writer who has explored for us man's struggle with the sea and its creatures in *Moby Dick*, works out his narrative in terms of a symbol, so rich, so complex that it can be read as an adventure story or a travail of the human soul. (This is the quality of a true symbol—to be many things to many men at the level they can accept.) He draws very near Conrad when he says, "For as this appalling ocean surrounds the verdant land, so in the soul of man there lies one insular Tahiti, full of peace and joy, but encompassed by all the horror of the half-known life."[6] But in another mood Melville writes, "There is one knows not

5. William Shakespeare, *The Tempest*, Act 1, Scene 2.

6. *Moby Dick, or The Wale*, in *The Writings of Herman Melville*, vol. 6, ed. Harrison Hayford, Hershel Parker, G. Thomas Tanselle (Evanston and Chicago:

what sweet mystery about this sea, whose gently awful stirrings seem to speak of some hidden soul beneath."[7] The description of the concourse of whales is a most moving paean to warm-blooded life. Both Conrad and Melville, although they also describe the sea in its sunny moods, are most telling, most powerful, when they describe the horror and the terror of the sea in storm. On the other hand, Coleridge, in *The Ancient Mariner*, reveals the horror of the sea in unnatural stagnation, in the putrid slowing down of its water within which the slimy snakes are seen. To him the tidal nature of the sea, which bears one home over the harbor bar towards the lighthouse and the kirk, is its essential grace. When "the very deep did rot,"[8] it revealed the horror of its depths—but also the beauty of the snakes, which surprised the Mariner into delight and opened the saving channels of response.

W.H. Auden[9] has seen the sea primarily as chaotic, terrifying, as something so horrifying that in the vision of the new Jerusalem the Gospel writer has cried with relief that "there shall be no more sea." Powerful, perilous, immense we know it to be, yet to many of us the sea will remain rather the one who bears up, the element that embraces and purifies men and shores alike—"the moving waters at their priest-like task of pure ablution." And, as the thunder of the sea is captured in miniature in a shell, so, as the pressures and trivialities of the job press in on us, a picture or a line of a child's verse will open our horizons and

> Though inland far we be,
> Our souls have sight of that immortal sea
> Which brought us hither.[10]

Northwestern University Press and The Newberry Library, 1988), 274.

7. Ibid., 482.

8. Samuel Taylor Coleridge, *The Rime of the Ancient Mariner* (Boston: L.C. Page and Company), 1900), 8.

9. W.H. Auden, *The Enchafèd Flood or The Romantic Iconography of the Sea* (New York: Vintage Books, 1967).

10. William Wordsworth, *Ode on Immortality and Lines on Tintern Abbey* (London: Cassel & Cassel: 1885), 21.

THE PICTURES AND POEMS MADE ON THE THEME OF WATER

I was struck by the fact that of all the children to whom the general subject of "Water" was suggested through discussion of the different aspects of water in the sea, in rivers, in lakes, pools, waterfalls, the great majority of the boys chose to represent the sea in storm, with waterfalls as the next most popular aspect. Waterfalls also come second with the girls, but the majority of them painted a pool. This might be explained in many ways. Battling with stormy seas is a common fantasy for boys of an island people, and may even be a genuine anticipation of their careers. The actual experiences with water these adolescents have had will influence their choice of picture. Yet it may represent a real difference that a consideration of the literature of waterfalls and pools in the next section might suggest to us.

When the established connection of the sea with our bodies is recognized, it is not difficult to explain why adolescents, when faced with the subject of water react in such strong ways. It appears to be deeply satisfying to find some way or means of expressing this hidden physical rhythm, which may be *soothing* with the lowered tension of an undulating motion, or *forceful* with the surge of power. Liquid paint is one of the most sensuous, fluid substances and one can identify oneself with a wave or a waterfall in the very act of painting it. But liquid paint is difficult to control and frustration over a lack of technique may dam the powerful feelings rather than channel them into an incentive to acquire it.

It was necessary to devise a way to help these adolescents[11] to identify themselves with the water whose nature they were exploring.

On the occasion when PLATES 10a and 9, "The Wave" and "The Waterfall," were painted, I gave them—contrary to the usual choice of color—only white paper. The paints were ready beside them, but for the first five or ten minutes they worked only with a candle held in their hands, using either the pointed or the stubby end.

11. Younger children accept the vagaries of the medium in less frustration because they read into or do in fact see in what they have done that which they intended to do.

We spoke about the quality of water, the way in which the sea heaves itself up in waves, or rushing rivers narrow in a gorge and throw themselves over into space, and of the way in which a whirlpool circles into a center eddy, is sucked under, and spirals out again to the circumference of the pool. I suggested to the children that if they wished they might close their eyes, but in any case they should feel the movement of the water in their arms and their bodies. With the candle held in their hands, they first swung themselves into making the movement in the air, then, when they felt they had captured some water rhythm, they transferred it without a break to the paper with the candle wax that left (at this stage) no obvious trace. They gave themselves up to this activity with extraordinary absorption. The girl who made the waterfall fiercely dashed her arm up and down almost the full length of the paper. The boy who made the great wave did this in one great sweep of his arm, concentrating solely on this one wave and giving only a few small strokes to the boat and the rest of the scene.[12]

When the boys and girls had exhausted their first intense preoccupation with the *movement* of water, they could turn to another quality, color. They mixed the paints that were ready to hand and washed rather liquid colors freely over the white paper. Now the candle-grease marks, the exact trace of their movements, were revealed because the grease threw off the paint and left the white paper showing. So the

12. This picture does bear an obvious resemblance to Hokusai's *The Great Wave*. It is not, of course, impossible that an adolescent should have seen a reproduction of this print, which has been not uncommon in our country for some years. When one compares the two, however, there are obvious differences. The backward bending curve of Hokusai's *Wave* is repeated in the smaller, claw-like sprays of foam that reach out to clutch the unfortunates in the boat. The wave is conceived as one part of the whole sea in motion and its shape is repeated in other waves, which give the picture a more complete formal unity. Timothy, on the other hand, has concentrated on the idea of one wave; he has not thought of the whole sea but has seen that wave rearing itself up and forward in menace. He has not identified himself with the people in the boat but with the water that threatened to overwhelm them. The rest of the sea undefined, it is only the element, as it were, from which this one great wave arises.

movement, which had been *felt* a moment before as an inner personal thing, miraculously became *visible* as something leaving its pattern on the world outside. These pictures had a directness and spontaneity that delighted them as much as me.

The danger of such a method becoming a stunt (in this case, perhaps producing pictures with a superficial resemblance to Henry Moore's) is only averted by a sincere concentration on the experience rather than the results. Certainly it freed these children from self-consciousness and helped them to lose themselves in contemplation of one element of their natural environment. A few of the class went on to explore systematically the effects of wax and paint, and to use them with foresight.

Often, it is not possible to provide fresh *visual* stimulus for a picture involving sea or waterfalls, and the children's visual memories may have been overlaid by commercial posters, e.g., of harsh yellow sand and flat cobalt sea. Since they are surrounded by such placards with crude status symbols and superficial wish fulfillments, we cannot blame them if they fall back on these secondhand images. But we can tell them of Keats's words:

> The Genius of Poetry must work out its own salvation in a man: It cannot be matured by law and precept, but by sensation and watchfulness in itself. That which is creative must create itself. In "Endymion," I leaped headlong into the sea, and thereby have become better acquainted with the Soundings, the quicksands, and the rocks, than if I had stayed upon the green shore and piped a silly pipe, and took tea and comfortable advice.[13]

The pictures just described arose from expressing in their bodies something of the rhythm of water. Through opening the channels of present experiences in one sense, it was hoped to encourage the use of memories in other senses. It is not possible to prove whether this happened, but the comment of one pupil is interesting:

> As I was swinging my arms I began to remember all the water-falls I had ever seen. I saw them jumping off the rocks, so I

13. Letter to James Augustus Hessey, 9 October 1918, in *The Letters of John Keats*, ed. H. Buxton Forman (London: Reeves & Turner, 1895), 207.

> forgot about looking and jumped too—but I don't know how it
> feels at the bottom.

Possibly such a method is more successful with those who experience
most fully through sensation.

Pondering on the theme in words (as has been described) often
produced an image that was apparently remote from any sense mem-
ories but yet had an authenticity.

The boy who painted PLATE 11*a* has used a configuration for the
waves that bears no visual relationship to their actual shape but per-
haps echoes Hartley Coleridge's "slimy snakes."[14] He, a secondary
modern boy of fourteen, said he did not know the poem, but he may
have forgotten that he had heard it while yet remembering the image.
At any rate, his strange picture reminds us of our first ancestors who
dragged themselves across the shore onto dry land. For me it also
provides a link with the ancient mother goddess, who in the form of
the snake goddess at Knossos was honored by the bull leaping, and
whose familiar survived as the classic python at Delphi.

What are we to make of the harbor picture (PLATE 12*a*) by a girl
described by her teacher as "slow and timid"? There were many virile
harbor pictures—some particularly fine ones by children who had
visited Whitby and painted the great claws of the North Sea anchor-
age stretching out and almost encircling the little herring boats
within its calm. But here is a harbor that has no outlet—no inlet!
Two clumsy landlubberly boats (few boys would have drawn box-like
boats with so little possibility of speed, an ineffectual sail, and a mere
suggestion of a funnel), squat, inert, and hopeless, as though they
had given up all hope of voyaging over the waves again. The signifi-
cance of walls in drawings has been realized and few alert art teach-
ers can have missed the obsessive way in which many children work
on the wall round a garden with more care than the garden itself.
Here, the embracing quality that emerged in the other harbor pic-
tures is hardened into that dark wall; the rather obsessional houses
(menacing to me) have no chimneys (no life within?); and the water

14. "Sketches of English Poets," in *The Complete Poetical Works of Hartley
Coleridge* (London: George Routledge, 1816), 319.

itself—not done by the candle method I have described—is reduced
to dead mud. It is a sad picture.

In my mind, this picture is linked with another painted on the
theme of water (PLATE 12b). When most of the adolescents in the group
were stirring up storms at sea, or rushing over waterfalls, Violet chose
to paint a pool in the park at Barnsley. Drawn in ink, and painted in
light, delicate watercolors, this picture represents water tamed, civi-
lized, and kept within very strict bounds. The carefully tended flowers
bloom feebly, the little birds chirrup; it is the kind of park a too-well-
brought-up little girl can safely wander in. But with its fountains and
roses it has a faint and etiolated echo of Margaret's rosegarden. Per-
haps it is a personal vision just barely kept alive in an unsympathetic
household or a harsh district, something to which she clings even
though its debility of color and line hardly survive among the strong,
virile coarseness of her coal-mine environment.

The first poem is by a primary and the other five by secondary
children:

THREE POEMS ON THE WATERFALL

> Now smoking and frothing
> Its tumult and wathin
> Till in the rapid race
> It reaches the place
> Of its steep descent.

> It runs down the hillside,
> Never changing its course,
> It's not very small and it's not very wide
> It gurgles about as it reaches the moors
> It leaps over the stones
> Which stand in its way.

> It ripples through the countryside
> Mingling with the morning tide.
> Hurrying, Scurrying to the sea
> With the energy of a tiny bee.
> It gurgles and bubbles on its way down
> Twisting and turning past many a town.

I thunder down the side of a cliff with a tremendous force.
When I reach the bottom, foam flies about everywhere.
At each side of me there are large rocks
Sometimes you will find a small cave behind me
Rivers join into me, as they reach the hillside.

THE SEA

The rolling bounding sea
On a misty cloudy day
The peaceful hush of the sea
On a lovely sunshiny day.
The seagulls crying and the white foam
The cliffs tower above the white sands
And the caves dark and gloomy
The boats sail on the colored water
I like the sea, the sea.

WATER

I hardly make a sound
but I am so strong
That no man can stop my demand
I aim to cover all the land

I wrecked the galleons
I wrecked the steamers
And I aim to wreck
All the ships that sail upon me.

THE SEA

The sea kicks the wind blows.
The ships sway to and fro.
 The waves foam on the windy shores.
The waves twist against the rock.
And when the waves splash on the rocks
He sounds like a roaring under.
And when the sea goes out again.
The shells glisten in the sun,
 And fossils with their patterns.
And fish glide near the sandy shores
And when you listen to the shells,
You hear the sea roaring.

(2)

SOME ASSOCIATION WITH THE THEME OF CAVES

Birth

Rhea, wife of Cronus, was overwhelmed with boundless grief [because Cronus swallowed each of their children as soon as it was born]. When the time approached for her to give birth to Zeus[...]she went to Crete and there, in a deep cavern, she brought forth her son.
—*Encyclopaedia of Mythology* (Larousse)

Love

Soon during the hunt a confused rumbling started in the sky.[...] Dido and Troy's chieftain found their way to the same cavern. Primaeval Earth and Juno, Mistress of the Marriage, gave their sign. The sky connived at the union; the lightning flared; on their mountain-peak nymphs raised their cry. On that day were sown the seeds of suffering and death.
—*The Aeneid* IV (trans. W.F. Jackson Knight)

Marriage

One day Kore was gathering flowers with her companions when she noticed a narcissus of striking beauty. She ran to pick it, but as she bent to do so, the earth gaped open and Hades (Dis) appeared. He seized her and dragged her down with him into the depths. Hades plunged back into the earth hollowing out a vast cavern in the process.[...Later] Zeus commanded Hades to return young Kore—who since her arrival in the Underworld had taken the name Persephone—to her mother. Hades complied[...]but before sending his wife up to the earth tempted her to eat a few pomegranate seeds. Now this fruit was the symbol of marriage, and the effect of eating it was to make the marriage indissoluble.
—*Encyclopaedia of Mythology* (Larousse)

Life After Death

There is a cleft in the Euboean Rock forming a vast cavern. A hundred mouthways and a hundred broad tunnels lead into it, and through them the Sibyl's answer comes forth in a hundred rushing streams of sound.[...] "Aeneas, O man of Troy," she cried, "are you still an idle laggard at your vows and prayers? For till

you pray the cavern's mighty doors will never feel the shock and
yawn open."
—*The Aeneid* VI (trans. W.F. Jackson Knight)

Meditation

And he came thither unto a cave, and lodged there, and behold
the word of the Lord came unto him, and said unto him, What
doest thou here, Elijah?

And he said, [...] I, even I only, am left; and they seek my life to
take it away.

And he said, Go forth and stand upon the mount of the Lord. And
behold, the Lord passed by, and a great and strong wind rent the
mountains [...]; but the Lord was not in the wind: and after the
wind an earthquake; but the Lord was not in the earthquake:

And after the earthquake a fire; but the Lord was not in the fire:
and after the fire a still small voice.
—1 Kings 19

The counterpart to fluid water is solid earth, and caves, which were
hollowed from the rocky ground by flowing rivers, hold immutable
the reverse mould, the concave antithesis of moving water. In their
hollows, the solidness, the massive weight of the earth, is most pres-
ent to us because it is not only beneath our feet but above our heads
and round our sides, encircling us. The light, coming from only one
aperture, emphasizes the roundness of the forms, smooth stalactites,
jagged ridges, or faceted boulders. The drip of water reverberates in
the silence, and the gush of a stream is as thunder. The semi-dark-
ness heightens our other senses. We rely for our safety on the echoes
resounding from dark surfaces and use our fingertips as antennae as
we grope along the walls. It is cold, and the dank smell has the ancient
odor of bats and snakes.

Caves are the unfathomable places of the earth, drawing one in
curiosity and fear, in excitement and apprehension. Through them we
go into the bowels of the earth, into the secret places.

We cannot forget that to our remote ancestors these offered their
only shelter, and those who could not accept caves, could not feel
at home in their domed hollows, must have died out in the glacial
epochs. Paleolithic families lived at the mouth of the cave and issued

out into the world to hunt or search for wild fruits to fend off the continual hunger. But they went back into the heart of the cave to depict these astonishing animals, so vividly alive today beside the faceless skulls of their makers. The cave is a place of mystery, and therefore of propitiation—for in the face of mystery we try to enter into some relationship with the unknown power. Even when men learned to build cities in the plains with sun-dried bricks, the cave remained a place for worship, and where there were no natural caves, men built dolmens and earthed them up to create underground chambers for their mysteries. All our later temples echo this, the Gothic vaults, the Orthodox domes. A more frivolous age titillated its sense of mystery by building mock grottoes for romantic encounters.

Caves are the legendary haunt of the snake and the dragon, guarding a treasure of gold or a princess; or the couch of mortals who sleep a hundred years and come forth again. Caves are places to which sages, heroes, and saints retire for meditation or renewal—retire into themselves perhaps, to bring forth a new capacity for thought or deeds. Caves are often the birthplace of streams that well up as inexplicably from the depths as creative thought itself.

This is implicit in Prospero's cave in *The Tempest*, the brooding center of the enchanted isle, in which he hatches dreams and comes forth to wreak his magic of wits bedeviled in mazy wanderings, of storms that initiate the sea change that turns out to be a kind of resurrection, of symbols of air and earth made manifest in creature form.

But these are the pregnant caves of poets. Plato, a rationalist, felt that poets encouraged a dangerous phantasy and banished them from the Republic. He plants his deluded watchers in a cave, preoccupied with mere shadows of mere marionettes—for they knew only the cave and could not come and go between the sane sunlight and the shadows. But no man can live entirely by the light of reason, and each of us holds within himself dark places of retreat where reason finds fertile concourse with phantasy and breeds anew.

It is a poet, Coleridge, who has argued most cogently for us the conjunction between phantasy and reason in true imagination, and he has focused a cluster of images into a garden poem, which is

surely, as much as the *Ancient Mariner* is, a poem about the birth of poetry itself—poetry whose springs are hidden but whose rhythms are measured:

> In Xanadu did KUBLA KHAN
> A stately pleasure-dome decree:
> Where ALPH, the sacred river, ran
> Through caverns measureless to man
>> Down to a sunless sea.
> So twice five miles of fertile ground
> With walls and towers were girdled round:
> And there were gardens bright with sinuous rills
> Where blossomed many an incense-bearing tree;
> And here were forests ancient as the hills,
> Enfolding sunny spots of greenery.[15]

THE PICTURES AND POEMS MADE ON THE THEME OF CAVES

The paintings of caves from a student-teacher's class was one of the thought-provoking experiences that led to this study. I was astonished that this—as much as any one of our themes—should provoke these results since some of the children had never even seen a cave. I noticed that the treatment of this, more than most themes, seemed to depend on the personality of the teacher. Some were able even with few attractive visual features on which to dwell, to evoke the atmosphere that proved inspiring; others, as successful with other themes, could not. Caves have in themselves so little necessary structure or form, their actual topography is so often confusing and accidental looking. But where the intellectual realization of this fact brought from the teacher a suggestion to impose a form—for a picture must have structure, composition—it destroyed the mystery. Where the idea was allowed to evoke of some of its own profound mysteries, form arose naturally.

Although it can seldom have been the dominant visual impression, the image of retreating arches of color was often used, sometimes with a startling boldness and simplicity. This was found equally

15. S.T. Coleridge, "Kubla Khan," in *Christabel: Kubla Khan: a Vision; The Pains of Sleep* (London: John Murray, 1816), 55.

in the pictures of a mine—which was sometimes linked with caves in the introduction as an alternative[16]—and none of these children had been down a mine. Many of the painters represented the *sensation* of being in a cave rather than its appearance and, on several occasions, the surface of the earth was shown above. This is so in the strange archaic-looking vision (PLATE 15a) of the pale sun rising from behind a mountain almost filled by a cave with tooth-like projections (stalactites and stalagmites?). Inside the cave is what appears to be a monolith carved with distinct features. This was a boy of low mentality in a secondary modern school and the unconvincing conventionality and crudity of the two top-hatted figures merely served to underline the stark clarity of the main image. Their positions and their inconsistency of style with the rest of the picture almost seems to suggest that they were pushed in at the last moment to give a fallacious air of normality to the enigmatic whole (Cf. FIGURE 9a).

The group (PLATES 13a-b; 16a) done at one time in Robert's class is so varied and interesting in its interpretation as to form a striking example of the value of such a subject, which allows each child a very personal interpretation. One cave is calm and spacious with swelling stalagmites supporting the roof like the groins of a Gothic cathedral through which one's eye is led in weaving convolutions; another, not shown, is full of black ravens and harsh yellow and acid pink growths; one is pierced by up-thrusting stalagmites like the devouring jaws of a crocodile; and one is cool, tranquil, and silvery, spiraling into a narrow aperture, the eye of a needle through which one only penetrates in dreams.

Among the pictures from a set not otherwise outstanding in any way, done in a secondary modern school under a sensible, stable, rather motherly woman, is PLATE 15b on this theme. The teacher, puzzled, told me how this little girl (a more intelligent child might have suppressed her impulse, guessing that it might be thought silly) had brought her this picture at the end of the lesson saying, "I don't know

16. At the beginning of the year that we used these, I still could hardly believe that one did not have to make more direct appeal to local and contemporary interests and I often gave the children the choice of a cave or a mine.

why I put the cradle there, but I somehow felt there ought to be a baby in the cave."

Contrast with those Marigold's[17] picture (PLATE 16b), which she brought up for the praise for which she was so desirous—even when she had worked casually—and which perhaps her rather slick drawing had previously won for her. It was done in a class among other quite moving paintings. This is a fairly typical adolescent picture from a child who has been reading the magazines and seeing the television usually provided for this group—we have all seen hundreds rather like it. But it was quite striking in its difference from the other caves and mines done in this study. This girl has obviously not been able or willing to sink herself in the experience of the mystery and depth of the cave. Not only has she romanticized the idea of the cave or tunnel with the introduction of the elaborately locked door, the key, the torch, and so on, but the children (herself and her phantasy playmate?) occupy the center of the page and capture all the attention by their color and style of painting, which is in contrast to the rest of the picture. It is as though she had to bring the idea of mystery and hidden delight, which most children found in the idea of the cave itself, on to the superficial plane of schoolgirl romances of the locked room. The cave entrance is bricked up with a door, man-made, and the picture's triviality emerges when compared with the man-made mine (PLATE 14b) in which some of the primeval mystery remains. She has reduced everything to the pretty level. In choosing to paint thus, she may discover the pieces of eight, or even the box of jewels this door suggests, but she will not find her own origins. I suspect that she is not exploring reality but a romantic substitute for it.[18]

––––––––––––––

17. Marigold is the middle child of a family of three, and thus most understandably falls between the concentration of attention given by her parents to the first child and their self-indulgence in spoiling the youngest, the only boy in the family.

18. Nevertheless, the subject of "Treasure Trove" is one that moves girls deeply, if in a different way from boys. A history teacher friend has told me how spellbound her girls always sit when she relates the record of Sutton-Hoo, how Mrs. Pretty had mounds in her garden, and no one knew what was inside until she invited the archaeologists to open them up, and how the large

Apart from a very few superficial paintings like this, it will be seen that, both in my own classes and in the classes of other teachers, most of the adolescents were exploring this cave subject at a level deeper than I had reached in my own thought—consciously at least. Because I recognized—and now looking back I see how slow I was to do—some profound mystery in caves I felt impelled to pursue it further, but as usual, time and the general pressure of life postponed this, and it was not until I met this theme in another context that I did so, as will be recounted in a later chapter of this book.

mound contained a ship (Latin, *navis*, cf. nave of a church, center hub of a wheel, navel) housing the cenotaph of a king and his golden treasure.

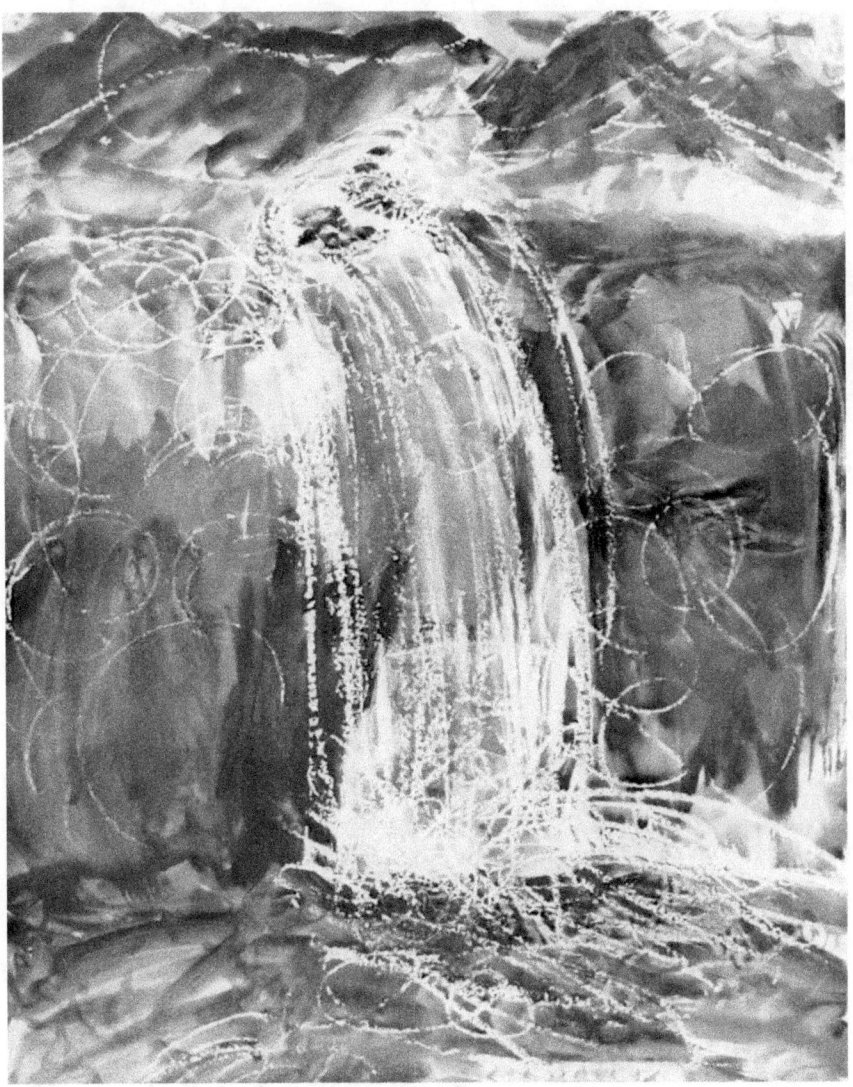

PLATE 9 "Waterfall." Drawn with candle wax and watercolor (*Girl, age 14*)

PLATE 10*a* "The Great Wave." Wax and watercolor, on the theme of "The Sea" (*Boy, age 14*)

PLATE 10*b* "Pool with Spray." Powdered paint and ink, glowing orange, blue black (*Girl, age 14*)

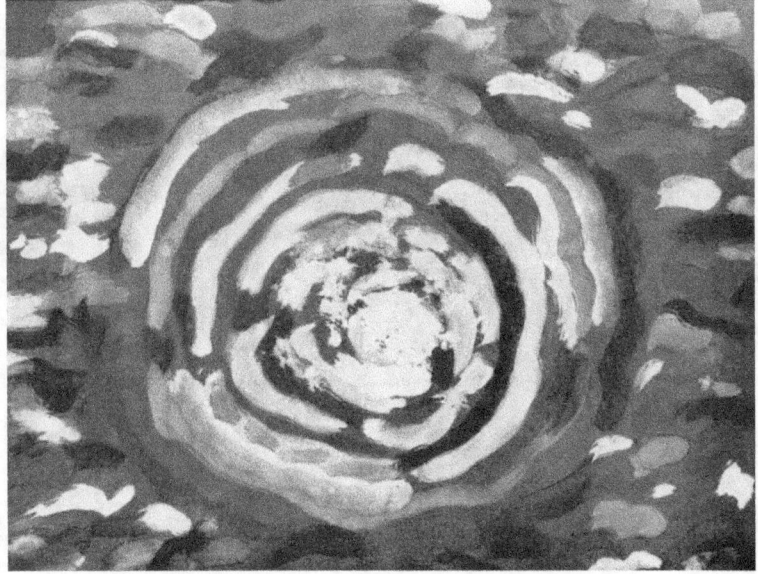

PLATE 11*a* "Snaky Sea." Recalls Coleridge's "slime snakes," a nonvisual image (*Boy, age 14*)

PLATE 11*b* "A Pool." A restless, noisy girl made this simple soft blue-white pool (*Girl, age 14*)

PLATE 12*a* "Harbor." No way in or out, the houses dominate it (*Timid girl, age 13*)

PLATE 12*b* "Barnsley Park." On the theme of "Water." An etiolated echo of Margaret (*Girl, age 14*)

PLATE 13*a*　"Stalactite Cave." Receding hollows, modeled stalactites enclose recesses in soft colors
　　　　　(*Boy, age 15*)

PLATE 13*b*　"Toothed Cave." Monster-like forms emerge from slimy depths, harsh tones (*Boy, age 14*)

PLATE 14*a* "White Stalactite Cave." Painted in 15 minutes, white and gray on black (*Boy, age 14*)

PLATE 14*b* "Mine Tunnel." Foreground pool, receding arches of iron brown (*Boy, age 14*)

 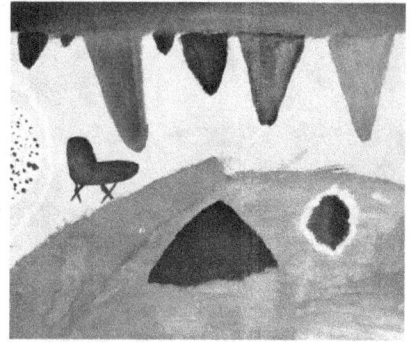

PLATE 15*a* "Dolmen Cave." X-ray view showing pale sun over hill (Inarticulate *boy, age 13*)

PLATE 15*b* "Cradle Cave." Mound in center, pool, stalactites, cradle (*Girl, age 13*)

PLATE 16*a* "Silver Stream Cave." Cave with silver stream issuing from center of blue–gray circles
(*Girl, age 14*)

PLATE 16*b* "Treasure Cave." Man-made construction, artificial light, hard lines (*Girl, age 13*)

INTERLUDE

ON GARDENS

The Interlude on Gardens traces another line of thought I had been pursuing from time to time with growing interest. Being a rediscovery of the work of artists and writers, not of children, it calls for a different treatment. In the end, it is found to illuminate the first incident in the book and to illustrate the persistence of a common theme in a set form throughout the centuries.

Those who are more interested in the work in the classroom in PART TWO, may prefer to omit this interlude at present, but the two levels of thought, in teaching and in being led to new discoveries myself, are integral to one another.

Thus the heavens and the earth were finished, and all the host of them. And the Lord God planted a garden eastward in Eden; and there he put the man that he had formed. And out of the ground made the Lord God to grow every tree that is pleasant to the sight, and good for food; the tree of life also in the midst of the garden and the tree of the knowledge of good and evil.

And a river went out of Eden to water the garden; and from thence it parted and became four heads.
—*The Creation of the Garden of Eden,* as recorded in the
 Old Testament

Adam and Eve took one flower from Paradise. This, the rose, with all its summer magic, is next grouped with "autumn's Amaranth," symbolizing matured experience of an even greater fragrance than "passion's flowers."
—G.WILSON KNIGHT, *The Starlit Dome*

The [...] masters have left such frigid interpretations that there is little encouragement to dream of paradise itself.
— SIR THOMAS BROWNE

One summer evening, far from schools and students-in-training, I was sitting outside the miniature Tuscan basilica of San Miniato al Monte high above Florence where I often went to escape from the noisy city. A quiet-voiced brother broke into my vacancy to inform me that I was shut in, the gates had been closed an hour ago. After my apology he led me through the monks' garden, warm with the scent of herbs, and out of a little gate in a high wall. I crossed the Piazzale Michelangelo and strolled down to the city through the Boboli Gardens with their trees, statuary, and fountains. The formal terraces of the gardens were darkening swiftly and by the time I came to the river bank (this was after the war in which most of the bridges had been destroyed), the red flowers had gone blacker than the gray olives. I stood cold and alone on the bank hopefully waiting for the ferry supposed to operate at that point. Then, against the dark silhouette of the city—much

the same silhouette as Dante saw, with the thin mullions of Giotto's Campanile and the crenelated tower of the Palazzo Vecchio poised in the sky—there came a wavering light rising and falling with the stream. A high-prowed boat with a lantern at the stern approached silently out of the darkness. I scrambled down a decaying pile of rubble and mutely was handed into the boat by a wrinkled old man whose eyes were almost hidden in his bushy brows. Silently he poled us out towards the city side across dark green water (pale sandy-green by daylight, its shallow volume took on infinite depth by night). I sat in a trance, given up to this strange sensation of travel, and when we reached the shore and two black and white nuns loomed out of the darkness, lifting their voluminous skirts to step daintily in, I indicated my wish to return with them to the Boboli side. Again that trance-like journey over the water: the slow withdrawal from the dark cliff of buildings to the moment of poise in midstream and then all too soon we were approaching the other bank. The nuns stepped out, and when I refused the boatman's claw-like hand and put instead in it a triple fare, saying that I would return to the city, the old man came close to me and peered into my face as though to search for the motive of putting off so reluctant an arrival. But I wished only to savor the journey, the cool air in my hair, the swift passage of the dark water, and this Charon—as I suddenly saw him—silently poling me back from the garden to the city. At the worn steps I thanked him and made my way along the Lungarno in that receptive state of mind induced by night journeys over water.

My nose was full of scents, and my mind dwelling casually on the difference between the austere, practical herb garden of the monks and the wide pleasure terraces, the exotic trees and extravagant Neptune fountain of the Boboli. Suddenly the "rosegarden" of Margaret, that funny collection of pieces of clay on a desk, came to my mind. Why had a rosegarden come to her mind? How had the whole idea of gardens come to men's minds? I was woefully ignorant, but I knew that rosegardens were a favorite theme for poets, and the obvious "a green thought in a green shade" and "God wot, rose plot" sprang of course to my mind. So at odd moments over the next weeks I read these and other garden poems, but they had no power to lead me further. However, discarding Thomas Edward Brown had sent me back

to his near-namesake, and I spent a delightful evening following the arguments of old Sir Thomas Browne as to whether Noah or another was the first husbandman, and the discourse on the size and shape of the "decussated plot"[1] of the ancients. Whether he is arguing from ancient works and recorded wonders or from what is "elegantly observable in several works of nature"[2] (the spider, or teasel heads or "leaves and sprouts, which compass not the stalk and are often set in a *rhomboides,* and making long and short diagonals, do stand like the legs of quadrupeds when they go"[3]), Sir Thomas is reporting, deducing, putting forth a balanced argument in his beautifully ponderous prose. But at the end of the chapter comes a paragraph in a different key:[4]

1. Hyades near the Horizon, about midnight at that time.

2. *De insomniis*

3. Artemodorus et Apomazar

But the quincunx of heaven runs low, and 'tis time to close the five ports of knowledge; We are unwilling to spin out our waking thoughts into the phantasms of sleep, which often continueth pre-cogitations; making cables of cobwebs, and wildernesses of handsome groves. Besides Hippocrates hath spoke so little and the oneireocritical masters have left such frigid interpretations from plants that there is little encouragement to dream of paradise itself. Nor will the sweetest delight of gardens afford much comfort in sleep; wherein the dulness of that sense shakes hands with delectable odours;

1. "Garden of Cyrus," in *Sir Thomas Browne's Works, Including his Life and Correspondence,* ed. Simon Wilkin, vol. 3 (London: William Pickering, 1835), 388.

2. Ibid., 401.

3. Ibid., 404-5.

4. Ibid., 447.

4. Strewed with roses

and though in the bed of Cleopatra, can hardly with any delight raise up the ghost of a rose.

Surely it was not the fact that I grew drowsy that night toward the end of the chapter, that from complete absorption in his Cyrus garden the image of Margaret's "rosegarden" drifted again into my mind. It was something in the measured rhythm of the prose, which moved from rhetoric into the mood of evocation and incantation. He leaves his attempt to trace "delightful truths, confirmable by sense and ocular observation, which seems to me the surest path to trace the labyrinth of truth,"[5] for another realm and hints at the temptation "to dream of Paradise itself." I felt I had drawn near something without getting a sight of it.

Sir Thomas was writing about twenty-five years after another famous essay on gardens, so the next day I turned it up, remembering Bacon a little ruefully from school days. In his melodious recitation of the lovely names he warms a little:

> There followeth, for the latter part of January and February the mezereon-tree, which then blossoms; crocus vernus, both the yellow and the gray; primroses; anemones; the early tulippa; hyacinthus orientalis; chamaïris; fritillaria.[6]

But they remained a catalogue. For dry, precise Bacon would relate them by geometry, and would shape a garden by arithmetic—four acres of ground to be assigned to the green, six to the heath, four and four to either side for plots, and twelve to the main garden. "In the very middle," he wishes, "a fair mount, with three ascents, and alleys, enough for four to walk abreast; which I would have to be perfect circles."[7] Somehow for me the *pattern* was right but the *atmosphere* was all wrong. What could I hope of a man who dismissed roses as

5. Ibid., 446.

6. "Of Gardens," in Francis Bacon, *Complete Essays* (London: J.M. Dent & Sons, 1906), 137.

7. Ibid., 140.

"fast flowers of their smells"[8] and spoke in the commercial idiom of buying shade?[9]

This sort of garden did not have the right smell for me. Returning to Sir Thomas Browne I followed up his clues from Virgil and Pliny. Pliny the Elder, solemn and portentous, considered the growing of vegetables and herbs as an obligation, since it was the right and duty of every housewife and husbandman to be self-sufficient. But pleasure gardens within a city he regarded with suspicion as "curious and undesirable inventions." This puritan attitude to gardens would hardly cast light on Margaret's "rosegarden." But, only a generation later, this sternness relaxes, and the Younger Pliny is writing lovingly of his Villa Tusci with its fine view of the Arno.

At this period I spent all my weekends in libraries pursuing any clue that might throw light on rosegardens. I succumbed all too often to intriguing diversions such as making potpourri—"take a pound of petals, thyme, marjoram, and musk"—or trying out a seventeenth-century recipe for sugaring "Frosted Rose Petals."

Time outwitted indeed! The French herbalist Pomet, provided a fascinating diversion: "There is[...]a Conserve made of the white Roses, but it is of little Value. We have from the same Place besides, another liquid Conserve, or Honey of Roses, which is made with the fresh Juice of *Provins Rose* and Honey boil'd together.[...]Besides the Water [of roses], there is a fragrant and inflammable Spirit made of Roses, which is very proper to refresh and exhilarate the Spirits as well as strengthen the Stomach[...]. The Roses which remain in the Alembick, or Still, after Distillation, and which are found like a Cake in the Bottom, being dried in the Sun, we call *Rose-Cake.*"[10] When I look at these scraps of paper now I find cryptic messages to myself saying, "Topiary, look up HYPERNOTOMACHAL 1499" or "Bacon—water garden with claret wine?"

The sheaves of paper accumulated, but the educational significance eluded me. I could not begin to file these oddments because I

8. Ibid., 138.

9. "You ought not to buy the shade in the garden" (ibid., 139).

10. Pierre Pomet, *A Complete History of Drugs* (London, 1748), 66.

did not know what I was looking for. There was no *inherent* pattern,
and I was reluctant to impose an arbitrary one that would tidy them
into files where they were removed from the happy possibility of just
that clue I needed beckoning me in an unguarded moment.

So, all these accounts of gardens, fascinating as they were, did not
sound the same bell for me as the "rosegarden" of Margaret. They
seemed rather extensions of agriculture or of the villa (and I saw how
deeply Bacon had been influenced by his classical reading). They
were so sane, so urbane, so ordered. They all—like Browne's Cyrus—
"brought the treasures of the field into rule and circumspection."
Then I realized what they lacked—*magic*. Margaret had explicitly
described her model as "a rosegarden." The gardens of the ancients
that I had been pursuing, arising first in Egypt from the practical
need to control the Nile, to terrace earth and canalize water, had not
quite lost their practical and utilitarian origin. They were chiefly con-
cerned with the growing of vegetables for food and trees for fruit and
shade. Flowers there might be, especially after the sixth century BC
in Greece when the wearing of wreaths (unknown in Homer's time)
became more common, but utility and the healthy life seemed the
dominant aim.

Where could one find, not simply agriculture extended to include a
meagre measure of flowers and herbs but, rather, all that was summed
up in the word "rosegarden," the intensification of delight, the over-
tones of poetry, above all the magic? I pinned up round my room,
to live with them, all the pictures of gardens among my collection of
prints. There were Egyptian water gardens stocked with fish and fowl,
a few plans of classical gardens, urbane frescoes from Pompeii, then
historically a long gap with only a few views of ordered monastic lay-
outs, until suddenly from the thirteenth century onwards a plenti-
tude of gardens in the *Books of the Hours,* illustrations to medieval
poems (PLATES 17a-b), and a growing number of religious scenes in
gardens. Fra Angelico's endearing Paradise Garden where the Blessed
take part in a kind of round dance (each blessed one between two
angels as though to accustom them gradually to a bliss too incredible
to those just come from earth). There was also a group of the risen
Christ, not only mistaken for the gardener as in Fra Angelico's limpid

scene, but actually wielding a spade (PLATE 18) or silhouetted in that cartwheel of a hat that Rembrandt uses to throw up the light of the Easter sunrise.[11] The urbane opulence of Renaissance gardens was quite out of mood, but it still showed the recurring motifs of fountains, grottoes, and rose beds. More in harmony were Indian and Persian garden scenes, meetings of Krishna and Rama, princes receiving their guests, princesses repining for absent lovers or exulting in secret meetings, with music, refreshments, and always the sound and sight of water and the flowers forever in bloom.

The Persian miniatures above all others exemplified for me the magic garden. Here was the epitome and quintessence of rose-gardens. Here was order without rigidity, an intuitive identification with plant and animal nature whose vigor just saved it from languorous decadence. A sense of shared dependence of man, creatures, and vegetation on a common Source illuminated and infused the mythic poems of that people (FRONTISPIECE and PLATE 19).

While I responded to the vigor and vitality of the earlier Persian work and especially to the close bond between men and animals, it was the miniatures of the fifteenth century that exemplified most fully my idea of the rosegarden theme. What combination of fortunate circumstances at that time had produced this matchless zenith of an art providing the illuminations for a poetry recited to music and can themselves only be described in terms of music and poetry.[12]

11. Thus echoing the Father-Creator of the Old Testament who figures several times as a gardener, notably as the planter of a vineyard (Isaiah 1-17), which has a wall and a tower and a very fruitful hill.

12. The conquest of Genghis Khan and the Mogul hordes that followed him, destroyed the libraries and dispersed the courts so that the fine arts, closely concentrated on these centers, should logically have disappeared. But with astonishing vitality, the hieratic Persian style of figures formally placed without a background not only survived the conquest and inclusion in the Greater Empire, it absorbed the Chinese influence to which that opened the gates. The nervous calligraphic Chinese line, the essential setting of figures within a background, refined and elaborated the traditional Persian style. Drawing on this double heritage, the formal elements remain in the composition, but the drawing is enlivened by sensitive line, until, in a copy of

These Persian artists have found forms that evoke in me an emo-
tion sharing some essential element with that aroused by such widely
different arts as Mediaeval romances and Byzantine ornament. One
scholar writes about PLATE 19:

> The action is, as it were, seen with the eye of heaven. Some may
> suspect in front of these mortal combats on flowery meadows a
> sentimentalism which would spread a veil of poetical unreality
> over everything. But consider such a scene as the meeting of
> Humay and Humayun in the garden, where flowers are in fact an
> essential part of the subject as illustration. What has happened?
> The flowers are not a background; they are in the forefront of
> the picture: it is the human figures which are subordinated to
> the extent of having taken on a flower-like stance in arrested
> expectancy. Here we are shown the scene of the lovers' meeting
> as it might have appeared to themselves in recollection.[13]

In another picture, a manuscript of poems is presented to a young
prince seated in a garden—a favorite subject. The fountain pool is
fluted like a flower itself, and the fence, here more solid, is entered
through an arched gate, which emphasizes the "closed" aspect of the
garden while allowing us to see over the low wall. Dark compact cones
of cypresses poised on slender stems are used to encircle and isolate
the separate flowers of the almond so that one is led to look at each
individual blossom, even at each individual petal with its pink heart.
In another garden scene, the host is gracefully bending the branch of
a bush behind his head to smell a rose. To a cultured Arab, "the abode
of felicity" was the enclosed garden with high walls, sweet-smelling
trees, and, above all, flowing water. Yet far behind this idea of a garden
as a sanctuary is the idea of the *temenos,* the sacred place, which was

The Book of Kings of the second quarter of the fourteenth century, these are
fused in a perfect matching of figure and landscape, of vigor and delicacy.

It is a moment to compare with the brief life of Giorgione when first in
European painting human beings were placed in full relationship with the
world of nature, which as a living entity contains them, both setting and
reciprocating their mood. This also is a world in which music evokes the
mood and hints at deeper overtones we hear but can never describe.

13. Basil Gray, "Introduction," in *Persian painting from Miniatures of the XIII-
XVI. Centuries* (New York: Oxford University Press; London: Batsford, 1947).

within a magic circle, where one could come to no harm. Such min-
iatures are so perfectly composed that one can enjoy the patterned
effect from the distance, even turn them upside down to appreciate
more fully the balance of forms, of flat areas, and of detail; one can
peer into the jeweled perfection of each quarter inch or follow the
subtle paths through which the eye is led (as by the white blobs of
the turbans or the silver-gray angular fence) before returning to an
imaginative participation in the story.

For a thousand years, from the sixth to the seventeenth century,
there are recurring elements in these garden scenes, the wall with a
narrow, usually arched, opening, the central pool or fountain, from
which streams or paths run at right angles, the flowering rather than
fruit-bearing trees, and always roses: "Of the flowers, the rose, con-
stant simile of Persian poets, was queen,"[14] as Sheba was the Rose of
Sharon. Remembering the elaborate walls in Margaret's model, I was
interested to find confirmed that the Persian garden is invariably sur-
rounded by a wall, for it is a retreat and privacy is of its very essence.

Also, Christopher Sykes writes:

> What can be said, and for certain, is that the Persian garden
> owes its character and its great beauty to the fact that it springs
> from a vital need.[...] The Persian garden is a refuge from the
> all-surrounding waste.[...] The garden-making of Persia is the
> most unself-conscious of arts,[...] there are certain conventions
> which, like the Unities of French drama, are rarely departed
> from. The garden must be surrounded by high walls, must have
> as its centre feature a pool [or fountain] must if possible have
> running water, must contain shady trees, and must have soft
> green grass. The princely gardens of Tehran[...] all share these
> essentials with the poorest hovel[...] poets tell of roses and
> nightingales there.[15]

14. Arthur Upham Pope and Phyllis Ackerman, *A Survey of Persian Art from
Prehistoric Times to the Present* (New York: Oxford University Press, 1964), 3:
1439.

15. Christopher Sykes, "Persian Gardens," *Geographical Magazine* 30 (1957):
326-29.

Our knowledge of earlier Persian gardens is obtained from the "garden carpets." In the days of Croesus I, the most important of the Sassanid princes, a marvelous carpet was woven, sixty yards square, of which we have a description:

> The ground represented a pleasure-garden, with streams and paths, trees and beautiful spring flowers. The wide border all round showed flower-beds of various colouring, the "flowers" being blue, red, yellow, or white stones. The ground was yellowish to look like earth, and was worked in gold. The edges of the streams were worked in stripes, and between them, stones bright as crystal gave the illusion of water, the size of the pebbles being what pearls might be. The stalks and branches were gold or silver, the leaves of the trees and flowers were made of silk like the rest of the plants; and the fruits were colored stones.[16]

The Arabs brought their culture to Europe with them and in Spain and Sicily we can get an impression of what their courts were like. One hot day, I myself wandered through the dusty, poverty-stricken suburbs of Palermo keeping to the shady side of the pavement and picking my way over the old people crouched on doorsteps and the stretched legs of children too languid to run around, until I found the peeling ruin of La Zisa, a pavilion built by Arab workmen for one of the Norman kings of Sicily. To enter the cool arched hall with its stalactite form of building was like entering a grotto and down the center ran the gold mosaicked channel which should have held cool water in which to dip the feet. No water ran there now, but round the walls peacocks, symbols of immortality, fronted the tree of life in the timeless brilliance of mosaic. Although what should have been the garden in which this pavilion stood was all built over now with sordid streets, I still got some insight into what water, coolness, and the blessed shade of trees could mean in a dusty land. In that place I also first grasped how the Arabs related house and garden, bringing water and plants into the pavilion, and conversely taking cool shelter and comfort out into the garden, a relationship never again so perfectly achieved until eighteenth-century England developed its landscaped grounds, balconies, and terraces suited to a colder climate.

16. Marie Luise Gothein, *A History of Garden Art*, ed. Walter P. Wright (London & Toronto: J.M. Dent & Sons; New York: E.P. Dutton, 1928), 1: 143.

Turning again to the Persian miniatures, I was reminded inevitably of the only thing in western European art perhaps truly comparable with them, the faded pink tapestry, sprinkled with just spring flowers, of *La Dame à la licorne* seen years ago in the Musée de Cluny in Paris (PLATES 24*a-c*). I knew of course that the fable of the unicorn, the wild creature who can only be captured by a virgin in whose lap he lays his head, was an allegory. But why was the scene laid in a garden, and just such a garden of frail flowers, panoplied pavilions, seclusion for tender meetings as one finds in so many of the Arab romances and in the European poetry of the thirteenth and fourteenth centuries (for the designer of this tapestry, woven in the early sixteenth century, was deliberately using, like Spenser and Bruegel, an archaic mode to give the "distance" that brings his symbolic statement into focus).

Though gardens had been known long before, it was the Crusaders who brought home tales of the fabulous gardens of the Orient, and the passion for gardens, bursting like a frost-bound bud in a warm wind from the east, extended European life in the many directions implicit in the idea of a pleasance. But there was little space inside the walls necessary in these troubled centuries for a garden extension to a pinnacled castle or to a battlemented town, and so the gardens were often places at some distance from the castle and enclosed against the forest beasts. When we do find a castle garden, it is usually, as in the one on which Nicolette's prison room looked down, "strict and close." She herself of course was brought "from the land of the Saracens":

> In the garden from her room
> She might watch the roses bloom,
> Hear the birds make tender moan;
> Then she knew herself alone.[17]

But the form of the Mediaeval garden was fixed and crystalized for centuries by the authors of the *Roman de la Rose,* the separate garden entered by a "wiket smal" with high walls and arbors, with flowers and rose bushes and "trees from the land of the Saracens." Such gardens, repeating the same conventions, the walls, arbors, the rose trees, became the setting for a hundred stories of romantic love.

17. *Aucassin & Nicolette and Other Mediæval Romances and Legends,* trans. Eugene Mason (London: J.M. Dent & Sons; New York: E.P. Dutton, 1912), 4.

We know their appearance from the illustrations to the *Roman de la Rose* and other romances—the fountain in the center, the rose arbor, the turf seats (PLATES 17*b* and 20*b*).

The Courts of Love were often held in gardens and the scene became so intimately bound up with the tender feelings that the Garden of Love becomes a conventional symbol. In the mid-fifteenth century, one of the earliest copperplate engravings shows a Garden of Love, walled with clumps of trees, flowers, a fence to lean on, and hexagonal table spread with fruit and wine.

Now it is an extraordinarily interesting fact that this hexagonal table spread with fruit and wine and several other elements of this Garden of Love appear almost identically in the Paradise Garden of a German Master, painted about 1410 (PLATE 21). Here Our Lady, a doll-like girl, reading in a book, happily leaves the Christ child to play on the grass with a zither, and an angel lounges, conversing with two men in easy familiarity, while the Evil One, reduced to a harmless baby dragon, lies stretched with its pathetic paws in the air. The pool of water is there, the apple tree—echoing another age of innocence—the crenelated walls, and the carpet of flowers.

But a more profound and perhaps the loveliest of all "Paradise Gardens" is that by Stefano da Verona (PLATE 22), in which the feeling of enclosure is emphasized by the small area of the garden and the roses trained over the high walls and the trellises in the foreground that almost close the shape, seeming to encircle the Virgin. The long blue tails of two peacocks—again the immortal birds—themselves like angels, lead the eye up to the apex of the triangle of blue robe, to the high forehead above the quiet face. The fountain is a sophisticated Gothic structure in gold, and in the midst of all the angelic activity the Virgin sits, child in lap, in a dreamy meditation, aureoled by delicate rays and stars.

So the Garden of Love has become the Garden of Our Lady, and one may ask why it was this—the *Arabian* garden tradition and not the other, the *Roman,* a useful orderly garden of vegetable plots, which provided the image? The idea of that same Roman garden survived, if tenuously, through the so-called Dark Ages, and was given fresh impetus by the Benedictines (who ate no meat and in whose gardens

the central pool or fountain was a fishpond). The Carthusians also spread both their knowledge of horticulture and their belief in the contemplative virtues of gardening as their Houses stemmed out over Europe. It cannot have been that this practical man-made garden (as opposed to the heavenly or magic garden) did not lend itself to Christian imagery, for already in the eighth century, Maurus Rabanus had taken the garden, "because there is always something growing there," as a symbol of the Christian church, "which bears so many divers fruits of the spirit and in which flows the sacred fount of healing." But obviously this image, in key with the staid matronly Madonna of the early Christian frescoes,[18] was not appropriate to the delicate adorable Madonna who was the ideal of the fourteenth and fifteenth centuries. Two images, that of the spiritual mediator, the mother of God, and that of the queen or lady of the Troubadours who must be served, worshipped, and loved without requital, had coalesced. The lady of the *Roman de la Rose*, a spiritual allegory in the form of a love story, is indistinguishable from the Madonna of the Rosegarden.

This theme of the Virgin as the lover figure had been lightly woven through the medieval Latin lyrics, and something of the full compass of the images fused in the person of Mary are apparent in the Litany of Loreto. Here we find her described not only by her age-old titles (just how old I was gradually beginning to suspect) of "Stella maris" and "Rosa mundi." She is also "Hortus conclusus" (an enclosed garden).[19] This image of the enclosed garden is weighted with its full significance in certain Madonna pictures, such as Fra Angelico's *Annunciation* into whose light one comes suddenly at the top of the stairs in San

18. She is echoed in the "Roman matron madonna" of Niccolo Pisano's pulpit at Pisa, one of the earliest Renaissance sculptures inspired by Roman fragments lying around the baptistry.

19. In *Psychology and Alchemy* (CW12), ed. and trans. Gerhard Adler and R.F.C. Hull (Princeton, N.J.: Princeton University Press, 1969), 72, C.G. Jung shows a seventeenth-century illustration from Hugo Prinz's *Altorientalische Symbolik* (1915), which represents the Virgin on a horned moon "surrounded by her attributes the quadrangular enclosed garden, the round temple, tower, gate, well and fountain, palms and cypresses (trees of life), all feminine symbols." Jung's *Psychology and Alchemy* is rich in such illustrations.

Marco, Florence (PLATE 23). That the scientific spirit and devotion to the new knowledge did not necessarily supersede religious faith is demonstrated clearly in this picture. Fra Angelico shows his gentle Lady seated under a colonnade with Corinthian capitals (the *latest* of the classical orders, as though to suggest that the true fulfilment of the Classics is now attained in Christianity). The colonnade is set within a garden strictly fenced—outside are woods, inside are grass and flowers. The round-arched colonnade, which forms a little arbor within the garden, is treated with complete simplicity echoing the simplicity of this Virgin. But the symbolic use of perspective in this scene combines an intellectual passion with tender feeling. Perspective to Fra Angelico was the perfect system of representing a scene from one viewpoint (and we forget how recent was this conception: medieval and early Renaissance painting shows many viewpoints and incidents of different times within one picture). The perspective[20] that Renaissance men had invented, did for Angelico but mirror the divine viewpoint from which all things fell into place. This divine order is again suggested by the perfect balance of the picture, the two figures inclined towards one another in a holy concord. Perhaps the pillar of the arcade between them represents the division between heaven and earth, for above it is elevated a circle, the key signature indicating the mood of the whole painting, forming an essential link in the composition and in the situation. The utter stillness is pregnant with meaning, the circle is "the still center" suspended in space and time for us to realize this glorious moment. The Virgin does not twist away in shocked humility as in the earlier *Annunciation* by Simone Martini in Siena, nor is divine condescension emphasized by an earthy or even ugly Madonna as in later work of Bruegel. This is the moment of perfect balance, of divine stooping and human upraising, of divine giving and human acceptance.

It is interesting to notice that except in specific association with the Virgin there are very few true gardens in early or high Italian

20. Paolo Uccellos's wife said of him that he would sit up at nights and not come to bed because he was wedded to Perspective.

painting.[21] Even where the subject is the Madonna, she is more often, in out-of-door scenes, placed in a meadow than a garden, and Francia's *Madonna of the Roses* has only a frail trellis of roses separating her from gentle landscape. The Madonna by Raphael in the Louvre, called significantly *La Belle Jardinière,* is in a meadow. The Garden of Olives and the Garden of the Sepulchre are usually represented as extensions of natural landscape not vastly different from it.

It was in the Arab countries then, wrested desperately from the desert, or in Northern Europe, fenced in against the encroaching forests with wild beasts, that the high-walled garden, and therefore the quintessence of the *temenos*-garden (refuge, magic, or sacred place) is fully apparent. This feeling that the garden was *over against* the natural world lasted in the North through the Elizabethan garden and the seventeenth-century garden as described by Evelyn. It was only with the draining of fens, the cutting of forest, and the developments in agriculture in the eighteenth century that the enclosed pleasance opened its walls (developing the ha-ha to make this apparent) until the garden led by graduated steps through parkland into the country.

Yet the juxtaposition to desert or forest defined by its wall (underlining its enclosed quality) is an element in the *idea* of a garden that even to this day survives in poetry and art, for instance in T.S. Eliot's *The Four Quartets* and Paul Klee's garden pictures. From almost the earliest human records, the Egyptian Island of the Blest, Elysium, the Garden of the Hesperides with "the apple-tree, the singing and the gold," the Garden of Eden with its angel-guarded gate, the Persian myth of the Garden of Yima where the germs of life are preserved—all garden themes echo a poignant desire for fulfilment amidst the confusion and accidents of life:

> The wall encloses the desirable, the beautiful, the ordered, shutting them off from wildness and rough weather. Eden was the more Eden when it was "spiked with palisade." [...] If Mediaeval poetry is full of such paradises temporarily regained, gardens

21. One exception is the garden in which the worldly revelers sit in Francesco Traini's *Triumph of Death* in the Camposanto in Pisa. Perhaps it was inspired by the Garden of Boccaccio, which was also an enclosure, a flight from plague and death.

"set with the lily and with rose," it is because they were the Medi-
aeval response to the perennial human need for a Tir-na-n'Og, a
land of heart's desire where "flies no sharp and sided hail." They
are such stuff as dreams are made on.[22]

That Margaret's garden bore so little relationship to the visual
appearance of the gardens she knew (and she must have had a
great stock of flower, tree,
and other images *if* she had
wished to use them) is now
explained for me by the fact
that what she was doing was
recreating a symbol, a focus
through which her ideas
and feelings could play. Her
symbol is like those referred
to by Kenneth Clark when
he says, "We must admit that
the symbols by which early

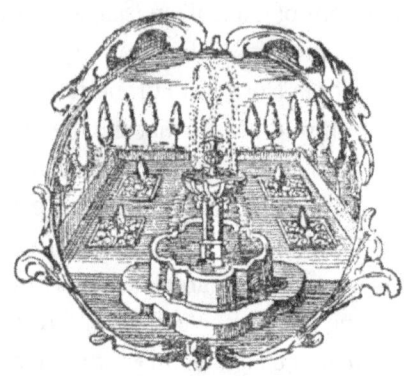

FIGURE 1 The Fountain in the walled garden.
From Boschius, *Ars Symbolica* (1701)

Mediaeval art acknowledged the existence of natural objects bore
unusually little relation to their actual appearance."[23] Jung says that
the more fully an object is functioning as a symbol, the less it needs
to resemble the actual thing.

 In writing on my experiences in following, through the intervening
years, the garden theme, I have been tracing some of the associa-
tions that any one of the children's works might have opened up. If I
have chosen this rather than, say, the history of peacock symbolism,
which was equally fascinating, it is because I hope the garden will be
of interest to a greater number of readers of English.

 If I had known then as much as I do now about the rosegarden
tradition in European art and literature, I would have recognized the
mode in which she was working, and I might have been able to help
her much more. But

22. J. A. W. Bennett, *The Parlement of Foules* (Oxford: Clarendon Press, 1957),
50.

23. Kenneth Clark, *Landscape into Art* (London: John Murray, 1949), 2.

the masters have left such frigid interpretations [...] that there is
little encouragement to dream of paradise itself.[24]

Pondering on the need for our scientific age to recognize these truths
that can only be portrayed in symbolic form and to pause in contem-
plation of them—for they do not reveal themselves in rushed living
or high-pressure teaching—I found the Song of Songs and the lita-
nies echoed in the tapestry of *La Dame à la licorne*. Looking back at
her, who even in reproductions bridges the centuries with her grave
gaze, an invocation to her for that wisdom, without which knowledge
is lethal, took word-shape in my mind.

LA DAME À LA LICORNE

Sweet Damozel,
Trysting with eternal Eden
Wearing circle of seed pearls.

Your jeweled zone is yours alone
Not to yield to strength or stealth
Conceal your wealth.
Guard your treasure
For love's measure only.
Awaiting the white horn.

Gentle Dame,
Mary of the tented isle
Paradise is nuptial ground.

Lay your rose-ring by, enclosing
In casket deep, while around
Proud Lion, guileless
Unicorn Keep guard
While holy seedling sleeps
Waiting to be born.

Sage Donna, wise.
With Anna's eyes,
Robed in faded roses' hue
Woman pierced by man's probe
Bide your time, bear the seed

24. Browne, "Garden of Cyrus," 447.

Share man's pain since you must store
Against man's need in weal and woe
Wisdom's dark light.

We reel with power to gore the moon
Our stark plight crowns history's score
To festering core we close our eyes.

Lady, to heal our plight
Unseal your lore
Reveal your Mystery
Soon, I implore.

— S.M.R.

PLATE 17*a* Lovers in a garden
The Book of the Queen, c. 1410-14
British Library, Harley MS 4431, fol. 376r

PLATE 17*b* Lovers by a fountain
Simon Bening. *Book of Hours ("The Golf Book")*, c. 1540
British Library, Add. MS 24098

PLATE 18 Christ, the Gardener greets Mary Magdalene
 Jacob van Oostsanen, *Noli me tangere*, 1507
 Gemäldegalerie Alte Meister, Kassel

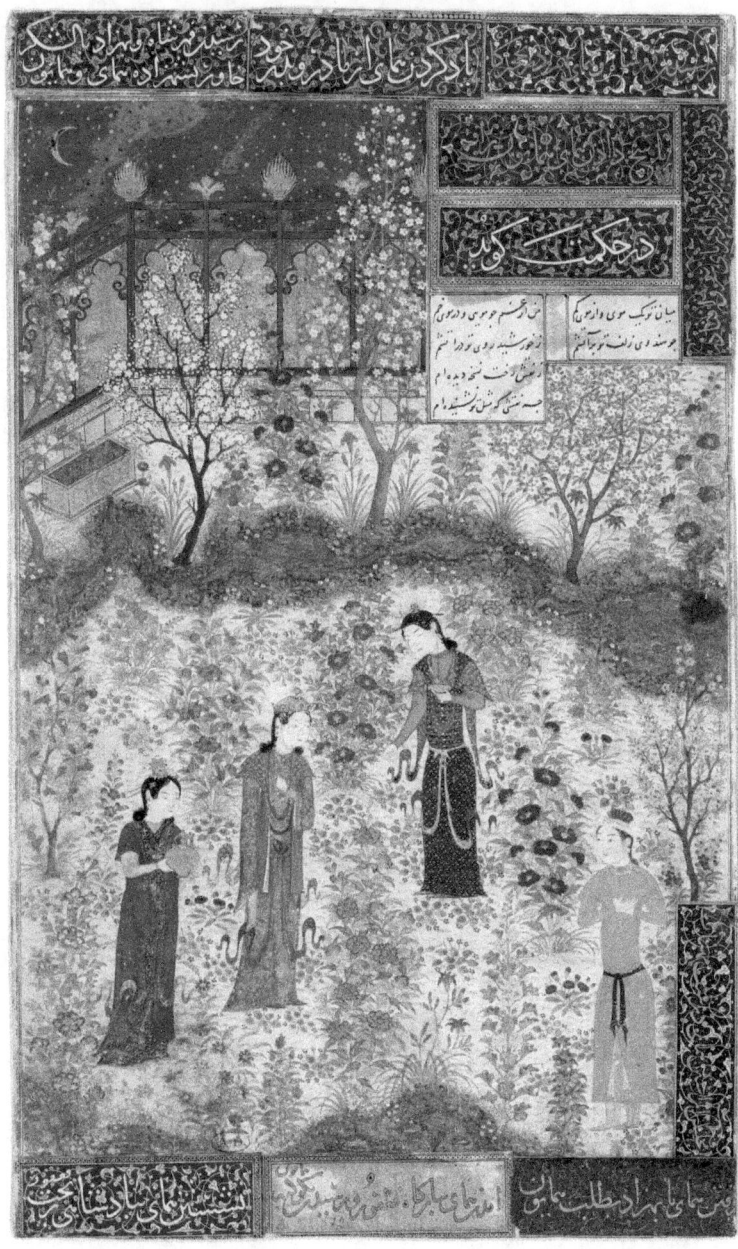

PLATE 19 Anonymous, 15th century
Humay Meets Princess Humayan in her Dreams, c. 1430
© Musée du Louvre, Dist. TMN–Grand Palais/Raphaël Chipault/
Art Resource, NY

PLATE 20*a* The Fountain of Youth
 From: *De Sphaera*, Italy, c. 1470
 MS. Lat. 209 DX2 10r 14c
 Biblioteca Estense
 © Scala/Art Resource, NY

PLATE 20*b* Lover attains the rose whose plucking is the climax of a torturous quest
From: Guillaume de Lorris and Jean de Meun, *Roman de la Rose,* c. 1490-1500
British Library, Harley MS 4425, fol. 184v

PLATE 21 Paradise Garden
Upper Rhenish Master, *Paradiesgärtlein,* c. 1410
Städel Museum, Frankfurt am Main

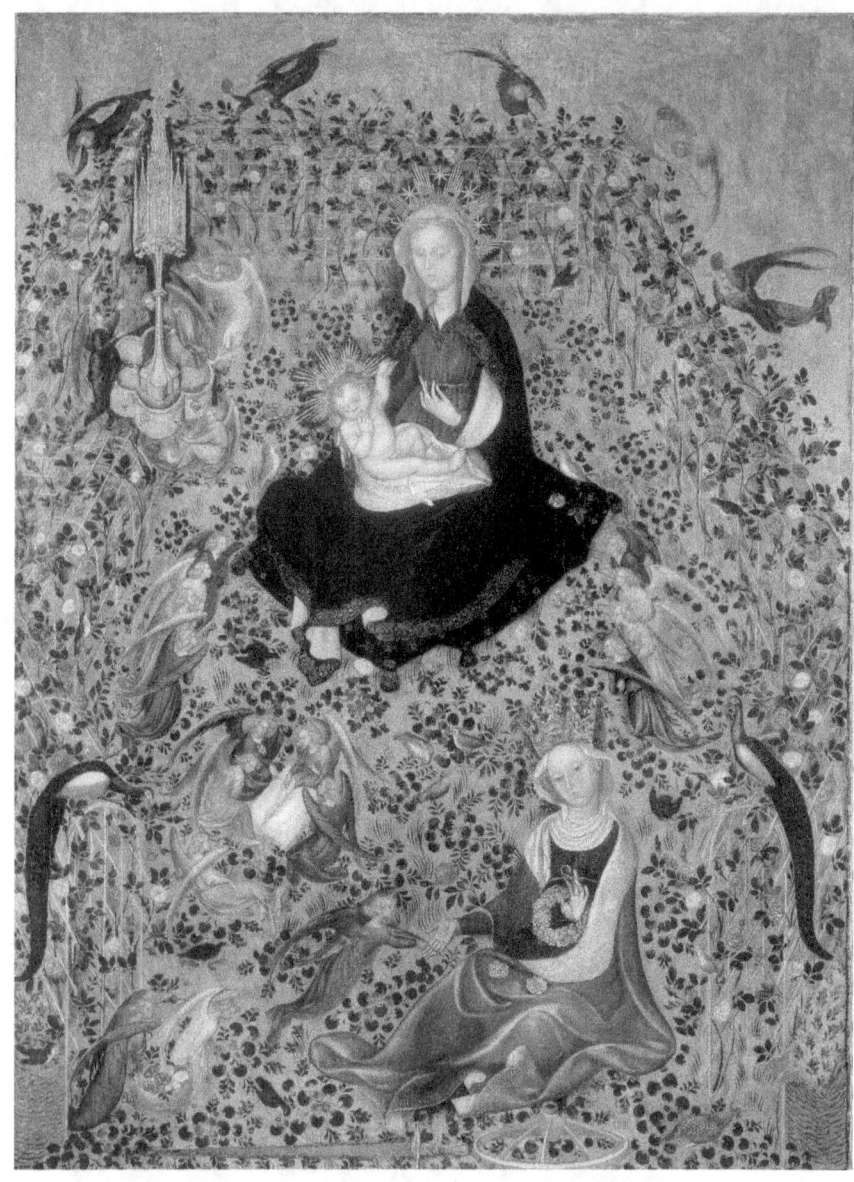

PLATE 22 Paradise Garden
 Stefano da Verona, *Madonna of the Rosegarden, c.* 1435
 Museo Civico di Castelvecchio, Verona

PLATE 23 Fra Angelico, *The Annunciation*, 1437-46
 Convent of San Marco, Florence

PLATES 24a-c *La Dame à la licorne*, c. 1500
 Tapestry
 Musée de Cluny, Paris

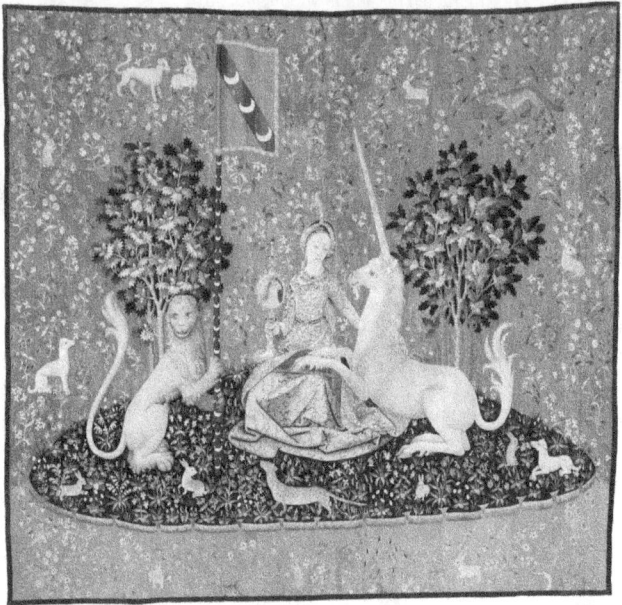

The three tapestries show (*a*) the Lady smiling and smelling a rose;
(*b*) pensively laying her necklace in a casket; and (*c*) showing the
unicorn, with great sadness, his face without its horn in a mirror.

PART TWO

Part Two comprises a discussion of symbols, the description of a class of teachers, showing the power of the symbol to lead us to another level of experience, and a brief review of the implications of this fact for us as teachers.

VI

SYMBOLS

A man that looks on glass,
On it may stay his eye,
Or if he pleaseth through it pass.
—GEORGE HERBERT, *The Elixir*

The arts represent a human need and they rest on a trait quite
unique in man, the capacity for symbolism.
—LEWIS MUMFORD, *Art and Technics*

In this way, through the study of adolescents' pictures and models,
and of past works of art on similar themes, it slowly became appar-
ent to me, as doubtless it has long since to the reader, that most of
these boys and girls were using the suggested themes *symbolically.* Yet
when the subject had originally been suggested to them by my stu-
dents or myself (before the list had been drawn up), no such thought
had been in our minds. I have traced how this conviction emerged
for me through my observation of a different mood in the class and
an exceptional degree of concentration while working; through a
personal satisfaction in the results out of proportion to the actual
achievement, as though those painters were actually seeing through
the work to something beyond it; and through the effect of the fin-
ished work on myself and others, which acted like an incantation in
poetry or the rhythms of Buddhist or Byzantine art, suggesting much
more than it stated.

Although the simplicity and rather primitive crudity of the forms
in some cases give these works a certain superficial resemblance to
the schemata used by young children (and may be mistaken for them),
they differ in essentials. They also differ radically from visual images,

although they have of course certain elements derived from visual perception. The distinguishing quality of visual images, a fresh aware-ness of things as *seen,* an individual, personal vision is outweighed here by the "universal" and intuitive character of these images. These, like tradition, are "more than one man deep." They have the possibility, not so much of extending our vision by projecting someone else's in front of us as visual images do, as of deepening it to levels that were always there in us but of which we were hardly aware.

In drawing up the final list it became apparent that the themes fell into groups of natural and man-made objects, of people, and of beasts. It was apparent that many had a rather archaic flavor that, as I have noted, made me question their value for modern adoles-cents. Nevertheless, I could not ignore their power to produce this intense state of concentration from which the painters and modelers emerged in some way changed, renewed, *more centered.*[1] Through my own experiences in teaching during that year, and through the work produced on them by the group of teachers cooperating, I became convinced that these themes had the potentiality of focusing mean-ings and associations far beyond their overt subject and of serving as symbols for many different kinds of people. In painting caves (PLATES 13-16, which lose immeasurably through lack of the color that reveals their mood and often mystery), these adolescents have to differ-ent degrees used the opportunity offered by this theme to explore not only their own memories of actual caves, not only the dragon-haunted, treasure-guarding caves of our literature, but sensations of darkness and enclosure, of losing one's daylight personality in finding a way into the earth, "mother earth," and into hidden and lost experi-ences of the individual and the race.

Any subject may serve as a symbol for one individual, becoming loaded with personal associations and capable of touching strong emotions through some pattern in his own history. But these themes were evidently able to do this for whole classes, even when neither

1. A work on any subject about which the artist feels intensely can do this of course. My point is that these themes tended for ordinary people to effect this concentration and satisfaction more often than did others.

children nor teacher were aware of their full significance. I could not be content with my own enjoyment in the work, but as a teacher I must pursue this question of symbols.

Children's pictures and models had often sent me back to soak myself in the poetry they suggested, but I had never found much time to read literary criticism. Now the need to understand more fully demanded it. The exploration of symbols in the work of the great poets showed how autobiography or letters might reveal incidents that explained how an object came to play the part of a symbol in the life of one particular man, whose work only communicates fully to us when we know this. But the symbol that is more-than-personal, that is common to us all, had also been explored. In 1914, in his Annual Shakespeare Lecture, Gilbert Murray, comparing Hamlet and Orestes, spoke of the great stories and situations that are "deeply implanted in the memory of the race." Such themes when we meet them may be new to us, "yet there is that within us which leaps at the sight of them, a cry of the blood which tells us that we have known them always."[2]

Jung has shown that symbols that are, as it were, the great types of human functioning—the archetypes—keep cropping up in universal forms such as the Great Mother Goddess or the Wise Old Man. They may take their form through the experience of a community in whose history the theme has arisen—such as the Biblical Flood, a destroying and cleansing force; or they may embody philosophical concepts—such as the Paradise-Hades image—which might arise in human consciousness at any time or place.[3]

A struggle during these years with many of the volumes of Jung, as they were successively translated into English, gave me some inkling of the profundity of the field and brought an intuitive response but never complete understanding. A change of mood or the production of a picture such as the snaky sea would send me back in relief to

2. Gilbert Murray, *Hamlet and Orestes: A Study in Traditional Types* (New York: Oxford University Press, 1914), 26.

3. Phyllis, whose progress is traced in Appendix I, summed up her needs and yearnings in her painting *The Wise Old Man of the East* in an East London slum school though she had never heard of archetypes.

the poetry itself, and I marveled at the power of Coleridge's decep-
tively simple language to contain the turgid images of the sultry sea,
the star-dogged moon, the bloody sun. Immersion in the poem would
give way to a mood of enquiry again, and thus I found Maud Bodkin's
Archetypal Images in Poetry. She sets out to investigate a thesis thrown
out by Jung that the fundamental appeal of certain great poems rests
on their evocation of an archetypal theme: for instance in *The Ancient
Mariner* and *The Waste Land,* the rebirth theme; and in *Paradise Lost,*
the Paradise-Hades image. From her study of poetry, as Jung did from
a lifetime's study of unconscious motives and forces, she concludes
that there are themes of such eternal durability that they are truly
archetypal and have a particular form or pattern (that persists amid
variations from age to age) and that corresponds to a configuration
of emotional responses in the minds of those who are stirred by the
theme. The water and cave themes on which we had stumbled seemed
to me such subjects, and noting her words that a profound response
to great poetic themes can be secured only by living with such themes,
dwelling and brooding on them when the mind is open to their influ-
ence, I hoped that we had been encouraging just that.

She was studying, as was Gilbert Murray, great poems and dra-
mas, in which the primordial images had found worthy expression
and in which the poet's power to move us arose from his language
being matched to the depth of his theme. I was concerned not with
the work of poets or artists but of adolescents and untaught adults
who had neither the insight nor the technique to paint or compose
masterpieces. Yet even their efforts when working on these themes
had a sense of depth and significance that urged me to this study. The
work illustrated varies greatly in its control of the medium and in its
accomplishment. But its fundamental appeal does not lie in these.
Even of masterpieces Gilbert Murray wrote:

> In plays like *Hamlet* or the *Agamemnon* or the *Electra* we have
> certainly fine and flexible character study, a varied and well-
> wrought story, a full command of the technical instruments of
> the poet and the dramatist; but we have also, I suspect, a strange,
> unanalysed vibration below the surface, an undercurrent of
> desires and fears and passions, long slumbering yet eternally

> familiar, which have for thousands of years lain near the root of
> our most intimate emotions and been wrought into the fabric of
> our most magical dreams.[4]

Some of the children's work that revealed their magic dreams had, even when crude and unskilled, more power to move than works of technical competence and confirmed our common fund of archetypes. I am, however, a teacher and very much less concerned with the effect of these pictures and models on us who look at them than with their effect on the makers themselves. When they had worked quickly and surely in this mood of complete absorption, their satisfaction was not damped by lack of technical skill. But the essential condition was that the teacher should accept the "primitiveness" of the work. I saw cases where this was so, but where the adolescent was so conscious of standards of realism in the world outside school to which he aspired that he continued to be self-critical even when his teacher was encouraging. But I never saw a pupil who could continue to be satisfied with the *result* (however much he had enjoyed the experience) if his teacher was disapproving.[5] She alone can create the atmosphere of permissiveness in which the class can let themselves go down into those depths of the self at which symbols operate.

The acceptance of symbols demands from each of us a standing aside of what has been called by Marion Milner "the discriminating ego." Speaking of the necessity for normal growth of symbol-formation through the identification of one thing with another, she writes that

> the basic identifications which make it possible for us to find
> new objects, to find the familiar in the unfamiliar [Word-
> sworth's definition for poetry] require an ability to tolerate a
> temporary loss of sense of self, a temporary giving up of the
> discriminating ego which stands apart and tries to see all things
> objectively and rationally and without emotional colouring.

4. Murray, *Hamlet and Orestes,* 27.

5. A searing account is given in Joyce Cary's *Charlie Is My Darling* (New York: Harper & Brothers, 1960) of the undermining of Charlie's pride and satisfaction in his crude but vital drawing of a bull by the vague disapproval of his prissy teacher.

Perhaps it requires a state of mind described by Berenson as "the aesthetic moment."

"In visual art the aesthetic moment is that fleeting instant moment, so brief as to be almost timeless, when the spectator is at one with the work of art he is looking at[...].He ceases to be his ordinary self, and the picture or building, statue, landscape, or aesthetic actuality is no longer outside himself. The two become one entity; time and space are abolished and the spectator is possessed by one awareness. When he recovers workaday consciousness it is as if he had been initiated into illuminating, formative mysteries."[6]

Her comment is that we know that the boundaries exist—each of us is an organism within its boundaries—in a world of other organisms within boundaries, but the young child does not: "It is only gradually and intermittently that he discovers them; and on the way to this he uses play. Later, he keeps his perception of the world from becoming fixed, and no longer capable of growth, by using art, either as an artist or audience."

Surely all our lives we should keep our perception of the world from becoming incapable of growth, but in adolescence, when the physical and emotional development is in a state of fluid unrest, and yet pressures from both school and work tend to tie one down to being more objective, more definite, this experience is crucial for the flexible growth of the self.[7] If we cultivate in school only the discriminating ego that stands apart and looks at things objectively, then we cut off children from the possibility of losing themselves temporarily in the work of a mind much greater and richer than their own—from experiencing that aesthetic moment that is one of the nodal points of education. But more important, we cut them off from the creative experience of tapping all the differing layers of their own being

6. Marion Milner, "Psycho-Analytic Concepts of the Two Functions of the Symbol," in *New Directions in Psycho-Analysis,* ed. Paula Heimann, Melanie Klein, R.E. Money-Kyrle (London: Tavistock, 1955), 97.

7. A sociologist as objective as David Riesman points out, "While the children's paintings and montages show considerable imaginative gift in the pre-adolescent period, the school itself is nevertheless still one of the agencies for the destruction of fantasy." *The Lonely Crowd: A Study of the Changing American Character* (New Haven: Yale University Press, 2001), 62.

through shaping a symbolic image—a fusion of many related aspects existing on physical, emotional, intellectual, and spiritual levels. And the symbols they use may bring them not only into a relationship with unsuspected depths in themselves but also with such taproots in others through the common traditions of race or humanity.

In order to find this new meaning, we have, as it were, to loosen our coercive hold of the old. One may have some recognition that one's actual mother was a supremely formative influence, worthy even of the sort of veneration associated with the traditional notion of a goddess. But it is not until one ceases to concentrate the feeling and confines the word to this physical, actual, bodily relationship, until one pushes off from the familiar to face the expanse of the unfamiliar, that a university can truly become an alma mater, or a country a motherland, or that a hint of the terror and magnificence of the ancient Mother Goddess image we each of us bear inwardly can illuminate our whole relationship with the other sex. I believe that adolescents have an instinctive (and I use the word advisedly) feeling that chaos must be gone through in order that a new order may come. Sometimes, when they display this sense of turmoil in their dress, in their vacillation, in their painting, we become impatient and impress or demand an ordered form before it arises from the depths of themselves. This is as true of art as of manners and of morals. The artist knows this chaos, which must be undergone if things are to rearrange themselves organically according to some pattern that echoes another Order. He also knows the destruction (of a white canvas, of a trim block of wood, of a bar of precious metal) that must be accepted if he is to create something new. Keats made a positive affirmation about this chaos when he wrote to his brothers:

> Several things dovetailed in my mind, & at once it struck me what quality went to form a Man of Achievement, especially in Literature & which Shakespeare possessed so enormously— I mean *Negative Capability,* that is when man is capable of being in uncertainties, Mysteries, doubts, without any irritable reaching after fact & reason.[8]

8. *The Letters of John Keats,* ed. by H.E. Rollins, 2 vols (Cambridge: Cambridge University Press, 1958), 1: 193-4.

He also found the resolution of this state in the great poems that embody unforgettable symbolic images: "La Belle Dame sans Merci," "Endymion," and "Autumn."

As teachers we should be concerned to provide opportunities for a kind of melting down of the hard edges of objects and of ideas, of a dissolving of differing layers of experience into one another, till apparently unlike things interfuse, dovetail, and finally interlock in one clear pregnant image. This is how a symbol arises.

On reflection, it need not surprise us too much that in the second half of the twentieth century, an age of electricity, nuclear power, earth satellites, such themes as fire, water, woods, should still fire the imagination and bear this symbolic overtone. All the evidence from archaeology and anthropology seems to suggest that such technical advances have left the human mind very much the same. In addition, it seems that new inventions hardly ever take on this power of symbolic role for the whole social group unless they can be linked with some former, related symbol, gathering to themselves its associated power. A modern queen, however powerless politically, however insignificant as a person, bears an aura of queenship derived from thousands of years of real power. An airplane is primarily a powerful engine of flight, but it also carries associations of conquest of the sides formerly reserved for gods and angels!

Every age must express itself in its own terms and its own language, but the underlying symbols prove to be very much the same. It is not to be expected that adolescents will invent new symbols.[9] What we can expect them to do is to find their own individual image for a traditional symbol, and reinforce the sense of their unique personality *and* their common heritage in one and the same activity. I believe that it is this experience that produces the sense I noted of being centered,

9. "The living symbol cannot come to birth in a dull or poorly developed mind, for such a man will be content with the already existing symbols offered by established tradition. Only the passionate yearning of a highly developed mind, for which the traditional symbol is no longer the unified expression of the rational and the irrational, of the highest and the lowest, can create a new symbol." C.G. Jung, *Psychological Types* (CW6), ed. and trans. Gerhard Adler and R.F.C. Hull (Princeton, N.J.: Princeton University Press, 1974), 478.

rooted: balanced on one's own mainspring, and rooted in that which is deeper than oneself.

In a different age or a different civilization, I would not have had to stumble accidentally across the importance of these themes, nor to struggle to free myself from my own upbringing to accept them. The themes of which I have been speaking would have been the normal—in fact sometimes the only—subject for art. The Interlude on Gardens showed how widely that theme was accepted in Europe and the Near East for over six hundred years. One writer[10] goes so far as to say that the garden theme almost *is* medieval European civilization. While it is true that we know the rosegarden and cave themes— though not the labyrinth, water, bird, animal, or queen-goddess themes—*more* through literature than through the visual arts, they need not for that reason be damned as too "literary" for painting. It is when the *style* of a painting is literary or anecdotal that one begins to question. The truth is that they are fundamental themes, capable of inspiring any of the arts, but that dances and ritual dramas, relying on performance for their perpetuation, have often been lost.

I have written elsewhere[11] about the potency of tradition and the way in which a living tradition bears up quite ordinary people who serve as channels for its spirit. Korean Celadon pottery is acclaimed as one of the highest forms of art. Yet we hardly know the names of any of the potters. Those simple, humble folk, working almost as laborers without self-consciousness, achieved such heights because they were relying on a tradition to which they were heirs. They were in accord with it in two ways. They used traditional *motifs* or themes, and, through hundreds of years, thought it sufficient to paint the bamboo or the cherry rather than find new subjects, because these were loaded with symbolic meaning for them and for the users of their pots. They used traditional *forms* (both of pottery and in the sense of images), showing superb skill, varying them only so far as spontaneous brush strokes vary.

10. Bennett, *The Parlement of Foules,* chap. 1.

11. Seonaid Mairi Robertson, *Craft and Contemporary Culture* (London: G. G. Harrap. 1961).

The adolescents of whom I have been speaking have no valid traditional *forms* in which to work. The inherited forms of folk art and visual religious imagery are not now living channels through which the sap can flow. They are somehow not the right shape to contain their feelings. The vapid naturalism of magazines and calendars comes to them with all the insidious authority of being taken for granted by the majority of adults around them (to whose status and standards they desperately aspire). Even if they reject those and look to the contemporary artists, they find experiment, vitality, turmoil, but no point of rest. There are no accepted and acceptable forms in which to express those feelings that, they would be relieved to find, link them with every generation. But if there are no forms (and this age of excitement, expansion, illimitable possibilities could not have remained bound within the forms of a more static age), there are those archetypal themes that belong equally to all ages and, rooted in man's remote past, can yet emerge in contemporary images. While they can provide the excitement of exploration, of discovery, they also provide a point at which to rest; they bear within themselves such a wealth of ripe tradition from the past that even to sink into them empty or uninspired is to be borne up by rich and teeming associations. They offer, as it were, a vertical path back into the core of oneself rather than the horizontal extension of many school activities no less, if no more, necessary.

Such an "inward turning" can be reached by the writing of poetry, the making of music, and other activities, each of which will appeal to some individuals. I would point out that in the visual and plastic arts, two additional conditions are present. The first is that often the actual movements involved in painting or modeling some of these themes are, as in some dances, likely to induce an inward-turning contemplative state. The second is that the result is an actual object in the world and therefore a record for oneself by which later to assess the experience.

It must be emphasized that the themes we discovered to have this potential were not subjects that *demanded* this contemplative or symbolic treatment, which they so often received. Those who wished to treat them as memory studies or to construct intellectually composed pictures on them were quite free to do so, and a few children always

did. On the other hand, the treatments I would be bold enough to call "symbolic," having a sense of significance greater than the overt image, varied enormously even in one class, as the illustrations show. Some are almost abstract and were, I am sure, intuitively reached through a falling away of the concrete, localized associations. But to their makers they did in some sense *represent* this thing in its essence. Thus at the artist's level, Ivon Hitchens's paintings through successive versions arrive at an almost abstract relationship of forms and colors that are yet the very essence of woods and water. And just as an image, sometimes a figurative image, arises out of the "chaos" of letting the paint get on to the canvas by a Jackson Pollock or an Alan Davie, so it may be *at his own level* for an adolescent.

It would be very unfortunate if I gave the impression that I think the subject in any literal sense is the most important thing in art. These pupils were not artists, and I hoped not to make them artists but to give them something of the experience artists have. They cannot share the artists' sense of mastery in the medium—that takes years of training to acquire. They cannot share the artists' knowledge of the past and their sense of standing at the extreme boundary of the present, revealing new things to their generation. But they *can* share the utter absorption of the whole being in this act of painting, a gathering into one concentrated act the physical, emotional, intellectual forces that, free of their normal outward pull, can spiral down through the layers of one's own personality. And if they are encouraged to be completely involved they can stand at their *own* boundaries discovering further things (which may sometimes look banal to us but which extend them) through this fusion of inner-outer, higher-deeper in intense concentration.

If we agree that this experience is one we want for children and adolescents, what are the conditions we can provide in which it is likely to happen? This fusion of layers of experience only appears to take place in certain circumstances.

Marion Milner—whom I quoted earlier on the necessity of forming symbols in the normal process of growth—when she sets out to study, in her own words, "the emotional state of the person experiencing this fusion," fastens on the word *concentration* and says:

I wish to bring it in here because[...] I have often noticed, when in contact with children playing, that there occurs now and then a particular type of absorption in what they are doing, which gives the impression that something of great importance is going on. Before I became an analyst I used to wonder what a child, if he had sufficient power of expression, would say about these moods, how he would describe them from inside. When I became an analyst I began to guess that the children were in fact trying to tell me in their own way, what it does feel like. And I thought I recognised the nature of these communications the more easily because I had tried for myself, introspectively, to find ways of describing such states, mostly particularly in connection with the kinds of concentration that produce a good or a bad drawing.[12]

She also says, "Perhaps in ordinary life, it is good teachers who are most aware of these moments, from outside, since it is their job to provide the conditions under which they can occur, so to stage-manage the situation that the imagination catches fire and a whole subject or skill lights up with significance."[13] The metaphor of catching fire is an apt one because the fusion will not take place except at certain intensity of concentration. This in turn implies a lack of nagging worries about getting dirty or being late for the next lesson. The teacher's "stage-managing" must include putting minds at rest about such things.

It may also require in the painter or modeler sufficient skill not to be hampered by concern about his materials—this will vary very much with the difficulty of the medium used. Margaret made her garden on the first occasion she used clay, and many of the other models shown were made at the first contact with clay. We are less likely to meet adolescents—though we do find untaught adults—who have not used powdered paint, and I acknowledge that the ease shown in many of the pictures may come from previous work on more formal lines with the teacher. The interrelationship between acquiring techniques and "self-expression" is worked out in the Appendix on

12. Milner, "Psycho-Analytic Concepts," 86-87.

13. Ibid. She goes on to say that in psychoanalysis, however, the process can be studied from inside and outside at the same time.

Phyllis's progress, but is too familiar to many of my readers to repeat here. I shall only emphasize that I see week-by-week planning as an alternation of the discipline of mastering techniques with the opportunity to plunge into "the creative moment" when it arrives—either fortuitously because the wind bloweth where it listeth, or because the teacher has one eye on the stars and his trimmed the sails with foresight and wisdom.

On the other hand, what *was* a living symbolic form can become dead for an individual or a community, just as a ritual can. Then it acts as a constricting grip on further growth and has to be broken through. This has happened frequently in the history of art, as when the figure of the Christ crucified remained a stiff enigmatic cypher in early Italian painting while the figures around the cross, or in associated scenes, were already taking on the physical flesh and human characteristics that were to be more fully explored in the Renaissance.[14]

In the same way, the visual symbol in which a fundamental theme is expressed may, for a child or adolescent, ossify into a too-confining formula. This can be broken through by preparing for an infusion of new life through shattering the fixed symbol-image by a shock of sense perception, a sudden "seeing afresh" in a new light (perhaps

14. I discovered, on a visit to study styles of Byzantine Painting in Macedonia, that the wall paintings in the Church of St. Panteleimon in Gorno Nerezi show in the twelfth century a sudden flowering of human feeling in this formerly hieratic scene. But the human pathos of the dead Christ's body and the human sorrow of Mary proved too shocking to be acceptable to a people long used to a more remote hieratic and symbolic art, and this more human treatment of consecrated scenes was dropped, and the ritualistic attitudes re-adopted. Over the next century, small minor changes paved the way for the acceptance of a more fully human as well as divine interpretation of the Christ, which is not found again until almost a century later at Mileševo.

In *Landscape into Art* (London: John Murray, 1949), Sir Kenneth Clark traces the development of what he calls "the landscape of symbols" from the unconvincing equivalents of Eadwine's Canterbury Psalter through the mosaic floral backgrounds of the Cappella Palatina mosaics, and the highly conventional rocky mountains in the background of Duccio's *The Three Marys at the Tomb* towards what he calls "the landscape of fact," drawn from observation, involving sensory images.

literally floodlit, which can often be arranged by the teacher). We are fed through sensation—the messages of our senses—and a fresh sensory experience contributes to a new image. Something like this happened to Hilda, who used the subject of "Our House" (in which they were encouraged to portray any aspect, including the family at home) to produce again the stereotyped doll's house kind of drawing that she had been repetitively scribbling for a long time. This obsessive drawing of houses is common in children, especially girls, who are insecure. It seems to be for them a kind of reassuring talisman and I would not myself express any dissatisfaction with it until I could spend a fair amount of time with the child, trying to understand her situation. With Hilda I encouraged her to discover new visual aspects of her own home, to see it literally from a new angle, to describe odd corners and aspects of it, to make things for it. I was trying to sustain the feeling of belonging while urging her to see it, even for brief moments, objectively. Later, she was persuaded to venture into the independence of seeing it and drawing it as one home among many, in fact, her street, her township, which could become as much her own as her house was.

I do not pretend that one can cure a neurotic child in this way (though it may be possible to work with a psychologist in consultation), but at least we can try to work within the orbit of the individual problem, when we become aware of it.

A second way of breaking out of a too-confining symbol-image is by penetrating reflection on the symbol's *meaning*. One of my students doing her teaching practice in a grim Yorkshire mining town on the edge of moorland country, chose Easter (which was approaching) and with one form carried that theme for several weeks through all her work in literature, painting, religious knowledge, and dance drama. She suggested that they should imagine the story as taking place within their own gray, sooty streets, with Christ as a pitprop maker for the mines. By reading and re-reading the story, by writing their own thoughts on how it would appear in our time, and by acting the various emotions of the crowds, the soldiers, the disciples, she and her class transposed the theme to their own environment. They envisaged, for instance, the healing miracles as following a car accident, and Christ retiring to the Huddersfield moors for the Transfiguration. The

whole atmosphere of serious study and solemn absorption created over weeks by these rather rough, rowdy adolescents was impressive. The pictures that emerged lined the corridors for Easter week and, compared with the former stilted representations of religious scenes, they enshrined an experience that enriched for us all the idea of death and resurrection.

Thus, an archetypal symbol will have both a dynamic and a stabilizing function, confirming one in the security of his traditions but offering the possibility of renewal in finding fresh meanings and experiences in familiar things. The teacher's awareness of these possibilities will help her to choose themes that answer different needs. It is not her job to search for or interpret obscure symbols—we are surrounded by sufficient in which we all share—but rather to recognize their power and the mode of their operation. We may take to heart G. Wilson Knight's words, "We must always be more interested in the symbols themselves than in our own interpretation of them."[15] By practicing an art even in a simple way, or at least practicing the appreciation of an art, and by being prepared to give herself up to the aesthetic moment when it comes, she can keep her own sensitivity alive.

POEM BY A SECONDARY MODERN GIRL SUGGESTING SOME ASSOCIATIONS OF A CONTEMPORARY SYMBOL-IMAGE

THE AIRPLANE

The creature of the air, to "which we owe so much,
a floating bird of profound beauty,
It soars above the tossing clouds
Where the sun shines, but to this
bird I have to say (in which we put our trust
In this age of war) I see thee and thy
 brothers do beguile your maker
You fly o'er land and sea but nought will change thee.

15. G. Wilson Knight, *The Shakespearian Tempest* (London and New York: Routledge, 2002), xiii.

VII

CIRCE'S ISLAND

Gas and electricity have killed the magic of fire, but in the country many women still know the joy of kindling live flames from inert wood. With her fire going, woman becomes a sorceress; by a simple movement, as in beating eggs, or through the magic of fire, she effects the transformation of substances: matter becomes food. There is enchantment in these alchemies, there is poetry in making preserves; the housewife has caught duration in the snare of sugar, she has enclosed life in jars. Cooking is revelation and creation.
— SIMONE DE BEAUVOIR, *The Second Sex*

Gilgamesh washed out his long locks and cleaned his weapons; he flung back his hair from his shoulders; he threw off his stained clothes and changed them for new. He put on royal robes and made them fast. When Gilgamesh had put on the crown, glorious Ishtar lifted her eyes, seeing the beauty of Gilgamesh. She said, "Come to me, Gilgamesh, and be my bridegroom; grant me seed of your body, let me be your bride and you shall be my husband. I will harness for you a chariot of lapis lazuli and of gold, with wheels of gold and horns of copper; and you shall have mighty demons of the storm for draft-mules. When you enter our house in the fragrance of cedar-wood, threshold and throne will kiss your feet [...]."

Gilgamesh opened his mouth and answered glorious Ishtar, "If I take you in marriage, what gifts can I give in return? What ointment and clothing for your body? I would gladly give you bread and all sorts of food fit for a god? I would give you wine to drink fit for a queen. I would pour out barley to stuff your granary; but as for making you my wife—that I will not. How would it go with me? Your lovers have found you like a brazier which smoulders in the cold, a backdoor which keeps out

neither squall of wind nor storm, a castle which crushes the gar-
rison, pitch that blackens the bearer[...]. Which of your lovers
did you ever love for ever? What shepherd of yours has pleased
you for all time? Listen to me while I tell the tale of your lovers.
There was Tammuz, the lover of your youth, for him you decreed
wailing, year after year. You loved the many-coloured roller, but
still you struck and broke his wing; now in the grove he sits and
cries, 'kappi, kappi, my wing, my wing.' You have loved the lion
tremendous in strength: seven pits you dug for him, and seven.
You have loved the stallion magnificent in battle, and for him
you decreed whip and spur and a thong[...]. You have loved the
shepherd of the flock; he made meal-cake for you day after day,
he killed kids for your sake. You struck and turned him into a
wolf; now his own herd-boys chase him away, his own hounds
worry his flanks.[...]And if you and I should be lovers, should
not I be served in the same fashion as all these others whom you
loved once?"

When Ishtar heard this she fell into a bitter rage, and she
went up into high heaven.[...]

Ishtar opened her mouth and said again, "My father, give me
the Bull of Heaven to destroy Gilgamesh. Fill Gilgamesh, I say,
with arrogance to his destruction; but if you refuse to give me
the Bull of Heaven I will break in the doors of hell and smash
the bolts[...]. I shall bring up the dead to eat food like the living;
and the hosts of dead will outnumber the living."

— *The Epic of Gilgamesh* (English Version by N. K. SANDERS)

Some time before this I had been asked to take a group of teachers,
men and women, for a day's course in Junior School crafts. They were
teachers of a small industrial Yorkshire town and its surrounding dis-
trict, and though I had never met them before I guessed from visiting
some of their schools that they would be not a very easy group to
introduce to new ideas. From knowing the work that went on there I
felt that the most valuable thing I could do in one day was to intro-
duce them to clay, but the organizers of the course had provided a
great quantity of scrap and waste material (tins, boxes, card, etc.) in
order that I should suggest some of the things that are possible when
there is no bought material available. While I believe that none of us
need ever be completely halted because we do not have supplies of
the materials we want for craft, and while we must learn to use the bits

and pieces of material that are thrown in the waste paper baskets, I also believe in the value of an inspiring material for the children. This is one of our greatest assets. So I tried to meet the situation half-way and compromised by having, as well as the waste material provided, two colors of clay available, a dark rough clay, almost black, and a smooth white. I myself also brought some natural materials such as feathers, acorns, cones, and twigs that cost nothing at all but have subtle, natural qualities of their own.

Some of those teachers had come from the surrounding district and were very understandably regarding this as an opportunity for meeting their friends, so that when I entered the room little groups were sitting about in corners chatting, and there was a good deal of noise and hilarity going on, which I found quite difficult to subdue in order to introduce myself. Even when I called my group together to show them the materials provided for them, the uncertainty of these teachers in finding themselves for a day in the role of learners was so great that they sheltered behind a certain amount of fooling, noise, and jokes. They were convulsed by the cardboard centers of toilet rolls among the scrap material, until later someone found that jammed into one another they served for the trunks of palm trees. Although these teachers had come voluntarily to join this group they were obviously apprehensive, and some of them said to me in a downright way, "You needn't think that you are going to get me to use clay. I've always set my face against it—it's messy stuff." Because they felt a little foolish themselves, they had to make fun of me who was their teacher for today. One of the men picked up my yellow Italian straw hat that admittedly resembled a wastepaper basket (or perhaps a dunce's cap!), and putting it on his head, sidled about the room in a comic fashion to the accompaniment of roars of laughter from everyone. This then, was the group with which I was faced. Their insecurity in the face of a new material made them try to put off beginning the session. I had to conquer my own nervousness at the unsympathetic element in the group, but at last, by going round giving them a lump of clay individually, they were persuaded to settle. Nevertheless, even as we began, their defensiveness still found an outlet in jeering at one another jocularly across the room for "playing at baby stuff like clay."

One or two of them said to me, "Can't I just sit and watch the others and take notes?" There were still a few mutterings, and even a certain amount of resentment at my insistence, but eventually they did quiet down, and sitting on the table in front of them, I gathered them in a group close around. I told them that I would later give them all the *facts* about where to buy and how to store clay for which they were clamoring, but that the first thing we ought to do together was to get our hands into the stuff, and make something.

Now, I had previously given great thought to approach clay with this group of teachers and I sensed that it must be different from any of my usual introductions to modeling.[1] With a less vulnerable group I would have left the suggestions to come from them, but I could (as they could not) foresee the technical difficulties and possible frustration with some of the subjects they might suggest. Moreover, during the early stages, such a varied group is often pulled apart by discussion rather than knit together, and in one day I felt we would become a group more surely by *working* together. So we must get down to that as quickly as possible. A clear lead was needed. It was necessary, above all, to choose a subject in which none of them would feel incapable or at a loss, in which they could all accomplish something. Therefore the subject must appear extremely simple and yet hold out a challenge to those few who had initiative or who had some experience of this medium. At the same time, it was desirable to show them a method that they could adapt for their own classes. Although I have many reservations about group work, I felt beforehand, from the little I knew of these teachers, that this course might help them to get over a dissatisfaction with their own efforts by incorporating their individual work in a greater whole. However, when I began to think of subjects for group work they might use in their own primary schools, subjects such as the circus, or Gulliver and the Lilliputians, or fun fairs or harbor scenes, almost everything I thought of seemed too obviously junior, or too reminiscent of school projects for this group of grown-ups. I had usually found that some slightly fantastic subject, such as clowns, or scarecrows, or fairground eccentrics, released the

1. Two such are described in Chapter 1 and in *New Era* (May 1958).

timid by obviating the necessity for representing naturalistically. But how to avoid any suggestion of condescension in such a subject, and to avoid limiting the more ambitious to mere phantasy? After long thought, just the evening before, I had an inspiration. I decided to use a part of the *Odyssey*, which could hardly be labeled babyish, had the cachet of classical associations, and offered incidents of varying complexity. So I chose the Circe episode in Rieu's translation.

I told them briefly about the dilemma of making a choice of theme and of the suggestion I proposed. They still tended to giggle and protest among themselves, but as I opened the book and began to read, quietness gradually fell. I had reminded them of Homer's order of telling the story and read from the arrival of the Greeks and their search of the island, seasoned warriors, boldly challenging the unknown:

> In a clearing in the glade they came upon Circe's house, built of polished stone. Prowling about the place were mountain wolves and lions that Circe had bewitched with her magic drugs. They did not attack my men, but rose on their hind legs to fawn on them, with much wagging of their long tails, like dogs fawning on their master, as he comes from table for the tasty bits he always brings. In the same way these wolves and lions with great claws fawned round my men. Terrified at the sight of the formidable beasts, they stood in the palace porch of the goddess with the lovely tresses. They could hear Circe within, singing in her beautiful voice as she went to and fro at her great and everlasting loom, on which she was weaving one of those delicate, graceful and dazzling fabrics that goddesses make.
>
> Polites, an authoritarian man and the one in my party whom I liked and trusted most, now took the lead. "Friends," he said, "there is someone in the castle working at a loom. The whole place echoes to that lovely voice. It's either a goddess or a woman. Let us call to her immediately."[2]

Early in the reading, the headmaster of the school in which we were working strode into the room. I greeted him only briefly and tried to concentrate on conveying the story, on letting the magic of the words, even in translating, enchant us, binding us together in the tenuous

2. Homer, *The Odyssey*, trans. E.V. Rieu and D.C.H. Rieu (London: Penguin, 1991), 131.

relationship we had begun to achieve. The headmaster fidgeted in front for some minutes, lifted the lid of a clay bin, dropped it back, walked round, passing between me reading and the group. However, when the door closed with a clatter, our restiveness under his scrutiny subsided; we were all captivated again by the spell of the story. Before the end they were listening in complete stillness. When we started quietly to discuss how we should portray the scene, most of them were serious—and eager to begin. I suggested that each should choose one thing on Circe's island to model (which gave them a wide choice), with a reminder that, as well as the pigs and the swine who were Odysseus's men, we were told that there were lions, wolves, and many other sorts of animals, the victims of Circe's spell. In addition, there would be birds on the island, and of course there would be trees and Circe's castle. In building up this background without spending too much time, the scrap material would be useful They could begin by shaping one of the men or animals in clay; then they might go on to do something in different materials, a tree or a bird. Afterwards we would assemble them all on the island, which was to be prepared on a large table at the side.

With interest whetted they scattered to their places, and after the first excitement of hands in wet clay and a few nervous and self-conscious gibes between the men, most of them settled down contentedly. Three men were left sitting together who, armed with clear, open notebooks "for taking notes," were drawing strength from solidarity and refusing to risk making fools of themselves with clay. They were cajoled into taking off their jackets and persuaded towards the clay bin just to lift the lumps that were too heavy for me and finally enticed into trying the feel of the stuff itself, and very soon they were modeling like the rest. There were in this group three nuns, sweet and very earnest, who found it painfully difficult to make anything in the clay at all. Genuinely anxious to learn anything that would be helpful for their pupils and half persuaded intellectually as to its value, they could not, in spite of voluminous overalls, let themselves enjoy the material. As I walked round the class, they gently called for my attention, obviously distressed and unhappy about their productions. Two of them had made identical squat terrier dogs of the sort one so

often sees as plaster mantelpiece ornaments. I am usually glad when contact with clay persuades anyone to break through the inhibitions that produce such stereotyped and sterile productions, but if they had indeed "let themselves go" with the clay, they would have been left unsupported at the end of that day to cope with a kind of experience for which I guessed their ordered lives provided no channel. The first real contact with clay can be shattering and may need further experience with clay to work through to the *forming* stage that follows the disruptive one. I asked them if they would be happier working all three together on Circe's castle to place on the topmost point of the island, and they apologetically welcomed this suggestion. Twittering like gentle serious birds, they delicately picked at the box of scrap materials with white fingers. They did in fact turn out a charming conventional construction of cardboard, something between a castle and a bower with a great arch under which Circe could appear.

Of the group of forty or so, most seemed happily absorbed in their work, and there was the sort of movement to and fro among the boxes of bits and the clay bins, purposeful yet quiet, that one expects to find in a working group. Many of them had been able to overcome a real reluctance at being novices in a strange material because with this subject they could work in a fantastic rather than a realistic (and therefore "measurable") way. Some, after begging repeatedly to be shown the "right" way to model a man or a lion, discovered with pleasure that they *were* able to model what they wished—there was no "right" way—and they gained rapidly in confidence. The danger of this approach was that they might consider art and craft all too easy and frivolous, but on the other hand such a relaxed attitude opens the channels for the real nature of the material to be apprehended, giving a sound basis for more demanding work. When I came back to the three difficult men who sat together, one of them called me aside into a corner. He pleaded that he really could not bring himself to use the stuff and was most ill-at-ease. I believed that if I could have had a little longer alone with him and the clay, or if I could have started him working in the dark so that he was not self-conscious about results, that he would have got over this miserable stage. But as it was, he must not go on feeling frustrated and influencing the others

by his restlessness. It was essential to restore his confidence, so I proposed that he might make the island on the large side table (a simple but responsible job, and incidentally further away from his jeering companions). He brightened up at this prospect and started at once. Provided with large sheets of paper in brown and blue, he could cover the table as with the sea and roughly build up the island to a central height by boxes under brown paper. He worked there with a good spirit.

The day passed quickly after that. Perhaps an hour before the end we stopped, and as each one finished he came and placed his contribution on the island, disposing them so that they formed coherent groups from every side as one walked round the table. The nuns beamed shyly on seeing their castle perched on the topmost point, and in the next quarter of an hour the island sprouted trees and bushes that quickly became weighed down with birds. Underneath, the animals prowled—very many swine, but also a great variety of other animals in clay, some in wood scraps and cones—and the trees towered over all, waving their feather plumes or long streamers of colored paper. Those who had groped tentatively in the earlier part of the day were now combining unusual materials from the scrap boxes with a cheerful abandon. Even to me, it was exciting to see the empty table burgeon as an island, unskilled it is true, a piecemeal but nevertheless a meaningful whole. Discussing, encouraging, enticing this group to give themselves up to their work, I had been far too busy to notice whether we did in fact have a Circe. I had not wished to apportion the subjects, and so I had made no special provision for her, but when everything else had been settled in its place on the island and the teachers were quite startled to see what they had achieved on their first day, we looked round to see whether anyone had modeled Circe. We had, it then appeared, two Circes, and now they were brought up. (These were the only figures; no one had chosen to do Odysseus or his men.) One had been made by a young, rather pretty girl who had worked so quietly in a corner I had hardly noticed her. Her Circe, in white clay, represented a beautiful young woman with her wavy hair drawn back from her face, a necklace above her very low-necked bodice, a nipped-in waist with a long full skirt. She was very much the

idealized princess type and gave me a slight shock when she was pre-
sented as Circe. Then one of those men who had been most difficult
came up and produced diffidently from behind his back a Circe made
in the last few minutes from the black clay. She was a true witch figure
with a beaked nose almost meeting her bony chin, a tall witch's hat,
and a cloak of black clay falling from her shoulders. He had given her
a twig to hold—a wand or a broomstick? She was a frightening figure,
and when we put the two of them back to back on the topmost point
of the island under the archway created by the nuns, two essential
aspects of woman, the princess and witch images, were there starkly
in front of us. I was filled with that awe that wells up from time to
time in teaching. After working closely with this group for the day, I
would not avoid sharing my feelings with them. Although I had cho-
sen the subject, as I thought, for purely practical reasons, and while
what we had been doing might have seemed like childish play, we had
that day touched depths that sounded the maturity of us all. They
drew up their chairs and stools around the island table, and we found
ourselves discussing how close was the "white Circe" to the princess
phantasy of adolescent girls. Her modeler seemed to accept the com-
ments and joined in the discussion. We argued whether that phantasy
should not be more linked to reality by giving sympathetic attention
to schoolgirls' interest in their own appearance. We talked of how the
teacher's sympathy and appreciation can foster this; of the provision
of a sustaining if critical atmosphere in which to make experiments in
their own make-up and clothes before going out to jobs or college; of
the effect masculine appreciation as well as feminine understanding
has on the dawning realization of womanhood and the advantages
of having mixed staffs for adolescents. The men, now quite talkative,
gave their jocular opinions of women's fashions (including my hat),
and it was taken in good part. Very soon we found ourselves going on
to discuss the darker side of men's idea of women, the witch-like, the
frightening, the transforming or devouring woman—a conception of
woman that lurks somewhere in all men's ideas and the significance
of witch-hunts. Then we spoke of the apparent necessity in all ages of
mankind for this fear to be embodied in a witch-like personage—in
the Gorgon, in Ishtar, seductive and terrible in her rage, and in "La

Belle Dame sans Merci"—and of how the Goddess of Love was also Goddess of Death. Then we discussed precisely what, in fact, Circe had done in spell-binding Odysseus's men, and in what circumstances in our contemporary life men might be said to become swine. This led us on to what Odysseus had done to Circe, and the pain suffered by both men and gods, and the growth of the idea of gods who could suffer, and of the Suffering God.

So, here in one of the least promising groups I ever had to lead, I found we were talking on a level that would have seemed quite impossible to that ill-at-ease and nervously childish group and that diffident and slightly defensive tutor who had met that morning.[3] It dawned on me then, and I put it to them, that we had been freed to meet one another by the power of a symbol, made explicit in the double image of Circe they had produced, and that the possibility of this happening is enormously enhanced when one uses as material the great enduring stories of mankind, the vehicles of our culture.

3. One of my friends who read this account scribbled his own caustic masculine comment: "You of course were Circe. The chap who played about with your hat (and it is a funny hat) was saying that he might be a dunce, but you were a witch. You wove a spell and tamed the wild ones and got them eating out of your hand, but they did not find their true nature until, in the discussion at the end, distinct from but joined in company with women, they were full men again."

VIII

THE TEACHER'S TASK

> Memory should not be called knowledge—Now it appears to
> me that almost any Man may like the Spider spin from his own
> inwards his own airy Citadel—the points of leaves and twigs on
> which the spider begins her work are few, and she fills the air
> with a beautiful circuiting; man should be content with as few
> points to tip with the fine Webb of his Soul and weave a tapestry
> empyrean—full of Symbols for his spiritual eye, of softness for
> his spiritual touch, of space for his wondering of distinctness for
> his Luxury.[...]
>
> It has been an old comparison for our urging on—the Bee
> Hive—however it seems to me that we should rather be the
> flower than the Bee—[...]let us not therefore go hurrying about
> and collecting honey-bee like, buzzing here and there impa-
> tiently from a knowledge of what is to be arrived at: but let us
> open our leaves like a flower and be passive and receptive.
> — KEATS, *Letter to Reynolds*

When we see what surprising things these children, adolescents, and
adults have done with some of the themes offered to them, and how
they raise in our minds echoes from literature or the art of other ages,
it is worth pausing to consider what in fact goes on in an art class.

When we look in on a class where the teacher is suggesting a
subject,[1] what do we see? She presents a "theme" or "idea," either an
incident that the class are to portray, or an object or group of objects
or a human or animal model, which they will observe and either por-
tray or use as a starting point for imaginative work. There is then

1. I am not concerned here with other kinds of lessons, excursions, History
of Painting, etc., which will also be part of the whole course.

discussion, perhaps elaboration of the theme. The children work while the teacher gives individual help and comments. The finished work is "shown" in some form and probably discussed by the teacher or the group. If we just look in casually on a class this might appear to sum it up.

But what is really happening? The law insists that the children attend school rather than pursuing their own concerns; the school probably insists that the pupils attend this particular class whether they want to or not. Even allowing for the freedom of "opting out," as art teachers we use the positive power of suggestion to entice young-sters away from their own concerns of the moment to concentrate on our chosen "subject." We ask them to expose themselves to a stimulus we provide, whether it is an object or an idea, and moreover we ask for a *total* response, not merely an objective statement, or the perfect repetition of an exercise, but for imaginative participation in a situa-tion. Once this is admitted, it becomes apparent that the "subject" we choose must be worthy of their absorption; we must have confidence that the situation into which we plunge them is capable of bearing them up and carrying them to a new synthesis, a new point of rest.

In such a synthesis, past experiences and future anticipations may play their part as well as present sensation and perception. We may aim to direct their attention to one of three aspects of *time*.

In terms of the past, we may ask them to remember something seen, perhaps a strange creature at the zoo, or a familiar domestic scene at home, in which the recall and loving portrayal of simple objects engraves them on their minds. Or we may suggest they look back on the sight of the winter's first fall of snow, with its delicious shock of the familiar world transfigured, that they enter again such a moment and hold it steady in their minds while they capture its quality in shape and color. Barbara's "Wood" (PLATE 6a) was inspired by such a memory, but it must have been modified to its present form by other "mysteries" at which it hints. So we must not ask pupils to portray something pernicious, or too banal to merit their absorption. (If an individual takes the opportunity of a permissive atmosphere to express aggressive feelings or compulsive thoughts, that is different.) Stanley Spencer spoke of the necessity for the artist to see his subject

in a way that would enable him to love it. Yet we may suggest a subject, superficially unattractive but whose implications must be accepted such as a bleached sheep's skull or an industrial landscape, in the hope that appreciation, if not love, will emerge from the attempt to search its crannies and portray it.

Or we may direct their attention to the present moment, to something we have brought, or to a scene from the window, asking that they give themselves up to immediate sensations of texture, form, and color, and to "draw" this object. When we are going to draw something we must open ourselves and go to meet the object with a fresh *perception*—with as few *pre*-conceptions as possible. We must go out of ourselves into it, to get the feel of its life and structure from the inside.[2] Then we take back that object imaginatively into ourselves, as though we were tasting it, biting it, turning it over inside ourselves to assimilate as many aspects of it as possible—but all the time it is still out there existing in its own right—and what emerges when we "draw" is something that is part of us and part of it; either more or less "like" it or "like" us, according to our style. Once having come into such close contact with an object, we can never be quite the same person again, nor do we ever see *it* again as we see other objects. We have a special and intimate relationship with it. This is so strong that even looking at an artist's drawing can do this for us to some extent: we can never visit the Berkshire Downs without seeing the patches of trees as the dense triangular shapes that Nash saw, nor walk down a Cookham street without the instinct to put out our hands to touch with Stanley Spencer's tactile sense.

Or again, we may suggest that our pupils anticipate imaginatively some experience they will have to face later—starting a job, being in hospital, a wedding, all within the safe and stable framework of the classroom. It is, of course, possible to experience only a fragment in anticipation, but to explore one's own reactions in this way is in

2. We may remind ourselves of Keats who wrote that the poet becomes as it were for the time being one of the objects that interest him, since "he is continually in for—and filling some other Body." *The Letters of John Keats,* ed. by H. E Rollins, 2 vols (Cambridge: Cambridge University Press, 1958), 1: 386-7.

some measure to prepare. The teacher's sanction for phantasies and fears helps a little to relate them to reality, and fantasy has a positive part to play in development. It is very generally accepted that for the young child to express his fantasies makes it possible to acknowledge them and bring them into touch with reality.[3] But I think it has not been fully accepted how necessary this is also for adolescents, whether discussion stems from it or not. Many of the models illustrated, and the "mined mountain" described at the end of "The Mine in the Classroom," include this aspect. Apart from events in their lives that they are eager to paint in school, all these experiences we offer in the classroom invite the pupils to imaginative participation. If they do respond deeply and with sufficient technique (partly joined in more pedestrian moments), and with a knowledge of the qualities of their material and of the vocabulary of their art, this intensity of feeling (unhindered by too much concern for these) can raise the whole to the melting point from which it can be resolved into a new form. And as the object was never the same again after we had drawn it, so such an experience is transformed because we have made it part of ourselves. So art is a *way of coming to terms with experience.* Here we are brought face to face with the mystery of the self, which is shaped in the act of shaping material things and created anew in the act of creating.

This is a large claim in the face of the untidy scuffle in the art room, the messy daubs, the misshapen pots, the cliches of adolescent poems, the gaucherie of the school performance of *Romeo and Juliet*! But we are so often looking for the wrong thing—reaching after tangible evidence of our own abilities in good products to exhibit. We must have faith in our own experience that art does recreate; and we can only have our faith renewed by making recurring opportunities for our personal re-experience of this.

When the stimulus we provide or some event outside school *does* startle into this new awareness, how can we enable our pupils

3. One of the important contributions in this field was Ruth Griffith's *A Study of Imagination in Early Childhood and its Function in Mental Development* (London: Kegan Paul, Trench, Trubner, 1935).

to experience fully such heightened moments and to grow through them? It is the relationship that has been built up over the previous weeks or years that will count, a relationship not based on the teacher's greater knowledge or the child's immaturity but on the respect of one human being for another. We must create the atmosphere in which the pupil can savor such moments, can take them into himself, and be taken by them into something outside himself. We must accept whatever emerges in sincerity, even if it seems a crude cliché (a cliché *to us*), or a vulgar exaggeration (*to us*). We have to accept the sexual as well as the spiritual aspirations of adolescence. This is no passive acceptance of whatever comes. We have to search, so far as we are able, for the next experience, the further challenge that might be right for this boy or girl. I make no apology for veering in this study from a consideration of the effect of *creating* on the growing personality to that of *appreciating* works of art. The products are not comparable, but the *experiences* interweave at many points and enrich one another.

INTERLUDE

ON LABYRINTHS

Here follows an account of an investigation into labyrinths to which Margaret's original model, and the excitement generated by the mine in the classroom, had enticed me. This led me to make a journey to Crete as the earliest spring of European culture, which proved to be a journey even further.

Some readers may wish to omit this historical and anthropological matter and to go on to "The Visit to a Coal Mine" that echoed the labyrinth theme.

Trying to unweave, unwind, unravel
And piece together the past and the future.
—T.S. ELIOT, *The Dry Salvages*

In an earlier interlude I told how Margaret's model had led me to study the history of rosegardens. Sufficient of the recurring elements of the rosegarden theme, the walls, the narrow entrance, the roses, the foundations, and this central object (which began as a mound and was elaborated with pear-like appendages near the top) occurred in Margaret's "rosegarden" to link it unconsciously on her part of course with the historic garden image of which I have given some account. But it did differ in one important particular. Most of the gardens, actual and ideal, had a four-square or rectangular plan and, though the way in might be narrow, it was not often, as here, indirect. I peered again at the photograph (the material proof that I was not imagining the whole thing) and sketched the plan shape as I remembered it. It had a vaguely anatomical shape, I thought, but why had she taken the trouble to make two entrances at opposite ends? I looked up my notes

FIGURE 2 Plan of Margaret's model

of her words, and remembered Margaret tracing the path between the walls with her finger saying, "You come in here but you can't get into the garden. You have to come round that way, to the entrance at the opposite end." I was tantalized by the feeling that I could not understand what was there in front of me. I felt in a daze, in a maze— in a maze, that was it! Suddenly I saw that this shape was an incipient labyrinth, an extremely simple one, it is true, but one with the essentials where the seeker is deliberately made to trace an intricate path in order to get to the heart of the matter.[1] I saw that this was in fact what I myself had been tracing at intervals over many years now, and I had not yet reached the center. Why should a little girl of twelve put a labyrinth around a rosegarden? Obviously I must start to learn something about labyrinths.

I could remember two references to the labyrinth from classical authors, in the *Iliad* and the *Aeneid*. When Achilles finally decided to stop sulking and join the fight for Troy, Hephaestus forged armor for him at the behest of his mother, Thetis of the Long Robe. About the shield of Achilles (the shield, a weapon of protection) among other scenes Homer says, "the god cleverly depicted a dancing-floor, like the one designed in the spacious town of Cnossos, for lovely-haired Ariadne. Youths and marriageable maidens were dancing there[...]. They circled lightly round on accomplished feet, like the wheel which fits neatly in a potter's hand when he sits down and tests it to see if it will spin."[2]

In Book VI of the *Aeneid* (which, when I left school, I slammed shut), Aeneas, when he sails from Troy, comes eventually to the Western land where the portal to the underworld is located at Cumae in Southern Italy, and he stops to ponder on the labyrinth traced on one of the portals of the Sibyl's temple:

> Daedalus, for this is the story, when he was in flight from the tyranny of Minos, adventured his life in the sky on swooping wings

1. When I showed the photograph to Rudolf Laban without comment, he immediately recognized this and called it an "embryo labyrinth."

2. Homer, *The Iliad*, trans. E.V. Rieu, Peter Jones, and D.C.H. Rieu (London: Penguin, 2003), 335.

and glided away towards the chill north by tracks unknown. At
last he hovered lightly above the Euboean stronghold. In these
lands he first found refuge, and straightway consecrated his oar-
age of wings to Phoebus Apollo, for whom he founded a gigantic
temple. On the temple-gate he pictured [...] the Athenians obey-
ing the ghastly command to surrender seven of their stalwart
sons as annual reparation; and there was the urn from which
the lots had been drawn. The island on which Cnossos stands
rising high above the sea, balanced the scene on the other leaf of
the gate. [...] Here was the Cretan building in all its elaboration,
with the wandering track which might not be unraveled.[3]

This description of the labyrinth on the gates of the Underworld is
seen by some as a parallel to Aeneas's quest, by some others as a sym-
bol of entry to Hades.

These gates guarded the temple of the Sibyl—to me a strange and
shadowy figure of infinite age—and they led to the world of the dead.
Why should they depict a maze? I had read that Henry II hid his
Fair Rosamond in the maze at Woodstock. I knew the hedge maze
at Hampton Court and the simpler turf mazes in which boys used to
chase girls near English villages, but my only experience of anything
reminiscent of a real labyrinth was crawling with a candle through
an ancient tomb chamber in Guernsey to peer at scratched draw-
ings— as primitive as an infant's—of that Mother Goddess who was
still worshipped there, I was told, when the Romans came. I remem-
bered too that I had walked to the highest point of the island where
a menhir with worn protuberances of breasts had been set up after it
was discovered under the chancel of the little church there. (So who-
ever she was, she was powerful enough to be feared by the first Chris-
tians. They had to build a church over her to keep her down.) That was
the very year the war ended, and my restricted holiday had gained
interest by following any hints of her I found about the island, until
I began to think I had her too much on my mind. Walking to church
on Easter Sunday (day of rebirth and resurrection), I suddenly saw her
unmistakably before my eyes. The post of the local church gate, which

3. Virgil, *The Aeneid,* trans. W. F. Jackson Knight (London: Penguin, 1958),
147.

I had passed unnoticed many times, was a huge slab of stone on which some trick of the Easter light now threw into relief her necklace and a suggestion of features—vague but too like her authentic sister-stone on the island top to be mistaken. I thought for twenty-four hours that I had made a real discovery, but when, on Monday morning, I joined the island's archaeological society in order to consult their records, I found that this stone was known to English archaeologists—but that protestations about hanging the church gate on an ancient monument had been in vain. (So she was still feared; she had to be debased to a gatepost to persuade the villagers that her power was past.) When I enquired about the stone, the farmer's wife with whom I lodged told me that it was indeed "very very old," and that flowers were often hung around it and offerings of pennies put in the hollow of the head, but that "no one in the village would ever confess to having done so!" (Cf. FIGURES 4*a* and 5*a*.)

So a goddess had been worshipped here before the Romans came with their masculine civilization of Jove, before the Christians with their God the Father and God the Son.

I had hardly thought previously how the notion of godhead had risen in human minds, not why God should be assumed to be masculine. I knew the marvelous animal paintings in the caves of France and Spain and, picturing a brutish society concentrated on hunting to survive at all, I had presumed that men would have had no time for numinous speculations, and that religious ideas would have arisen comparatively late in human history. I thought I might best understand their ideas by what they shaped in clay, or stone, materials that stride the barriers of language. So I began to go to museums to look for representations of early gods and goddesses.

The museums were still all disorganized by the war, and objects not properly labeled, which slowed up my amateur investigation. But I worked my way back through the Bronze Age to Neolithic figures, which ranged from the representational clay models of squatting women to the cold abstract fiddle-figures from the Cyclades. At first I thought it was far-fetched to label these "women." I decided to make drawings of all the intermediate stages from different museums until I found that I had a complete range from the most realistic to the most abstract. I think I was almost as excited as the archaeologist who first

discovered it, when my drawings laid out in order convinced me that these fiddle figures were indeed the traditional goddess.[4]

I had expected by an analogy with the animal paintings that figurines would be more photographically realistic the further back one went to Paleolithic times, or else that they would be formless lumps of clay or stone through which human forms gradually emerged. But I was delighted and awed to find that, from very early times, these conceptions of divinity in the person of a fertility goddess had embodied a sense of formal relations.

a b c

d e f (front and side)

FIGURE 3 Paleolithic goddesses from Willendorf, Austria (*a*); from Mentone,
Italian Rivera (*b-d*); from Siberia (*e*); from Lespugue, France (*f*).
All are only a few inches high

4. Johannes Maringer's *The Gods of Prehistoric Man*, trans. Mary Ilford (London: Phoenix Press, 2002) and Edwin O. James's *The Cult of the Mother Goddess: An Archaeological and Documentary Study* (New York: Frederick A. Praeger, 1959) were not at this time published, and a conventional art training had introduced me only to cave paintings as Stone-Age art.

I got immense pleasure from making museum studies of these little figures, thinking to penetrate the secret of the thought of early men by an accumulation of evidence in paint and pencil. I began to plan my holidays to take me near towns with museums—travel abroad was still difficult—and once I chose Oxfordshire so that I could visit the Ashmolean. Disregarding all its other treasures I made for a glass case of primitive figures, and among all the hundred odd, almost jostling each other, one caught my eye as though it had rung a note that I of all the indifferent crowd could hear. Three inches high, of sandy clay, a heavy-breasted little figure held a child, which was not more than a pinched blob of clay, crooked in her arm. I did not know from what part of the world she came, nor from what period. I did not know why her nose was like a bird. Was this intentional or from the act of pressing it out between finger and thumb? I did not know why, wearing nothing else, she should wear a necklace.[5] But I found myself infinitely moved by the extreme simplicity and tenderness expressed in her primitive form through this common material. All the sounds of the gallery died away. I forgot my knapsack of paints and my weary legs. I became all eyes, only eyes to follow the modeled curves and hollows of her shape. I mentally fitted my fingers into the fingerprints of her maker—still as fresh as if they had been made an hour ago instead of five thousand years. I almost felt that those fingers were my fingers, and in so far as the modeler was the mother she modeled, so was I.

The attendant, thinking I was literally deaf, tugged my sleeve and thrust his watch importunately before my eyes. As I walked out dazed, I realized that it was more important to me than anything else at that

5. This strange circumstance is widespread, and I have not yet discovered the answer. The Persian goddess Ishtar had to take off her necklace to meet her lover on the river. Necklace might be transposed for girdle, but even much later we find the unknotting of a virgin girdle openly referred to, so why the transposition? Briffault refers to an Indian people who believe that her soul resides in a woman's necklace, and she must not take it off. Robert Briffault, *The Mothers: The Matriarchal Theory of Social Origins* (New York: Macmillan Company, 1931). This question has remained strangely unexplored by anthropologists.

FIGURE 4 Later forms of the goddess showing Neolithic abstractions from the earlier forms; with emphasis on eyes, necklace, breasts, underlining the prospective aspect rather than fecundity. Stone menhir, Iberia (*a*); bone from Iberia (*b-c*); clay jug handle from Mesopotamia (*d*); clay from the Eastern Mediterranean (*e*); bone from Bulgaria (*f*). Not to scale

moment to find out more about these early figurines. I knew that there must be authorities, but I was so ignorant that I did not know which books to read. It was hard to know whether these were dolls, or idols, or concubine-substitutes buried in graves.

I haunted the museums still hoping that the secret lay with the objects themselves. I plucked up my courage and penetrated the fastness of the inner and beyond-inner rooms of the British Museum, and was passed from one puzzled underkeeper to another until I finally reached an aged and parchment-thin professor, to whom I naively blurted out my fascination with some primitive Indus valley figurines I had just seen.

"Are you referring," he sighed, in a voice as dry as the dust that surrounded him, "to the dubiously authentic funerary prototypes of the supposedly stylistically comparable tutelary figurines, characterized by marked steatopygous regions, recorded as occurring concurrently with the multilateral or trapezoid brattices in the subferruginous layers of the cylindrical seal deposit of Mohenjo-daro, indicating the derivative iconography of their eventual antecedents of the third millennium?" I could only murmur an abashed apology and back out. I must speak the language in order to be able to learn from such people. I spent precious hours following the arguments of scholars in obscure journals, whose language defeated me, without any clear idea of what they were about. I read avidly, without guidance or discrimination, and still fascinated, got more involved and confused. It was, I remember, in the rather abstruse scholarly volume presented to Evans on his seventieth birthday that I first recognized the voices that spoke with authority, and this led me to the obvious sources, to the Palace of Minos, and later to Gertrude Levy. Here I found the answers to so many of my questions: why the early figures were nearly all women, why the Neolithic and Bronze-Age goddesses held their heads high and often nursed a child while the older Paleolithic figures were pregnant women with no features, no personality.

I began to get a total picture of that Great Goddess who, as a symbol of the miracle of fertility, seems to have been man's early conception of a divinity. From somewhere on the steppes her worship and her image must have spread to India, where her cow incarnation is still sacred;

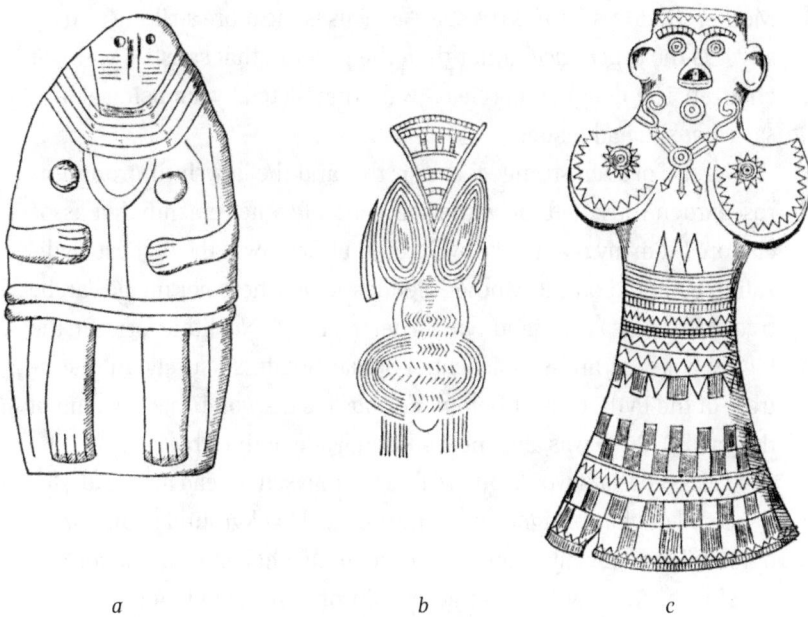

a b c

FIGURE 5 Abstractions from the form of the goddess. Stone relief on menhir,
Saint-Sernin, France (*a*); scratched stone, Czechoslovakia (*b*); clay
"bell figure" from the Danube river (*c*). Rosettes were used to designate
either eyes or breasts. Not to scale

to Mesopotamia where later we find her as Ishtar, the horned-moon
goddess; to Egypt where she anticipates the Mater Dolorosa as Isis
(nursing her son Horus, the reincarnation of him who died overcom-
ing evil and whose body was found in a tree); and to Greece where
in the Demeter-Persephone image she keeps her fertility character
as goddess of earth, corn, the Underworld, and the rebirth of spring.
Gradually evolving in the distinctive goddesses of the Greek Pan-
theon, she mirrors the increasing complexity and rationalization of
religious thought.

It was about this time that a little girl of eleven in my class took
off her eye-covering after a blindfold modeling session and ran to
me with a clay shape apparently as evocative but as little defined as
Margaret's "rosegarden." "Isn't it lovely," she crooned, stroking her
model as she put it in my cupped hands, I don't know what it is, but
isn't it lovely?" I might not have known a few months earlier what it
was, but irresistibly it provokes comparison with one of the Stone-Age

Mother-Goddess figures (PLATE 25d). This is the more striking as usu-
ally it is the *experience* rather than the product that satisfies younger
children. Her delight and release were unaffected by not being able to
say what she had made.

The use of such strange forms as this and the labyrinth-around-a-
rosegarden intrigued me with their echo of some remembered asso-
ciation. From my reading I now knew that Crete was the highest civili-
zation centered on the Mother-Goddess cult, where her image can be
traced through a thousand years from the rough Neolithic forms to the
highly polished and sophisticated Snake Goddess—surely an ances-
tress of the Pythoness of Delphi (*delphos* means womb, here "womb of
the earth"). Crete was also the traditional site of the labyrinth.

I resolved that I would go to Crete,[6] set myself to read and study, for
I was still deplorably ignorant of the general background of archaeol-
ogy. I seldom saw my friends. I "scorned delights and lived laborious
days" until the day I set off across Europe in my old camping van.
Ravenna, whose mosaics provoked reassessment of some children's
work discussed later, the Black Madonna of Puglia, the sight of horse-
less Ithaca, and the procession of ikons on Good Friday, which was my
first landfall on the Greek mainland, all contributed to this study, but
my objective lay further back than Athene's city, beyond even the Lion
Gate. (From close parallels in Asia Minor it is argued that the gate at
Mycenae would once have borne the Great Goddess's image standing
on the Tree of Life between the lions.)[7]

One evening, when Hymettus was as romantically purple as the
underside of the grapes that used to grow on its now stoney slopes,
a friend and I went down to Piraeus and, like the peasants around
us, spread our blanket to lay claim to a few square feet of deck and
cooked our supper to the notes of the three-stringed lyre.

6. My studies of the variations of the goddess's form in museums of this
country brought me a small grant from the Educational Research Founda-
tion to enable me to make this journey. My gratitude strengthens the impulse
to write down this record.

7. The aspect of the goddess's relationship to animals is discussed in
chap. 5 of E. O. James, *Cult of the Mother Goddess.*

As the sun dropped towards the pillars of Hercules and our gray Atlantic, I marveled to see that Homer's sea is "wine-dark" and opened the *Odyssey* again:

> Out in the wine-dark sea there lies a land called Crete, a rich
> and lovely sea-girt land.[8]

I am no scholar, and if I indulge in a purple patch to respond to such a moment, perhaps it is because I came only in middle age, when life tends to narrow in, to this tremendous widening of horizons that some glimpse of our Greek and pre-Greek inheritance means. I had been reading Greek drama, studying the evolution of the theater, soaking myself in Minoan art, above all, poring over the plans of Knossos so that, unconfused in space, I might better be able to take that imaginative leap in time. That evening, sailing past Aegina, gazing towards Troezen (where Theseus was begotten when Poseidon waded dripping to a husbandless girl), I gave myself up to the magic of the moment, I thought how Theseus must have felt, watching the whiteness of the Acropolis fade into indigo Hymettus as it was fading that night. On his triumphant return, his old father Aegus would have been watching up there for the white sail that Theseus had promised to hoist and, seeing it all black, had thrown himself down from the citadel in despair. With what a taut power to move us do these old epics speak across the centuries. They are as shaped and perfected as the wine jars still redolent of ancient vintages, while the cheaper pigskins expose their contents to the buffets of time and allow feeling to seep away until there is left only the dregs.

The next morning, sailing along the coast of Crete, I saw Mount Dikti where tradition says great Zeus was born who was to substitute the Father-God for the Mother and bring patrilinear organization, the light of logic, and the thunderbolts of war to that matriarchal, magic-ringed island, girdled by dolphin-haunted seas—and so to all Europeans. I did not regret my nights of study and days of hard travel, for Knossos holds so many mysteries and repays even a superficial searching.

8. Homer, *The Odyssey*, 252.

FIGURE 6 (a) Steatite plaque, Egyptian. Deedes writes: "The two figures can only be
the king-god and perhaps his royal consort united in a ritual scene. It is
possible that this scene is intended to represent the sacred marriage";
(b) Labyrinth on an Early Minoan seal from Hagia Triada, Crete; (c) Seal
of black steatite, with a loop for holding by, showing a spiral with four
buds. Middle Minoan

Scholars are still in doubt whether Knossos fell to an invading army
of Acheans, in a bull-roaring earthquake, or lost her impregnable sea
girdle of naval power. But how rightly is Crete's overthrow fabled as
the conquest of Ariadne by a young lover and how poignantly she
brought about the downfall of her own kingdom by proffering the
secret she was bound to guard, the dark mysteries of the labyrinth.
For Ariadne was the priestess of the cult of the Great Mother, and to
bring fertility to her island she had to celebrate the Hieros Gamos, the
Sacred Marriage. Perhaps if Theseus did not come she had to submit
to her brother—as did the Egyptian queens—but he was the Mino-
taur that dark monster bull-engendered on her mother Pasiphae the
Moon Goddess incarnate, when she put on the trappings of a horned
cow made for her by Daedalus.

Why do Cretan coins with the labyrinth design often show at its
center not the Minotaur but a rose, a crescent moon (sign of a vir-
gin goddess), or the goddess herself? Perhaps the Minotaur—whether
monster or bull-masked prince—made his way to the center of the
labyrinth to celebrate love and instead found death at the hands of
Theseus? That would be true to the traditions of the Great Mother
as Goddess of Death, figured in the Etruscan urns, with her mark on
the cave burial places across Europe since Aurignacian times and her
scratched image so near home as that Guernsey dolmen.

In all the pre-history of the Near East, Egypt and the Mediterra-
nean lands there is found her pregnant image (holding a bison's horn

at Laussel, "the horn through whose point, in later religious cults, the creative force of the beast was thought to be expelled"[9]). It is associated with caves, with winding paths, with cow horns, with a knot[10] (derived from the looped fastening of her cow-byre), which is her symbol as

FIGURE 7 Knossian coins of the type that preserved the labyrinth motif and legend into Greek times, one with a crescent moon at the center (*a*), the other with a rosette that had been the emblem of royalty in Egypt (*b*). Deedes states that the latter has the minotaur on the reverse side; for comparison, seals from Lerma (Greece), a Helladic site (*c* and *d*)

Goddess of the Gate of the Sanctuary that is conceived as her body ("He the Lamb and I the Fold"[11]). It is seen with a sacred, often milk-

9. Gertrude Rachel Levy, *The Gate of Horn: A Study of the Religious Conceptions of the Stone Age, and Their Influence Upon European Thought* (London: Faber and Faber, 1946), 59.

10. Thomas Hill, in *A most briefe and pleasaunt treatyse, teachynge howe to dress, sowe, and set a garden* (London: T. Marshe, 1563), refers to Masses or Knots, and says, "In the middle of it [the Maze] a proper Herber decked with Roses or else some fake tree of rosemary."

11. Levy, *The Gate of Horn*, 100.

yielding tree, and with the moon (to whose rhythms woman today are subject as ever).[12]

FIGURE 8 Knossian coins with a square labyrinth and the same form converted into a round. The square is related to the Greek key pattern, which retained a magical significance (*a*), while the round form was carried West by Bronze Age settlers (*b*); for comparison, Layard's diagrams representing the female Guardian Ghost who is herself the path beyond the grave (*c*), and sand tracing of labyrinth Journey of the Dead, Malekula (*d*)

Of the Cretan labyrinth Gertrude Levy writes, "Only Theseus penetrated to the centre, to 'discover' Ariadne[...], with the help of her own clue, her knot or Key of Life, and lost her again, as such a Goddess is always lost, in return to the outer world.[13] But he set up her image in

12. Robert W. Cruttwell, in *Virgil's Mind at Work: An Analysis of the Symbolism of the Aeneid* (Oxford: Basil Blackwell, 1947), traces these double images of the *Aeneid*: Cybele (Great Mother of the Gods) and Venus, shield and maze, urn and house, tomb and womb.

13. Probably Ariadne, being a princess and priestess, could not leave her homeland, or she would lose her lands, which would wilt without her revitalizing ritual.

Delos, and taught the rescued boys and maidens to dance before its horned altar the inward and outward windings of the labyrinth, singing the story as they moved."[14] Whereas the chorus and actors in the ancient world were men, ritual dancers were women, and this is the first record of men and women dancing together. Here we see the true genesis of a rite, and this maze dance was performed by the inhabitants of Delos for centuries. Evans records[15] a similar winding dance in Crete in 1930, which was danced *before a wedding.*

These old stories are like Evans's partial reconstruction of the Palace of Minos. You can walk up a solid gypsum-faced stair with broad steps, then suddenly it ends—your next step is in the air. Sitting on such a topmost step of the Minoan Palace one moonlight night the question teased me: why, since the labyrinth is constantly associated with Crete by Homer, by Plutarch, by classical historians and popular tradition (which surely only survives if it fulfills a need), was no labyrinth to be found in Crete? Graves tells us that "an open space in front of the palace was occupied by a dance floor with a maze pattern used to guide performers of an erotic spring dance."[16] No trace of it can be seen now, but the labyrinth idea persists when its prototype has disappeared.

Among the many forms that have come down to us as labyrinths, are the original Egyptian labyrinth mentioned by Herodotus, the dance associated with the death and rebirth of Osiris,[17] the dance of Theseus and his companions on Delos,[18] the "troy-games" performed

14. Levy, *The Gate of Horn,* 248.

15. Sir Arthur Evans, *The Palace of Minos: A Comparative Account of the Successive Stages of the Early Cretan Civilization As Illustrated by the Discoveries at Knossos,* vol. 3 (London: Macmillan, 1930), 76.

16. Robert Graves, *The Greek Myths* (London: Penguin, 1992), 345-46.

17. C. N. Deedes, "The Labyrinth," in *The Labyrinth; Further Studies in the Relation Between Myth and Ritual on the Ancient World,* ed. S. H. Hooke (London: Society for Promoting Christian Knowledge; New York: Macmillan, 1935).

18. "Theseus, in his return from Crete, put in at Delos, and having sacrificed to Apollo, and dedicated a statue of Venus, which he received from Ariadne, he joined with the young men in a dance, which the Delians are said to practice at this day. It consists in an imitation of the mazes and outlets of the labyrinth, and, with various involutions and evolutions, is performed in

by Iulus and his companions at the funeral of old Anchises soon after Aeneas's landing in Italy, patterns on Etruscan urns, English grass mazes called "troy-towns," Bronze-Age carvings found incised on rocks from the Aegean to Ireland, Roman floor mosaics preserved in several European towns,[19] the mosaics set into the floors of medieval churches,[20] which were trodden on their knees by penitents as "the road to Jerusalem" (the one at Chartres has a rose at its center!) The Cretan Labyrinth with high walls is pictured in the Renaissance Picture Chronicle attributed to Baldini of Florence, but probably derived from much older sources. We cannot be sure of the basic pattern of the dances except that they spiraled and wound in and out,[21] though we may have a hint in the suggestion that the Celtic interlacing ornament patterns are the plans of dances. But at least the last five examples I have given, and many others, share a clear and precise common plan, which is found on certain Minoan coins and seals. It is centered on a cross, and the path consists of only one passage winding and doubling back and forward until it wheels into the center. The key to its drawing is easily memorized as the cross with a quarter circle in its corners, and it can be drawn by numbering these points and joining them up in a certain order. It is so clear, so simple, and so intelligently worked out that one feels it is the product of man's intellect, working on an earlier accidental, confused, and haphazard path, which the ideas usually associated with "labyrinthine" lead one to expect. It is as though the human mind insisted on a pattern, even from confusion itself! This labyrinth form, and the rituals associated with it, were brought from the eastern Mediterranean (most likely originally from Troy) to Britain by Bronze age voyagers, and the shape in its pure form as here shown, incised into rock faces, can be traced up the western coast of Spain, in France, in Ireland, in Wales,[22] and in one recently

regular time." *Plutarch's Lives,* trans. John Langhorne and William Langhorne (Baltimore: William and Joseph Neal, 1831), 6.

19. Such as Frankfurt.

20. Such as Piacenza, San Vitale, Ravenna, Lucca, and Pavia.

21. In *The Palace of Minos,* Evans illustrates a clay model of a ring dance with a dove from the late Minoan period, 3:72.

22. At Bryn Celli Ddu.

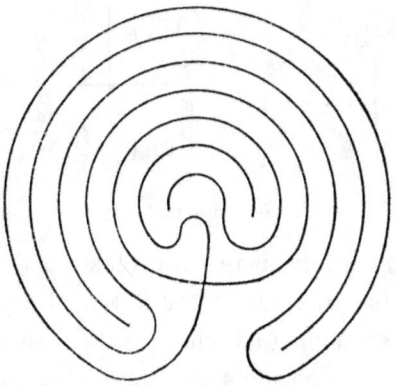

FIG. 9 Plan of the Cretan labyrinth

found perfect example in a river valley leading into Cornwall.[23] But it was carried even further, for it is found in maze figures laid in stones (sometimes white pebbles, sometimes huge boulders) on the islands in the Baltic, in Finland, Lapland, and Iceland.[24] It is called "Jungfru-dans" (Maiden's Dance) or "Ruins of Jerusalem," but most frequently some name akin to Troy-town, e.g., Trögeborg on Wisby island.[25]

As a craftsman I had always suspected that the patterns with which ancient peoples covered their objects of common as well as ritual use were probably much more than "mere decoration," and I had myself found that some hint of potency lasted on in peasants' use of traditional patterns even when the meaning was lost.[26] Here was

23. At Bossinney.

24. Since 2000 BC the Baltic area supplied Egypt and Crete with amber by the Danube route. During this time Troy was the center of distribution to Egypt and Asia Minor.

25. W. H. Matthews, *Mazes and Labyrinths: A General Account of their History and Developments* (London and New York: Longmans, Green and Co., 1922). W. F. Jackson Knight points out that Troy is associated with a root meaning "to turn" or "move actively," and that we may suppose that "Homer's Troy and all the other Troys were called after the word used for mazes and labyrinths. Troy was called Troy because it had some quality of a maze." *Cumaean Gates: A Reference of the Sixth Aeneid to the Initiation Pattern* (London: Blackwell, 1936), 113.

26. I gave an account of the peacock motif in Sicily in "The Sicilian Car-retto," in Seonaid Mairi Robertson, *Craft and Contemporary Culture* (London:

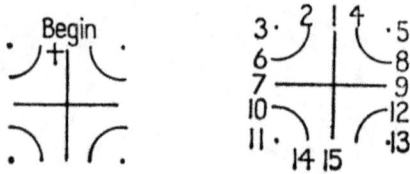

FIGURE 10 Key to plan

an explanation far beyond mere conservatism, of the persistence of a certain range of patterns of the spiral and Greek key type.[27] Children often produced something like these in their work, but that could be explained by their having seen patterns that are still used. The vitality sensed by the peasants in them is surely linked to the power they sometimes have to excite and satisfy children. But Margaret's "rosegarden" was provocative in its juxtaposition of garden *and* labyrinth. Most of the associations I now had with labyrinths, however, on burial places, round urns, in dances commemorating deaths, in addition to the original killing of the Minotaur himself, were associations with *death.* This did not seem to fit in to the mood of Margaret at all. What was the underlying *meaning* of the symbol of the labyrinth that resulted in its being used in these settings? And why had an adolescent, Iulus, led the ride at the funeral games of Anchises that Virgil described thus:

> The riders now moved in gay procession past the whole seated gathering in full view of their kindred.[...] They say that once upon a time the Labyrinth in mountainous Crete contained a path, twining between walls which barred the view, with a treacherous uncertainty in its thousand ways, so that its baffling plan[...] would foil the trail of any guiding clues. By just such a course the sons of the Trojans knotted their paths[...]. Much later[...] Ascanius inaugurated a revival of the Trojan Ride with its mock-battle, and taught the early Latins to celebrate it just as he had celebrated it in his youth[...]. Rome in her grandeur inherited it and preserved the ancestral rite.[28]

G.G. Harrap. 1961).

27. The Spiral and Key patterns are discussed by Jane Harrison in *Themis: A Study of the Social Origins of Greek Religion* (Cambridge: At the University Press, 1912).

28. Virgil, *The Aeneid,* 137.

Another curious tradition links Theseus with the labyrinth cult at Troy. His son, Hippolytus, was priest there, and "every maiden before marriage shears a lock of her hair for Hippolytos, takes the shorn lock and dedicates it in the temple."[29] The shorn lock was a substitute for her virginity, for originally a maiden could not marry in Babylon before she had surrendered herself to a passing stranger within the precincts of the Temple of Ishtar.[30] In Troy this was the prerogative of the priest-king, and C.N. Deedes suggests: "It is probable that the Athenian maidens sacrificed not their lives but their virginity to the Minotaur."[31]

But why were the mazes of England called "troy-towns"? Why did the traditional games played in them involve capturing a young girl, and why specially at Easter?[32]

Hampered by rusty Latin and no Greek I got tangled in the reading to which my visit to Crete had spurred me. This knot was unraveled for me by W.F. Jackson Knight's *Cumaean Gates* (those same gates to the Sybil's temple in the *Aeneid,* which had been my earliest memory of the labyrinth idea).

This fascinating study of the labyrinth theme relates maze myths from many parts of the world. The author shows that even in societies so widely separated geographically and in time as the Homeric

29. Harrison, *Themis,* 337.

30. E.S. Hartland, "The Kite at the Temple of Mylitta, in *Anthropological Essays Presented to Edward Burnett Tylor in Honour of his Seventy-Fifth Birthday, October 2, 1907* (Oxford: Clarendon Press, 1907). Jessie Weston refers to the curious practice during the festival of Adonis of "cutting off their hair in honour of the god; women who hesitated to make this sacrifice must offer themselves to strangers, either in the temple, or in the market-place, the gold received as the price of their favours being offered to the goddess. This obligation only lasted for one day." Jessie L. Weston, *From Ritual to Romance* (London: Cambridge University Press, 1920), 48. She points out that Mannhardt suggests "that the women here represent the goddess, the stranger, the risen Adonis" (ibid., n.24).

31. Deedes, "The Labyrinth," 37.

32. In Shakespeare's *A Midsummer Night's Dream* Titania, echoing the Sacred Marriage theme, laments: "And the quaint mazes in the wanton green / For lack of tread are indistinguishable" (Act 2, Scene 1).

Greeks and the islanders of the New Hebrides today, this myth can be linked by intermediate forms, especially by the elements these two share with the Sumerian Epic of Gilgamesh. There is a strong link between the journey-of-the-dead beliefs of the islanders and Book VI of the *Aeneid,* in that they share a belief that the dead cross the sea westwards, that they enter the earth by means of a cave—and the tracing of a labyrinth is featured here—that water is crossed beyond the cave with the help of a pole or bough from a certain tree, beyond which is open country where the dead have peace; and that all this is known because someone in search of an ancestor dared this journey and returned to tell it.

He also establishes the fact that a labyrinth has a double purpose, to *exclude,* to protect a sacred place (Margaret said, "You can't get in") and to *admit* those who may come in on the condition of having accomplished a devious route. In fact, the labyrinth is the symbol of *conditional entry,* used tactically in the protection of towns and fortresses such as Maiden Castle in Dorset but also magically to protect—in many senses—from those who did not know the secret.[33]

One of the examples the author gives is the Etruscan Tragliatella vase. It shows two horsemen apparently riding out from a labyrinth—which is pictured clearly and is of the exact Cretan type (FIGURES 6 and 9)—close to two pairs of figures in physical union that may typify the Sacred Marriage. This is conjectural, but there are Babylonian seals and an Egyptian plaque that seem to show the same scene surrounded by a labyrinth. The Sacred Marriage, which protects life by ensuring fertility, must itself be protected from evil influences, and its benefits must be protected for those who share the mystery—in fact entry is here conditional in every aspect.

So the tracing of a labyrinth is the weaving of a protective spell; Achilles rode three times round the body of his friend Patroclus in a rite of protection, just as he dragged Hector's body three times round

33. The tangled-thread pattern with which Scottish women decorate their doorsteps with white chalk seems a far echo of this, and Indian women do pattern their doorways with a maze pattern, which their husbands must tread before entering.

Troy *unwinding* its protective spell, (exorcizing it, presumably widder-shins, or anti-clockwise). We find it in the winding of witches spells, e.g., in *Macbeth*, and also in Coleridge's

> Weave a circle round him thrice.
> And close your eyes with holy dread:
> For he on honey-dew hath fed,
> And drunk the milk of Paradise.[34]

Some scholars associate the labyrinth with snakes—and the Mother-Goddess as Snake Goddess is, of course, the deity of Knossos—and others derive the mazy dance from the fact that Egyptian kinds were disemboweled for mummifying, and the ministrants, carrying away the entrails in canopic jars, were said to perform a winding entrails dance.[35] But if different threads wind in and out, it is not surprising, for we are dealing with a very old mystery. The parallel beliefs from modern inhabitants of the New Hebrides associate the labyrinth with two phases of life, death (where their labyrinth has to be completed by the ghost if rebirth is to follow), and initiation at puberty.[36]

W. F. Jackson Knight's theories would certainly explain many things sharing the labyrinth motif that have been difficult to relate before: Egyptian tombs, Etruscan burial urns, and cave tombs all sharing the hope of rebirth; the winding ride of the boys at Anchises; funeral games; the penance paths in the floors of churches to be traced on the knees as a condition of absolution—which is a kind of rebirth; the labyrinthine dance on Delos with which Theseus and his companions celebrated their escape from almost certain death and which was therefore almost a rebirth. Rites of passage or threshold rites are commonly practiced at points of life's transitions: birth, initiation, marriage, death.

34. S.T. Coleridge, Kubla Khan," in *Christabel: Kubla Khan: a Vision; The Pains of Sleep* (London: John Murray, 1816), 58.

35. Babylonian tablets connected with entrails divination show patterns in the form of a spiral form maze. Illustrated in Knight, *Cumaean Gates,* 116.

36. John Layard, *Stone Men of Malekula Vao* (London: Chatto & Windus, 1942).

But the author makes clear that the essence of the labyrinth motif is *initiation*; it is a rite performed, built, carved, painted, or danced to mark and magically to protect the transition from one state to another. The word initiation comes from *inire*, to enter, in the sense of "to enter the earth," originally literally a cave, or one of those holy lustral pits still to be seen at Knossos, where one entered the body of Mother Earth herself, to be purified and renew protection by contact with her.

By primitive and highly civilized peoples alike initiation has been regarded as a rebirth.

In the initiation rites of Attis, the future worshipper must "die and be reborn." First, through fasting he removes the impurity from his body; second, he eats and drinks from the Sacra; third, he goes down into the pit, and the blood of a sacrificed bull is poured over him; fourth, he comes out of the pit bloody from head to foot; fifth, during several days he is fed only on milk like a newborn child.[37] In the celebration of the initiates, "the first and most important point was a Mystic Meal, at which the food partaken of was served in the sacred vessels, the tympanum and the cymbals.[...]the food thus partaken of was a Food of Life—'the devotees of Attis believed, in fact, that they were eating a magic food of life from the sacred vessels of their cult.'"[38]

The initiation into the Eleusinian Mysteries included a voyage through a hall divided into dark compartments (a formal representation of earlier cave mysteries?); the climbing of a staircase and arrival in bright regions; the displaying of the Sacra and the representation of Kore's (the Spring maiden's) rising.[39]

37. Originally, these rites must have had a direct physical meaning; the neophyte emerged covered with blood as a child from his mother's body. Initiation as a kind of death and rebirth is widespread and well-documented among the Australian tribes, and there are other accounts of initiates putting over themselves the mother's skirt, or being covered with red ochre, being bathed, and other echoes of birth in rebirth.

38. Weston, *From Ritual to Romance,* 146.

39. C. G. Jung and C. Kerényi, *Introduction to a Science of Mythology: The Myth of the Divine Child and the Mysteries of Eleusis* (London: Routledge & Kegan Paul, 1951).

Art and ritual were in their beginnings indistinguishable,[40] and Sir Herbert Read has reminded us that art is a *dromenon*,[41] a thing done (from which we get "drama").

We do not know at what point in the history of mankind the ceremonies of which I have spoken—the shouting and stamping that must have begun as a direct attempt at identification with nature, the propitiation of the Great Mother Goddess by the blood of bulls, the defloration of girls by a stranger, the earnest of fertility in the Holy Marriage—rose to be what we should call song and dance, to involve drama and sculpture. We do not know when they rose above the desire for mere physical survival and involved some notion of spiritual content. We get some hints of that development of human thought in the change from bull sacrifice to bull dances; in an actual killing being superseded by the reaping with a sacred axe of a sheaf of corn—the symbolic "except an ear of corn fall into the ground and die." The Sacred Marriage came to be a vicarious consummation, and Gertrude Levy writes that the words of Asterius, who took part in the Mysteries, makes very clear one mystery was performed on behalf of all: "'Is there not a descent into darkness and the holy congress of Hierophant and priestess, of him alone and her alone, and does not the great and vast multitude believe that what is done in darkness is for their salvation?' Yet, as each candidate emerged at the end of his initiation, he was greeted with the words: 'Hail bridegroom, hail new light.'"[42] (Here, as elsewhere, the rite was performed in a cave or crypt.) This is as far from the collective consummation of the old fertility orgy as is the cutting of the corn from actual bloodshed.

By the time Apuleius wrote *The Golden Ass*, the Mysteries were certainly interpreted as a spiritual experience; participation offered a more intimate knowledge of, and finally a union with, the Divine. Later still, the beautiful frescoes in the Villa of the Mysteries at

40. This is the whole argument of Jane Harrison's *Themis*.

41. See Herbert Read, *Icon and Idea: The Function of Art in the Development of Human Consciousness* (Cambridge, Mass.: Harvard University Press, 1955), 57, 144.

42. Levy, *The Gate of Horn*, 299.

Pompeii—though we know little about the actual observances—speak in clear accents of a high order of experience. Participation was obviously essential to the rite: "The power of the sympathetic imagination has at last replaced the sympathetic magic in which it has always been present."[43]

Since the persistent human hope of physical rebirth in some form, which is embodied in burial rites, lends its symbols to other ceremonies of initiation—into sex experience, into marriage, or into the social unity of the tribe or community—these too must be conceived as a kind of rebirth, and this emerges clearly in many forms of initiation.

Jessie Weston[44] says that the Grail story should be viewed primarily as an initiation story, and Robert Cruttwell, speaking of the root ideas of the Grail legend, writes that in all its versions there is "a *Quester* or *Hero*, who [...] alternately urged to, and warned from, the Quest, who seeks now a *Dying King*, now a *Dead Father*, now a *Hidden Bride*, and now a *Lost Mother*."[45] Cruttwell equates "the obstacle with the Maze or Labyrinth, both within and without the Fort, i.e., Castle; the Quester with the candidate for initiation, whose object is both personal and cosmic; [...] and the Quester's Mother with the Earth Mother."[46] The Grail story reached most of us in such a sentimental and etiolated form that it is difficult to convince ourselves of its profound relationship to the old nature and fertility cults until we remember the

43. Ibid.

44. Weston says that the symbols of the Grail legends bear marks of their fertility origins—such as the Lance borne by a youth and the Cup by a maiden—and are of immemorial antiquity, but it comes down to us in the form of a divinely inspired quest and initiation into a state of spiritual perfection—which is not to be achieved here on earth. Even the quest itself, its bafflement, its wrong turnings and elusive interpretations, bear some marks of the labyrinth symbol. Jessie Weston, "The Grail and the Rite of Adonis," in *Sources of the Grail: An Anthology*, ed. John Matthews (Hudson, N.Y.: Lindisfarne Press, 1997), 431-48,

45. Robert W. Cruttwell, "The Initiation Pattern and the Grail," in *Sources of the Grail*, 423.

46. Ibid.

haunting quality of its images, the Wounded King, the Dark Wood, the Chapel Perilous, which still recur in so much poetry today.[47]

Initiation involves testing and the hope of new life, of rebirth. This thought is surely one for educators to dwell on. We may have lost our rites of initiation, but we know that adolescence is a kind of rebirth in sexual and emotional sense and should be marked by initiation into adult society. Emotionally it offers a second—and perhaps last—chance. Now, rituals of initiation, whatever else they may do, do offer an opportunity for pausing to dwell on the significance of this crucial change of status, which is not given in our pressure-ridden schools. Sometimes, as I have suggested, adolescents will use the form of age-old mysteries as a focus for contemplative thought or for the explosion of an emotion that is not finding a steady outlet. Just as peasants sense the vitality of certain motifs whose meaning is lost to them, so adolescents may gain an extraordinary satisfaction in using archetypal themes that they do not recognize *consciously*.

If I emphasize "adolescents" here, it is because I concentrated this study chiefly on that phase, and because certain human conditions are thrown into relief at this period by its very extremism. But it is true of all of us to some extent. We respond to forms that symbolize our conceptions about life. Colin Still[48] has shown that from the

47. A.A. Barb, "Diva matrix: A Faked Gnostic Intaglio in the Possession of P.P. Rubens and the Iconology of a Symbol," *Journal of the Warburg and Courtauld Institutes* 16 (1953): 234 et seq., points out that the word GRAIL can be related to GRAD ALE, GRAZAL, GRAAL. A gradale was a paten for carrying different meats—and the Holy Grail is a sanctified gradale. It was divided into foliated sections—a rose window is essentially the gradale shape—which were scooped into hollows. It is, in fact, the shape of the altar table in certain French churches, a shape that only appeared in Europe (though known in Syria) between 900 and 1300 after pilgrims to the Holy Land had been shown such a table as the original of the Last Supper. At Besançon, until the eighteenth century, a table of this type was filled with sixteen pints of red wine, solemnly blessed, and after every canon of the college had drunk a few drops, the rest was distributed to the faithful. So the Holy Grail may be the table of the last supper, as a symbol of the sacrament.

48. Colin Still, *Shakespeare's Mystery Play: A Study of "The Tempest"* (London: Palmer, 1921).

Eleusinian Mysteries (and likely long before) to *The Tempest,* with its "forthrights and meanders" through which Alonzo's party find their allegorical destination, the *labyrinth* has been an essential of what he calls the Universal Myth (the recurring myth expressing the conditions of the soul's journey to perfection)—implying the doubt and confusions through which men pass on their way to revelations of religious truth.

Looking back on the things I had discovered about the labyrinth dance on Delos, the depiction of a crescent moon or a rose at the heart of a maze, the neglected turf mazes of our country that are still used for kissing games in Scandinavia, and pondering on the tortuous social rituals of courting (whether of the formality of our parents' days or modern American teenage dating) as a social device for the protection of girls and as a form of conditional entry to secret places, I was not surprised to find that Margaret had put a labyrinth around her "rosegarden."

I am not for a moment suggesting that she knew any of the fascinating history of the subject to which the works of the scholars led me. But this was the form that arose in her mind. She sacrificed an opportunity to do many other things considered more appropriate and, one might have expected, more attractive to a young adolescent, to concentrate on her rosegarden-labyrinth image.

I do not want to overload the incident with significance. This is not the story of her education but of mine, of a quest undertaken in mild curiosity that imperceptibly became a driving passion. If I am a better teacher, it is not only because I have read Virgil again, with pleasure this time, have studied Persian miniatures more carefully, or have got some glimpse of the way in which human knowledge is built up by correlations from many different sources. It is because I am more aware of the overtones that may lie behind the simplest phrase or remark, the depth of satisfaction that may come from a queer and unintelligible piece of work, and so I think I am more responsive to the creative work of those I teach.

A POEM BY A PRIMARY SCHOOL GIRL OF TEN
ON THE HADES-PERSEPHONE STORY

PERSEPHONE

As Persephone played with the nymphs
She saw a flower so lovely and rare
And went to pick it and in the earth there was a crack
And from the earth came Hades King of dead, who
Snatched Persephone and took her to his Kingdom
To become his Queen
And she would not eat or drink
And she would not speak to him.
On earth Persephone's mother, Demeter
Made winter on earth for a year
For she had not found Persephone
And let winter creep over the earth.

WRITTEN WHEN PONDERING ON THE FORM
OF THE CRETAN LABYRINTH

We trod the pilgrim's road of dread, daze, loss,
A labyrinth where bulls breathe and serpents wind, we
Grappled with Ancient Eves—only to find
The maze a mandala, the crux a cross.

—S.M.R. 1959

PART THREE

First comes an account of an excursion with my students to visit a coal mine and illustrations of some of the work that arose out of this. There follow some puzzling pictures on the themes and an attempt to explain the mood that may have evoked them through the parallel with frontality in mid-Byzantine art, with which they show some surprising parallels. A possible connection with ritual is explored.

There follows some account of an enquiry into the part the *material* plays in the eventual image, which had been going on at the same time as the investigation into the source of *ideas*.

Finally, the two themes, rosegarden and labyrinth, which have been obstinately recurring in this study, are reconsidered as symbols of adolescence and as provocative themes for us as teachers.

IX

THE VISIT TO A COAL MINE

Macrobius, commenting on Cicero's *The Dream of Scipio*, says that philosophers make use of fabulous narratives because they "realize that a frank, open exposition of herself is distasteful to Nature, who, just as she has withheld an understanding of herself from the uncouth senses of men by enveloping herself in variegated garments, has also desired to have her secrets handled by more prudent individuals through fabulous narratives. Accordingly, her sacred rites are veiled in mysterious representations so that she may not have to show herself even to initiates."[1] The story that follows is no fable but, like the rest of this book, as honest an account as I am able to give of the events. Yet, as in the philosophers' fabulous narratives, there are many veils obscuring understanding.

The training college in which I worked lay in a pleasant stretch of countryside just on the edge of the Yorkshire coal field. After we had been there some years the thought occurred to me that, although so much of the life of children we met in the schools and so much of the economy of the whole area depended on coal mines, I had never been down a mine. We often had the strange experience, while rambling by bus through the Yorkshire landscape of walled fields and stone farmsteads under trees, of having the bus stop to pick up half a dozen miners with their blackened faces and their helmets still on their heads. They had emerged from under the fields, from tunnels just somewhere near by in this green countryside, and yet they seemed

1. Macrobius, *Commentary on the Dream of Scipio*, trans. William Harris Stahl (New York: Columbia University Press, 1990), 86-87

like beings from another world. So, in a lighthearted spirit of curiosity, my own tutorial group and I decided to visit a coal mine.

The mine chosen was a small, old pit quite near our college whose upper works of turning wheels and wires crisscrossing against the sky had been a familiar element of our landscape. Its spindly tracery had inspired many pen drawings. The refuse pit of this tip reared itself up in a shapely symmetrical cone, and through the spring it was tinder-red, streaked with grey ash; in summer, a covering of green and sharp-pink rosebay-willow-herb crept up the gullies and the crevices towards the dark top. After a fall of snow the pure white cone raised itself into the frosty sky like Fujiyama. But at night the liquid tarry waste from the mine factory poured out on the other side of the tip into a horrible black, molten lake.

This then was the mine that we were to visit. We set off by bus at two o'clock on a summer afternoon when the lawns of the college were mottled with daisies and buttercups, and the lilac scent weighted the air. The eighteenth-century balustrades of the terrace garden were lapped in a heat haze. With the twenty odd students I made the journey of half an hour to the mine. We were laughing and chatting, free from the college for the afternoon and with the natural exuberance of an excursion. Neighboring a field of cows and buttercups, with that propinquity typical of the West Riding that delights and shocks at the same time, reared up the mine tip.

When we arrived at the shabby buildings, an angular island in this undulating landscape, we were met by the undermanager and, although we had all put on old clothes, we were persuaded to get into dingy waterproofs or overalls too large for most of us. Then we filed through a narrow passage to a further shed and were handed metal helmets. As we tried them on we laughed at the funny appearance of familiar faces in such an uncouth garb. Then we went to the lamp house, and each of us was fitted up with our lamp stuck in the front of our helmets and with the battery swinging on a harness, rather grotesque but still amusing. We moved across a junk yard with odd pieces of rusting machinery and filed out of the sunlight into a high enclosed tower. Inside the buildings of the pithead everything was dim; every surface, gray stone, brown wood, and the navy serge trousers of our

guide, was uniformly dingy with coal dust. As we climbed a stone staircase around the inner wall, we passed a square of glassless window, and I saw the shape divided precisely in two, the lower half of green grass and the upper of blue sky. The full contrast of light tones and bright color emphasized the coal-encrusted walls closing in on us. Having heard so much about the modernization of the mines, we were a little surprised to find how ramshackle everything looked, but this was a small old mine, or we should not have been allowed such freedom. We stood crowded high on a wooden platform with a frail banister round it, waiting for the cage. When that clattered up to the surface, it was a surprise to find that we had to bend down and creep into this rickety-looking contraption, to crouch bent on the piece of rough wood placed as a seat along the side. There was barely room to perch on one another's knees or kneel on the floor. There were no walls to the cage, only two iron bars bolted diagonally together. It looked like an awkward Erector Set construction. Suddenly we started to descend, and it was as though we dropped plumb down like a stone in a well. We were not told until later the astonishing rate at which we had descended, but it was during those few moments that, for the first time, anxiety chilled us. The breath was sucked from one's lungs and left far above in the rushing descent. After the first long gasp some of the students started joking shrilly above the whine. In those few moments when we were crushed up against one another, choking and clutching the nearest leg or shoulder, I looked into the white face of the student next to me and saw there the same alarm that must have been in my own. I could not imagine how our frightful pace could slacken in time for us to come to a halt when, as suddenly as it had started, the cage had stopped with a clatter on the floor of the mine. There we crawled out and stretched ourselves, waiting for the rest to arrive by the next cage. We found ourselves in a huge tunnel like an arched station lit by electric light. I had expected the mine to be small, a series of narrow passages, and I was surprised and relieved, if even a shade disappointed, at this great cavern in which we stood, with tunnels running out of it in three directions and a little railway line down the middle. When we were all assembled we were told by our taciturn guide to fasten our helmets more firmly, to check our lights, and to

climb into the railway car drawn up near by. These little cars were as exposed and ramshackle as everything else, the merest skeleton of rolling wheels and platform, with two planks for seats facing one another: no back support, no other protection. We piled into the car and sat close up, clutching our helmets on because the electric wires ran, it seemed, only a few inches overhead. Before we were settled the cars set off, and we realized by the cold air rushing past our ears that we were gradually gathering speed. The large arched tunnel narrowed down until the walls drew in close to the sides of the car. We all hung onto our seats unless our hands were too occupied clutching our helmets. We had been told that we were on no account to try to get these back if they blew off, and this is exactly what happened to Diana. Diana was a clever, highly strung girl with delicate bones and quick bright eyes. I was sitting some cars behind, facing forward, when her helmet was lifted by the airstream. Instinctively, she rose to reach after it. I screamed to her not to move, and she restrained herself, but her pale yellow hair was swept up by the wind of our speed in a halo. Just over her head were the electric wires, and I sat in terror, fearing every minute that it would get caught in them, but I dared not call to her again for fear she would rise in order to hear me better. So through the dark tunnel we whistled. It was a strange sensation, realizing that with every moment we were rushed further away from the one exit to the world above. Yet we had embarked on this adventure voluntarily. I took myself firmly in hand and determined to enjoy it. I reminded myself that this was what the miners did every day and, despite the very occasional pit accident, the normal routine was the perfectly straightforward one of going to work along this whizzing tunnel and returning at night back to the shaft and up to the open air.

When at last the little cars slowed down and finally came to a halt I breathed with relief that everyone was behaving sensibly. We were now many miles from our starting point and were surprised at the name of the village that lay about half a mile overhead. In that close, dark tunnel miles from the shaft it was hard to realize that cows were grazing and people going out to tea, separated by yards and yards of rock from where we stood in an electrically lit cavern.

At this point we turned off into a corridor just head-height but dripping with damp from above. Now there was no more light but that

from the lamps on our helmets, the batteries slung on our backs. We pushed our way round a dust curtain, a piece of waterproof sheeting hanging like a door across the corridor, and started up a long slope. As we climbed the atmosphere got hotter and damper, we saw the moisture condensed on the walls of the shaft, and we had to negotiate many puddles underfoot. Now the students felt they were meeting the real thing, and they were full of fun, amused at their own situation and tickled at each others' appearance, for we were fast collecting smudges on our pale pink faces and felt grateful for the overalls that had been put over our clothes. Our unsparing guide walked rapidly, and it took us all our time to keep up with him on that upgrade. From time to time we had to negotiate a blast door, a little wooden door set high in the middle of a solid barrier across the corridor; this meant clambering up one side and down the other, and we would have been left behind if we had not hustled one another through. It got damper and stickier underfoot until we were sometimes wading through a few inches of mud. On the whole the girls had come very sensibly dressed, but Anita, red-haired, sophisticated, had on high-heeled shoes. In the mud pools she lost one of her shoes, and before she could rescue it the man behind had stepped on it and broken it. From then on she hobbled along in one high heel and one bare foot, in spite of out protests that it would be better to have no shoes than to have one. Gradually this corridor became lower until we had to stoop, heads thrust forward between our shoulders, constantly knocking our foreheads and our elbows on projections of rock. So far, although the stone was black and grimy, we had seen no coal—no coal in the seam, that is, for plenty of dross and coal dust was scattered underfoot. Entirely dependent on those little lights on our foreheads, we stumbled against the sides of the tunnel and cut our fingers and stubbed our toes. We began to get some inkling of the miner's great dependence upon his lamp. Few of us did not begin to imagine what it would be like to be alone in this place without a light, and to feel the comfort of that small beam that stood between us and an unimaginable darkness. The upward trek continued in a kind of crouched lope: we scorned to fall behind or beg for a rest.

During the last half hour we had been feeling a bit uncomfortable but still the brighter sparks were throwing out the occasional joke. Geoff, always a wit, had expressed great pleasure at the first large cathedral-like tunnel and asked loudly why he was preparing to be a teacher when he could get £10 a week down the pit?[2] Now Geoff's face was red and running with sweat, and over his shoulder he said to me, "It's getting a bit warm, isn't it, but I don't think it's as warm as Lower IV classroom. I'll still plump for that £10 a week!" So on we went. After about three-quarters of an hour of this steady, hunched climb with necks craned, we arrived filthy, sweating and a little bruised at the last barrier, the entrance to the coal face itself. This time the narrow door in the blast barrier was very high and we had to hoist one another up and push bottoms to get each one through. Those on the other side grabbed whichever part appeared and tugged hard.

Turning a sharp right angle beyond the last blast door, we found ourselves bent double at the coal face. In a low tunnel the shining seam of coal less than a foot high stretched horizontally and slightly irregularly beside us. It started from about nine inches above the tunnel floor and from the top of it a rough hacked arch bent over to give us between three and two and a half feet of height at the highest part. But not all the floor of the tunnel was available for crawling—crawling it now was, there was no possibility of walking—because the left-hand side carried a narrow belt with shovels attached on which the hacked coal was carried away. Here, the atmosphere was steamy with heat and the miners who crushed themselves against the entrance to let us pass were working stripped to the waist with the sweat running down their knotted muscles. It was also much more dusty, and we were constantly coughing and choking with the particles in our throats. One felt one would almost rather not take another breath than get that mouthful of grit, but breathe one must. We were now in a tunnel so low and narrow that there was no possibility of squeezing past anyone, or changing our order. The character of the person one found oneself next to assumed great importance. I had been a little bit concerned for one of the younger girls who, I feared, might panic.

2. This was in 1956.

I wished I had put myself next to her, but it was now too late. I even found myself grateful for the chance that had fixed me between two sturdy men who would be strong enough to push or pull if I actually got stuck. Our crawl was halted for a few moments while urgings and scufflings went on at the rear, and I realized with horror that Phillip, an exceptionally tall, large-boned student, really was stuck. However, by crowding up on all fours, scraping our knees and cutting our hands we were able to leave enough space for him to lie flat and get free. But it must have been very painful for him. I now see why miners are stocky types. There was no chance of hesitating or trying to back out, for no one could pass, no one could turn round; we must all go on following our guide somewhere far forward there out of the range of our lamps, seeing only the legs and hunched back of the person in front, avoiding as far as possible the kicks of his foot and the dust and mud thrown up. Now there were no more jokes; it was not simply that all our energy was needed just to keep going but that we were silent from awe. We seemed to be in a world quite different from the world we had left, how many hours ago? I remembered my last glimpse through that open window of the grass and the blue sky, and I had to make a concentrated effort to visualize the colors blue and green. For many yards of our crawl along the coal face it was the sheer physical discomfort of which we were chiefly aware. Then we began to hear a new sound. The wall of the tunnel along which we crept was supported by upright wooden posts at intervals and by cross beams resting on them; one or two of these posts were now straining with a squawking creak. Our guide and the miner crawling with us became aware of this and the column was halted while shouts and grunts echoed to and fro along the tunnel. So long as we were moving there was something to do, one could ignore the nagging apprehension by concentrating on the next movement, and telling oneself that we had at last reached our goal, the coal face. (I confess I was less concerned with the coal face than the thought that the sooner we got on, the sooner we would be out of this.) But now that we had stopped, our situation bore down on us and this seemed a strange goal ever to have desired. We squatted there in our small pools of light, seeing only the man in front, unable to turn

and look at the person behind. One eased one's body this way and that in an effort to find a better posture, but nothing would stop it, dread flooded into the mind—creaking posts, surely that was the first warning the miners heard? I thought of the limitless tons of rock above us, my mind boggled at arithmetical calculations of the weight held up by these fragile wooden props. I remembered how, when I was a child, the martins used to nest in holes in our quarry, and I had wondered how dare they trust themselves and their brood to holes in that wall of soft sandstone? Our little tunnel driven through the earth seemed as frail as the martins' holes. By now I could hardly convince myself that there was another world, the world that I had known all the years of my life above ground. I reminded myself that on that world too, night came—but with night there came the light of the moon, cool echo of the absent sun. One knew with absolute certainty that the sun would rise again, warming and easing the world, filling the trees with sap, swelling the grain—we had been painting in a cornfield last week, the students and I. Then suddenly came the thought that if something happened, how should I ever be able to write to their parents and confess that I had taken them down a mine just as an outing! Then as quickly the other thought—I should not be there to write. In our college there had never been a very strong feeling of the tutorial staff being a separate hierarchy. We made opportunities to meet the students on equal terms, and our position and experience was marked only by a few formalities such as High Table. Yet the authority of position was always subtly there. Here, down the mine, I felt at the same time responsible for them and yet completely one of them. We had seen the momentary trace of fear on one another's faces; we had shared the hot and dirty crawl, the human indignity of pushing our bodies through a small hole. Now jammed, as helpless as they, without a word being exchanged I knew that we shared the same welling of panic. For something to do, I picked a small piece of shining coal from the seam with my fingernails. Eventually a prop of wood was passed along the side of us, and we had to crouch our legs further to the side in order to push it on with small thrusts. Breathing grit, we waited in our places until it was propped up in position, and after more interminable waiting word was passed along to go forward again. The relief

was immense. Our one idea was to get to the end of the coal face—we thought no further than that.

Just as we reached the place where the coal seam widened out a little, there was room for us to pass three miners who were kneeling with picks in small hollows in the side of the tunnel. I could not see how they could wield the pick with any force behind it in that restricted space. Pausing to let us pass, two of them grinned at us, gaping bony as skulls in that light, but the third stared morosely silent. When Ann paused beside him and asked where the seam of coal he was working at was, he pointed for her low down beside his knee. But in the dim light she could not see it and with some considerable feeling he put his dirty hand on the back of her neck and thrust her face down until her chin was in the mud to show her. Did they then resent our coming as visitors to their mine? We had, it is true, started in a light spirit, from mere interest in our local industry, but by now there was no doubt that our sympathy was all with the miners. After we escaped out of this tunnel through a blast door, tumbling from it on to a heap of coal dust, slithering down five feet to the rock floor below and picked ourselves up and stretched our limbs as far as we could, one might have expected chatter and laughter. Instead there was silent pantomime of relief from constriction, each of us reaching into the bit of space around, obsessed by our own need to stretch. One by one we came out of this absorption to look at one another with new eyes. Our faces were almost completely black, and the white of the eyes stood out in a clownish way. But now there was no joking at one another's appearance. We had gone beyond that to some other relationship. What mattered was that we were all shaken and deeply moved, but we could not yet have said what happened to us. This subdued group dragged its way back from the exit of the coal face tunnel to the main artery of the mine. Even Geoff was deflated and, making up on me as we tramped down the last slope, now, blessed relief, able to stretch ourselves to our full height, he put his arm round my shoulder and said to me with the utmost seriousness, "They can keep their £10 a week for me."

When we reached the main hall of the mine again, we trailed silent along the railway lines towards the shaft. I could hardly believe that

we would indeed climb into that toy cage again and be lifted up to the surface. It was this sense of being in a completely alien world where the range of color, the span of time, had a different norm; that is what I find so hard to describe now. After all, we were down the mine only for about four or five hours. I do not believe now that any real danger threatened; perhaps the creaking of the props in the coal-face tunnel was to the miners just an everyday occurrence. Yet during that four hours we had become welded together as if squeezed in a giant fist. Even when we climbed into the cage I still dreaded that some wire would break, some hitch would occur at the last moment, which would prevent our returning where we belonged. Yet while we ached for sun, greenness, and our life's normality, we now understood that it was to this world, to the dim underground, that the miners belonged. They, who looked strangely out of place up there, who slouched uncomfort-ably in their heavy clogs on the tarmacadam roads and whose white eyes peered from inscrutable faces, they were perfectly at home down here. Here, their movements and their clothes were appropriate; the very voices of authority in which the merest boys had spoken to us, directing our attention or giving us an order, spoke of the security of being on their own ground. Now I understood a little more why the outlook on life of the miners is different from that of other men, why sons of miners often go down the pit as naturally as fisher boys go to sea.

As for us, we gasped to get up into the clean air and sunlight. The cage swept upward in that rush of air, and very soon we were step-ping again on to that same rickety platform from which we had taken off for the underworld. Stretching a stiff neck as we balanced across the plank over the space below, my eyes met the square of an open window we had passed on our way down: exactly divided, green grass below, blue sky above, now yellowed with evening light. The effect of those colors on me, the satisfying depth and fullness of the green, seeming to bear within itself all future grain, all milk and butter and honey, was like wealth after starvation. The blue appeared to stretch into illimitable distances, and once again my eyes could stare and stare, pierce the distance, and find no dark obstruction to shut in their range. When we went out into the evening and went through

the drill of returning our lamps to the lamp shed, returning our helmets to the hook, and divesting ourselves of the overalls we had been lent, the students were very quiet. Still with our blackened faces we climbed into the bus that was waiting to return us to the college. Driving back through the countryside that summer evening we looked with fresh astonishment at the shapes of cows, at the sheen of horses in the fields and at the fragile perfection of hawthorn in the hedges. As after being shut in a dark room during a long illness one greets the world again with sharpened sensibilities, every sight thawed us out and we dared to believe we were restored. Gradually on the half hour's journey back I felt the oppression lift, the tautness of the students stir. There was very little talking but gradually the underlying ferment started to "work" until there rose a feeling of subdued excitement in the bus load. As we swung down the curving drive to the college we all felt this was homecoming, this was the familiar, the pleasant life to which we belonged; but the strange thing was that we felt in some sense that now we also belonged to the mine and the miners. This spacious daylight world could not again wholly possess us.

When the bus drew up outside the tall windows of the eighteenth-century dining room, we saw students in neat suits and pretty summer frocks sitting at polished tables, patterned with glass and cutlery, eating their dinner with forks, not munching coal-dusty bread from a tin box. They all looked unaware—as we had been unaware six hours before—of what went on under our familiar parkland. We wanted to shake their complacency, to shout at them, "We have been down a *mine*." The civilized life that we and they had led seemed suddenly too protected, too incomplete. Though none of this was said, a tension was building up to breaking point. The conflict of sympathies could not be resolved so easily. I was concerned in case this tension should find some destructive outlet, some angry gesture against that element of artificiality which we too had formerly accepted. I was just about to suggest briskly that we would all have to bath before we went to dinner when I realized it would be a betrayal suddenly to act the tutor again the moment I stepped back into the college. I really wondered whether I would be able to persuade these students at that moment to wash their dirty faces (now the badge of our solidarity with the

miners) or take off their filthy clothes before they marched into the dining room. We could not wash off our experience. The need was to relieve that tension before we could meet our fellows; yet we could not talk about our experience—it was too raw. Besides, quite simply, we were very hungry and there was our dinner on the side table, waiting to be eaten when we were in a state to eat it. I hardly know how the idea arose, I think it simply sprang into life among us, but when it was voiced the students all turned to me, bright eyes staring from blackened faces and said, "Yes, yes"—then, the conventions of the old life closing in—"but you must go first, you will lead us." A college tutor, I yet knew that I was even more fundamentally one of the group who had been down the mine. I said, "Yes, I'll go first." We huddled outside the dining-room door, coal-dusty, sweaty as we were and clung close, while someone, I think it was Geoff, said, "Now we are going down in the cage, now we start along the tunnel." We crouched in the entrance hall and for a moment sunk ourselves back into the experience. Slowly pushing open the door of the elegant dining-room—eyes fixed on that remembered point where vision disappeared into the darkness—I led the doubled-up students in a re-enactment of our journey through the mine. In the astonished silence of the diners, who knew, of course, where we had spent the afternoon, we bent from our stooping walk to a shambling crawl, then dropped on all fours and finally we wound underneath the tables and between their legs in that last agonizing creep through the coal-face tunnel. We did all this in complete and serious silence. Balanced on the razor edge between the solemn and the ludicrous, we were, in effect, saying to them, "We have been down a mine; we have dragged ourselves like animals on our bellies along the coal face; we have felt the horror of that moment when pit props begin to creak, and we have come back to you not quite the same people." I sensed behind their astonishment an apprehension as to how this would be received—for formal dinner is a college ritual. As our journey was almost completed and the file was crawling back towards the door I passed under the High Table, and taking from my dirty dungarees pocket the small piece of coal I had clawed out, I wordlessly put it on the clean white plate in front of our principal—to whom be all honor that he accepted what had to be

done and allowed us to complete our silent progress out of the dining hall. Outside, a cheerful burst of talking and chattering showed that the tension was released and immediately I suggested that we should go and wash and without more ado eat our dinner.

That was the day on which we went down the mine.

The sequel to this story came the next day and the next evening. By good fortune I was due to take most of this group for the whole day for "Art Education." This would normally have consisted of a lecture from me, a discussion afterwards, reports by students on books they had been studying, and a school visit or reading time. When, the next morning, I met the students seated in a circle waiting for me looking strangely clean and normal, I felt there was only one thing to be done with that day. I said, "The experience we had together yesterday was something important for all of us. Let's not allow it to become overlaid with all the things we ought to do, or drift away from us in a vague emotional feeling, before we have made it fully our own by pondering on it, clarifying it and perhaps communicating it. I suggest that you go away, separately or in groups, and paint or model it, or write or dance if you prefer" (for movement study and dance was one of the arts practiced in our college), "but take the whole day if you wish. We'll meet together in the evening. Today I shall not try to help you with your work or criticize it. I am going to work too."

I modeled my huge "Miner," hoping to get some of the dignity of a brooding Buddha into him. In the evening, the students and I brought our work to show one another. There were many paintings, some models, prose writings and one poem, which had some of the labyrinthine character of the journey itself. Then we were invited to see the dance that Ann had made with four students who had not been down the mine, but whom she had so moved with her description that they were able to compose a dance with her, an evocation of that journey, danced to the music of the Troll King's Daughter. I do not forget that moment when they clung together on tiptoe then crashed to the floor as the cage went down. In watching that dance we relived the emotions and partly exorcized the nightmare of the cage.

One student, who had never had the confidence to draw or paint large figures but only rather elusive, tenuous wraiths, drew two very large muscular miners, filling the paper as though they would push out its edges that hemmed them in. Another painting was the empty receding arches of the mine itself, like some of the children's stark mines. We took time to look long at each, and every one revealed aspects of the experience important for him.

So, calmed and eased by our work, and gathered together by our common appreciation of each other's art, I felt that now we could talk. Sitting round in a circle of comfortable chairs in my tutorial room, the pale gold light (which would never again be taken completely for granted) slanting in on Geoff's flake-white shirt and Diana's newly washed frizz of hair, I began to talk about the day before, speaking a little of my own feelings of panic and of awe and of the bond of shared emotion, while our attitude to the miners and their job had changed hour by hour. Reminding them again of the moments when we stood outside the dining hall, and gently teasing them about their unwilling-ness to wash, I affirmed my own desire to assert with them our differ-ence, from the rest of the college, and yet our need to express to them the essence of our experience because they were our own community. We discussed together whether our action had been a little adoles-cent in our need to make a protest there and then, in our compulsion to relieve that overwhelming complex of emotions in some action. We agreed that something had to be done, and that it had somehow made it possible to meet other people and to step back into the life of the Hall. Some students said that they had not wanted to talk about it that night. Roommates had harried them with questions, but the simple facts were no adequate reply. Others evidently had stayed up half the night trying to explain. One married woman had written a ten-page letter to her small sons about the mine. But most spoke of how unbearable feeling had been released in the dining-hall episode, and afterwards they were dead tired and slept deeply. Sleep and renewed energy had made possible the concentrated work of today, while the images and emotions were still fresh. As the dusk fell we continued to discuss, the long silences broken by someone remembering this or that. I lit from habit the fire in the grate, and the sight of coal, which

we had last seen in the seam, crackling into living fire, brought back the tap of the miners' picks. In the darkness, and after finally sitting silent for some time, we rose to collect our works from where they had been kid aside, and one of the men students whom I regarded as rather shallow and foppish stood beside me in the half-dark and said, "I shall not forget these two days."

I have since asked myself what exactly it was that we tried to do in our crawl round the dining hall?

It certainly provided a bridge between the unbearable tension of the mine itself and the poems and paintings that were produced next day; while "fixing"—in cold storage as it were—these experiences, until we had eaten and slept and renewed ourselves sufficiently to sort them out and deal with them. I do not think it would have been possible to paint or dance the night before—emotions were too explosive, too undirected. It expressed our feeling of a close group while at the same time it insinuated us back into the larger group by sharing with them something of our experience.

Perhaps intuitively we produced a kind of ritual, differing from most of the rituals we knew in that it was not repeated but sharing with ritual the purpose of dealing with strong feelings that would have interfered with our absorption back into our society. It was also a *re-enactment* of an original incident in modified form, bereft of its real terror but following its pattern, the weaving in and out movement of the original. Was it perhaps one of the maize rituals I explored years after, as I have recounted; an initiation of re-entry? Unless I am reading altogether too much into the incident, the slightly comic aspect of crawling dirty and black-faced through a formal dinner also gave that release we all experience through a form of clowning that makes sadness more bearable.

THE COAL MINE

WRITTEN BY A WOMAN T.C. STUDENT
ON THE DAY AFTER THE VISIT TO A MINE

A strange world this,
a black tubular maze
Whitened by stone dust re-blackened
 by the contaminated air

A tangle of foetid roots
Screwing, probing—further, further—
For the hard roughage to satiate Man's mechanical trees.

Monochromatic:
A domain only half revealed
By the pallid aura of torch light cast cold on hallucinatory walls

Acrid, dank.
An atmosphere seeping, insidious.
Its foulness wringing moisture from the dripping caverns
 and sweat from overtaxed bodies.

Clutter of cables
Rusted wires like ravelled tentacles
Crawling sinuously through sombrous hollows,
 the pulsating lifelines of those human scrabblers.

The gasping stillness
Lurking and rapaciously devouring
The hysterical clatter of the feverish machines that clang, clang, clang—
 inexorable, incessant.

 —J.R.

X

FORM IN SYMBOLS AND IKON

O sages standing in God's holy fire
As in the gold mosaic of a wall,
Come from the holy fire, perne in a gyre,
And be the singing-masters of my soul.
—W.B. YEATS, *Sailing to Byzantium*

There is a striking similarity between the war-dance [of the Siamese fighting-fish] and the corresponding ceremonial dances of Javanese and other Indonesian peoples. In both man and fish, the minutest detail of every movement is laid down by immutable and ancient laws, the slightest gesture has its own deeply symbolic meaning. There is a close resemblance between man and fish in the style and exotic grace of their movements of restrained passion.

The beautifully refined form of movements betrays the fact that they have a long historic development behind them and that they owe their elaborateness to an ancient ritual.
—KONRAD LORENZ, *King Solomon's Ring*

I commented, in the discussion of pictures of caves, on how the straightforward teaching of composition in relation to these themes seemed to destroy the overtones that gave the pictures their significance. Should we then, as teachers of art, not teach composition? We know well that a picture needs a structure, but this structure may be derived from many different sources. With junior children I should have thought that an emphasis on the real subject being big in relation to the paper[1] gives the beginnings of structure within the picture

1. With pen or pencil the paper itself can be small. Space can be, even in a child's drawing, as much part of the real subject as it is in Chinese art, e.g., a kite flying in a wide sky.

space, as other things can then be spatially related to that. It is usu-
ally timidity that shrinks the subject to an insignificant object lost
in the empty spaces where the child himself feels lost, apprehensive
of his world's response to the experience he conveys, or crushed by
former criticism of his drawings. An emphasis on different viewpoints
also enlarges experience and brings the awareness of a fresh image to
an ossified schema. A change of viewpoint may be as simple as look-
ing at familiar things from the side or one corner or under a micro-
scope—which may suggest depicting the ant's eye view of the world or
the steeple-jack's.

Adolescents, especially in grammar schools, often take a more
intellectual approach to their painting and may be intrigued by the
study of composition, but I think this is perhaps best done not in
"composition lessons" but in close relationship to the art of the past,
after a soaking in the pictures and sculpture themselves. The stage of
just having come out of the complete response described by Berenson
as "the aesthetic moment" is often the time for this. One's first expe-
rience of any work of art should surely be a total response, not an
analytical one.

There is also necessary the study of line, form, and color in an
exploratory way and from a more objective standpoint, but while this
must have a considerable place in the training of art students I can-
not myself feel that it should be the main basis of school work.

Such studies, if they have indeed been digested, as all intellectual
knowledge must be before we can forget it sufficiently to use it at
a deeper level, will play their part in the structure of pictures and
models. But in most of the illustrations shown, the painters and mod-
elers had in fact no teaching in composition. Many of them had no
opportunity to soak themselves in the kind of pictures from which
they might have gained it unconsciously. When the subject of Mother
and Child resulted in formed and structured pictures of a peculiarly
satisfying kind (and I remember from long ago some pictures from
Marion Richardson's classes in which I had marveled at this), I had
concluded that the painters were unconsciously using aesthetic forms
derived from the many works they had seen on this subject. They
might well have seen the Raphael and Duccio, not only the Margaret

Tarrent versions of this, and composition is one thing that can come over even in crudely colored or black-and-white reproductions. But when we consider the cave pictures, a few of the children had not seen a real cave, and most of them, so far as we could discover, had not seen an artist's picture of one (as distinct from a photograph). Yet, where the idea was allowed to evoke some of its profound mystery, form arose naturally—a kind of artless art. The very satisfying relationship of forms in the models (PLATES 8*a-c*), several of which were made blindfold, also show this sense of form. It could be argued that the human body is already a symmetrical structure, but the body can convey any one of the range of human emotions, and here, surely, the modelers portraying a mother have found enclosing and protecting forms very cogent to convey their feelings. In the other two (PLATES 7*a-b*) no clear idea seems to have been present, but the result is an almost abstract form that conveys femininity to most observers. "My Family" (PLATE 5*c*), "A Wood" (PLATE 6*a*) and the "Harbor" paintings all use curving forms, suggestive of enclosure.

These curving forms contrast interestingly with another group having a strong vertical or horizontal axis. Although done in different classes—but all except one of the waterfall pictures done by boys—they constitute for me a group puzzling because they show an odd and unconventional viewpoint.

Among many others there are the two pictures of bulls (PLATES 27*b-c*), painted from the front so that the bull appears to be charging one head on, a most effective and frightening but very difficult view to draw; one water scene of a flood with a sea wall stretching level across the picture space and the sea breaking through in two places so that there is an uncompromising horizontality and symmetry (PLATE 27*a*). Using the extreme frontal viewpoint, but painted in a flat, decorative style, are two bold pictures of the "Three Kings" (PLATE 28*b*) in which they are represented full face and equally spaced so that there is again symmetry; also a harvest festival drawn from above the altar (PLATE 28*a*), a view the child could never have seen. In the last two instances the view chosen is in fact the "god's eye view" of the scene. These were not children who would have deliberately set themselves problems of viewpoint, nor had they had this suggested to them, and they had

been drawing profiles and three-quarter views on other occasions. This is the method of representation known in the history of art as "frontality," but even if we conclude that these adolescents had seen representations in this style, why did they adopt it, instead of their more usual way of representing, just for these particular pictures? The viewpoint chosen does create a powerful, awe-inspiring effect, but this has certainly not been consciously calculated by the painters. How did they come to arrive at such a difficult viewpoint, which is not that of an impartial spectator but seems to imply some particular relationship with the thing painted? In all these pictures—and several more where this frontality was used, and where consequently the picture had this curious horizontal-vertical structure of great strength and sometimes starkness—elements of fear seem to be present, yet the painter is not abandoned to his feelings, however intense; a certain distance is preserved, and emotion emerges in a structured form.

These pictures reminded me of Byzantine art with its flatness and frontality of the figures, its economy and simplicity of design, its lack of spatial depth. They reminded me inevitably of the Justinian and Theodora panels at Ravenna (PLATE 29*b*), whose impact, after knowing them only from reproductions, is striking, for they are placed in the *sides* of the apse of the church and yet they in no way lead the eye to the great central figure of the Christ in the conch but form self-contained centers themselves. The Emperor and Empress were, it is true, thought of as being Christ's regents on earth and worthy of veneration as such, and you are never allowed to forget this in San Vitale. As you approach the altar, on which a church is normally centered, you are compelled to turn away because these panels demand that you *confront* them. In pondering why these adolescents adopted such a strange viewpoint for some pictures, it seemed worth asking why the artists of this particular period departed from the relative naturalism of the preceding age—which must have been the art to which they were brought up (for example "Christ as the Good Shepherd" in late-Roman style of just less than a century before is only a few yards away in the tomb of Galla Placidia (PLATE 29*a*). Why did they accept the limitations of strict frontality? Why should they sacrifice the variety of viewpoints, the recession of the background and setting of the subject

in illusory landscape, for this stark, dramatic viewpoint?

A passage in Hauser's *Social History of Art* gives an explanation that might provide a clue:

> The artistic aim [of the Byzantine artists of this period] was [...]
> that art should be the expression of an absolute authority, of
> a superhuman greatness and mystic unapproachability. The
> endeavour impressively to represent official personalities who
> demanded respect and reverence of the people [...] reaches its
> climax in Byzantine art. The method used in the attempt to
> achieve this aim was, in the first place, frontality, as it had been
> in Ancient-Oriental art. The psychological mechanism which
> this method sets in motion is twofold: on the one hand, the
> rigid attitude of the figure portrayed frontally induces a corre-
> sponding spiritual attitude in the beholder; on the other hand,
> by this approach, the artist manifests his own reverence for the
> beholder [...]. This deference is the inner meaning of frontality
> [...]. By means of frontality every figure-representation takes on
> to some extent the features of a ceremony. [...] Everything here is
> awe-inspiring in its regal magnificence, with all human, subjec-
> tive and arbitrary elements suppressed.[2]

Is it outrageous to suggest that these pictures of secondary modern adolescents hold a faint echo of Byzantine hieratic art? They do, it is true, portray the characteristics of the objects—representing the force of the sea rushing through the sea wall, the fierceness of the bull as it charges—but it is not, any more than in Byzantine or Hittite art, a "*visual image*" (e.g., see the enormously enlarged heads of the bulls) but reminds one of that special sort of image called an *ikon*—and an ikon is made with the express purpose of creating an emotional state in the onlooker. An ikon is a symbol-image in that its form is a simplified abstraction that "means" to the initiated very much more than it reveals. It is also a symbol in the deeper sense of containing an archetypal idea—the virgin mother, sacred animal, the miraculous incident—and it is quite definitely a pathway through which we can and are explicitly intended to enter deeper levels of consciousness, and call on a strength greater than our own. This strength we gain

2. Arnold Hauser, *The Social History of Art*, vol. 1: *From Prehistoric Times to the Middle Ages* (London and New York: Routledge, 1999), 120-21.

through identifying ourselves with the "subject" of the ikon.[3] Perhaps frontality was used by these boys in the pictures of the bulls and the sea wall both to paint out their fear and also to identify themselves with the strength and fierceness. We cannot walk past these pictures any more than the Ravenna panels; we must face them as they face us and sense the unseen currents that link us to such works as firmly as electric wires.

Although it is true that perhaps the most common view of a water-fall is from the front, a kind of stark frontality was also used in many waterfall pictures, and identification with a waterfall is more difficult to understand. Yet, without being completely conscious of it, this is exactly what I had induced when my class painted waterfalls by the candle-grease method described in "The Themes Themselves." With the candle in their hands, the painters concentrated on the thought of water, its force, its fall, and let their bodies express that, leaving the trace of their movement to be revealed when the wax threw off the color later. The very fact that they were not at the time consciously "making a picture" at all, allowed them to be more free and expres-sive in their movements. They were able to concentrate on the idea of water without worrying about technique. I noticed that many of them had their eyes closed, and some were standing, legs apart, swaying on the balls of their feet, submerged in the rhythmic movement. In all cases the waterfall dominated the picture rather than forming part of a varied landscape. These pictures are the more powerful for this con-centration. A similar suppression of background and of inessential detail is found in many of the historic examples of frontality. Perhaps the action to which I had invited them bore some aspects of ritual, in that it enacted an event they had watched—the falling water—and in that they used repetitive movements to immerse themselves in it.

The Theodora and Justinian mosaics called up for me two phrases of the biologist Konrad Lorenz in describing antics of the Siamese fighting fish: "veritable orgies of mutual self-glorification" and "there

3. For a most interesting discussion of this, see Otto Demus, *Byzantine Mosaic Decoration: Aspects of Monumental Art in Byzantium* (London: Rout-ledge & Kegan Paul, 1948).

is a close resemblance between man and fish in the style and exotic grace of their movements of restrained passion [...which] owe their elaborateness to ancient ritual."[4]

The ritualistic element common to some of the children's paintings and to Byzantine art, and Niko Tinbergen's use of the word "ritual" for fish courting and fish combats, prompted the question of how far a rigid formula of expression (in painting, mosaic, church ceremony, social intercourse) invites, provokes, or demands a response from within an equally circumscribed sphere. If we enter this arena, so to speak, can we enter it only in terms of the traditional movements of the game?

An element of this process may lie further back in a primary part of the human makeup, which is usually hidden in the complexities of individual personality and the complicated behavior of civilized societies. While I am far from suggesting that human behavior can be described in terms of animal or bird behavior, certain facts are thought-provoking. Lorenz and Tinbergen have shown that many young things respond immediately after birth, before they have had time to learn any responses from their parents or from experience, to specific sign stimuli. For instance, chickens "with the eggshells still adhering to their tails dart for cover when a hawk flies overhead, but not when the bird is a gull or a duck, a heron or a pigeon." They react to the shape of the hawk moving forward (for the same shape cut in wood and moved backwards on a wire leaves them unaffected). As Joseph Campbell puts it:

> The image of the inherited enemy is already sleeping in the nervous system, and along with the well-proven reaction. Furthermore, even if all the hawks in the world were to vanish, their image would still sleep in the soul of the chick —never to be roused, however, unless by some accident of art, for example, a repetition of the clever experiment of the wooden hawk on a wire. With that (for a certain number of generations, at any rate)

4. Konrad Lorenz, *King Solomon's Ring: New Light on Animal Ways* (London and New York: Routledge, 2002), 23.

the obsolete reaction of the flight to cover would recur; and, unless we knew about the earlier danger of hawks to chicks, we should find the sudden eruption difficult to explain. "Whence," we might ask, "this abrupt seizure by an image to which there is no counterpart in the chicken's world? Living gulls and ducks, herons and pigeons leave it cold, but the work of art strikes some very deep chord!" Have we here a clue to the problem of the image of a witch in the nervous system of a child?[5]

Leaving on one side the point that Campbell weights the situation when he calls Tinbergen's wooden hawk "a work of art"—it might be or it might not—this response to unknown sign stimuli is surely relevant to the discussion of the emotion aroused in both makers and spectators by some of the "strange objects" discussed earlier in this book. It is the *image* of a moving hawk (not the *idea* of a hawk) that is "already sleeping in the soul of the chick." The man who said that he "did not know what he had made, but he had not been so happy for years," and the little girl who ran up with her model and said "I don't know what it is, but isn't it lovely?" had no idea, no intellectual concept of their work, but they had a shape that seems to have been intrinsically satisfying—satisfying, I suggest, because it embodied in a traditional image and form a theme significant to the human race and to these two as individuals.

On the other hand, our themes did present ideas, but what had first drawn my attention to them was a certain—to me and to others—intuitive *fitness* in the forms that emerged when children pondered on them. These forms, varied as they are, yet sharing an underlying rhythm, remind one of the movements or dance by which certain fish and birds respond to a "signal" from the partner. It would be possible to regard the material on which much of this book is based as a parallel to just such a chain reaction as biologists describe in the elaborate "ceremonies" of animals—with the proviso that for human beings not only one reaction is possible, but a number from which a choice is, largely unconsciously, made. Robert, moved by his own strong reaction to his Derbyshire caves, set the subject with

5. Joseph Campbell, *The Masks of God: Primitive Mythology* (London: Penguin, 1976), 31.

his children and, moved by the forms of their paintings, I included it in the list of themes; later, when the teachers suggested it to their classes, it evoked pictures we recognize as embodying a fundamental idea known to us.

That creatures are specially sensitive to the "imprinting" of sign stimuli at certain periods of their lives is well known. Lorenz gives the charming example of ducklings claiming the first large creature moving on their own level, which is seen *soon after birth* as their mother (in this instance himself) and becoming irrevocably attached to it. When *excited by nearness to its own territory*, the male stickleback will fight a rival he would ignore in other localities. When the male stickleback is *excited by the sight of a pregnant female* (and a vaguely similar cardboard model with swollen abdomen will precipitate this behavior, whereas a real female stickleback without will not), he reacts with certain precise movements that stimulate her in turn. But Tinbergen has also shown that with the coming of maturity (what we should call adolescence in humans) in Greenland, the Eskimo dog develops the capacity for receiving and responding to such stimuli almost overnight:

> All dogs of an Eskimo settlement have an exact and detailed knowledge of the topography of the territories of other packs; they know where attacks from other packs must be feared. Immature dogs, however, do not defend the territory. Moreover, they often roam through the whole settlement, very often trespassing into other territories, where they are promptly chased. In spite of these frequent attacks, during which they may be severely treated, they do not learn the territories' topography and for the observer their stupidity in this respect is amazing. While the young dogs are growing sexually mature, however, they begin to learn the other territories and within a week their trespassing adventures are over. In two male dogs the first copulation, the first defence of territory, and the first avoidance of strange territory all occurred within one week.[6]

6. Niko Tinbergen, *The Study of Instinct* (Oxford: At the Clarendon Press, 1951), 150.

The susceptibility of human adolescents to new patterns of thought cannot be demonstrated so precisely, but that firm "imprinting" of new ideas to which one is exposed in certain emotionally heightened situations can be demonstrated by autobiographies. Most primitive societies and highly civilized ones in the Near East, Egypt, and Greece up to the late Classical era seem to have provided the occasions and the ceremonies to turn such a biological factor to good account rather than leaving it to commercial exploitation. The function of the arts in all this was well known to such peoples.

Moreover, that the capacity for producing and enjoying works of art is, as it were, built into the human structure at fundamental levels, that we *need* to operate thus and are *deeply satisfied* in doing so, fits in with the idea of what biologists call "supernormal sign stimuli." (The term innate releasing mechanism (IRM) has been coined to designate the *inherited structure in the nervous system* that enables an animal to respond to the sign stimuli that triggers off the appropriate behavior.) Tinbergen writes: "The innate releasing mechanism usually seems to correspond more or less with the properties of the environment, the object or situation at which the reaction is aimed.[...] However, close study of IRMs reveals the remarkable fact that it is sometimes possible to offer stimulus situations that are even more effective than the natural situation. In other words, the natural situation is not always optimal."[7]

The male grayling butterfly pursues the female in flight and shows a preference for the females of darker hue. If a female *darker than anything that is known in nature* is presented to a sexually-motivated male he will pursue it in preference to the darkest female of the species. Here is an "inclination," a reaching after something that cannot be satisfied within nature, or in the natural circumstances in which the male grayling finds himself. This opens up all kinds of speculation not only about the necessity of art but of "the desire of the moth for the star" and the unfulfilled, almost inexpressible yearnings of human beings.

7. Ibid., 44.

On the plane of art and ritual, Campbell writes of this example:

> Obviously the human female with her talent for play,[8] recognized many millenniums ago the power of the supernormal sign stimulus; cosmetics for the heightening of the lines of her eyes have been found among the earliest remains of the Neolithic Age. And from there to an appreciation of the force of ritualization, hieratic art, masks, gladiatorial vestments, kingly robes, and every other humanly conceived and realized improvement of nature, is but a step—or a series of steps.[9]

With a warning against equating art with improvement on nature, we may relate this to the children adopting ritualistic conventions, such as frontality, in certain situations. While Tinbergen gives many examples of courtship displays that involve a set of trigger mechanisms, each one designed to touch off the next impulse in the partner (thus narrowing down the selection of a mate to one from the species that responds in the appropriate way), Kenneth Simmons[10] gives from the great crested grebes an example of another sort of ritual to *discharge* an emotion. In the first ten to fifteen days of life the young grebes are carried much of the time on the back of one or the other parent, which gives time for the waterproof coat to dry and saves them from predatory pike. When the young are between ten and fourteen days old, the parent tilts or pushes them off, and will even dive to dislodge them. Is it at this time that, after implicit trust, the first feelings of apprehension enter? Each parent adopts one or two of the chicks (broods are usually three or four) and takes charge of the feeding: "One parent great crest may not only refuse to feed the other's young, but actually drives them off. The young soon learn to appreciate the situation and become apprehensive towards the parent which does not feed them." But, as the time comes for them to fend for themselves even the supporting parent shows aggression. The young grebe "may

8. He uses the word "play" throughout, not in a light but in a very fundamental sense.

9. Campbell, *The Masks of God*, 43.

10. In a broadcast on 8 December 1957, which was an extension of comments on this ceremony made by Simmons in "Studies on Great Crested Grebes," *The Avicultural Magazine* 61 (1955): 235-53.

snatch food very quickly from the adult, turning away to make off at the same instant. All this gives the impression that the young one is very apprehensive of the adult. The parents not infrequently show aggressive behavior to their larger young." As time goes on the parents are provoked to ever stronger expressions in order to drive the young away. Since grebes nest singly on a stretch of water the feelings of uncertainty and fear this arouses become set in a pattern towards all grebes in adult plumage. But such a pattern, when the maturing youngsters move away to other waters, would prevent the approach to a potential mate and a continuation of the reproductive cycle. Simmons suggests that some of the displays he has seen are a ritual re-enactment of fight, flight, and reconciliation, which in fact have taken place in the history of the race but had not, in fact, taken place in the history of that particular bird. He cites the display that shows the two birds, in a tentative phase of courting, picking up the dark weed from the bottom of the pond—the weed they will use in building their nest—and with it in their beaks rushing towards one another across the water—as they do when genuinely attacking—until he thought that they would collide. "With the impetus of their motion the two birds came actually to touch each other with their breasts[...]the birds would have fallen forwards had each not supported the other. Only the very tip of the body was in the water. In such a breath-taking union they sway together for a few moments."

Simmons saw this ceremony a dozen times in the same form over several seasons. He, whose knowledge of grebes is unchallenged, believes that in this mock battle the fear and aggression that had been conditioned to appear at the sight of another grebe are exploded, and the pair can settle down to an affectionate lifelong partnership. This is a ritual for the release of an inhibiting emotion.

I said in Chapter 3 that children and adolescents would use whatever subject we gave them to work out emotions and pressures building up inside them at that time. Would it be farfetched to explain this curious change to "ikon style" and frontality in these cases, as an intuitive device to work off the fear that might have paralyzed them in the real situation—and so be able to make contact with the features of the subject that attracted them?

In many religious and social rituals, a certain range of emotions is roused not only by the weighty associations of the occasion but by physical elements of form and pattern in the ceremony itself; by the color, by the shape of the building and its furniture, and by our own or others' ritual movements—kneeling to pray, rising to honor, walking in procession and so on. In a ritual we are not spectators, we take part actually or vicariously. If the ritual has, over a period of time, evolved *an aesthetic form*—as the re-enactment of some deeply significant historical event, such as the Last Supper, or the symbolic representation of a universal theme, such as the loss and restoration of Persephone in the Eleusinian mysteries—then in identifying ourselves with the principals celebrating it, we are *involved* in what is itself a work of art. We can, without being creative in an original form, be satisfied in a way bearing some resemblance to the traditional craftsman's content in shaping age-old forms, or to re-treading the steps of traditional dance.

Perhaps much of the art I have been describing is a kind of ritual—not in the sense of "mere ritual," "empty ritual," but in the sense of identifying ourselves with the subject within that hieratic framework that gives "distance." This would explain why one feels that the boy who painted the seawall has a deep sense of this force but is not overwhelmed by it; why the two bulls are terrifying yet the boys are not cringing—they are also the bulls and draw strength from the bulls and know the glory of being behind that immense head as well as the terror of being in the path of it.

Rudolf Laban once said to me, when we were discussing the effect of dance on the emotions, "The ritual dances and the communal rites are gone. Religion has lost its wide appeal. Now only art remains. It is all in the hands of you art teachers." As so often, I did not fully understand what he meant, but perhaps it was this.[11]

I have no doubt that many readers will have very great misgivings about the method I have suggested, fearing that it will simply result in a giving up of the restraining, controlling part of ourselves to an

11. I do not mean to imply that art can be a substitute for religion, but through the rites and forms of art we make contact with the infinite.

unbridled emotionalism. Any loosening of the carefully won control of "the discriminating ego" can be dangerous; but in order to reach these new syntheses, chaos cannot be avoided: the ego-control must be flexible. The crucial question is to what shall we sacrifice it? Today our adolescents, when rebellious or frustrated, are surrounded by more degrading themes that evoke their emotional response. A mark of art is that it is not diffuse, not merely emotionally enveloping. It has a structured form that is the essential embodiment of its theme. The archetypal themes we used—and many other themes could do the same—did seem to result in a form that hardly suggests a mere wallowing in emotion, and the painters and modelers, after intense immersion in them, seemed to come to rest at a new point of stability. Marjorie Hourd has written:

> One of the reasons why it is difficult to forsake the chronologi-
> cal in writing and the photographic in pictorial art is the fear
> of being at the mercy of the irrational parts of one personality;
> quite simply it is the fear of getting to know oneself.[12]

Perhaps when people of any age let go of the discriminating ego they do become terrified of what emerges, and their panic efforts to close down the battens again may be reflected in hard, harsh, often black, linear structures. But I myself feel that all these pictures illustrated show a sense of structure that has yet not destroyed the autonomous life of the subject—not killed the thing that was feared by making a dead drawing of it. Rather, the "artist" has drawn on its vitality, as is apparent in the independent life of the picture and portrayed the organic structure of a living theme.

Moreover, contrary to an opinion expressed with great author-ity in our time, I found that, while the more permanent "personal-ity type" of the child or adolescent might often be detectable in his work—as in his movement or gesture—the mood of the moment was the determining factor, because the research showed that a person painted and modeled differently in different atmospheres. This mood might come from the need to exorcise fear or derive warmth, as in the

12. Marjorie L. Hourd and Gertrude E. Cooper, *On Coming Into Their Own: A Study of Children's Verse-Writing* (London: Heinemann, 1959), 20.

ritualistic pictures; or it might come from bodily identification as in the waterfalls and some of the models; or it might come from plumbing one's own depths through these archetypal themes—or from all three. Often a "class mood" of contemplation resulted, for many normally extroverted youngsters found themselves drawn in by the temper of the group, which the teacher can sense and guide. Finally, the responsibility for the general mood and atmosphere created during a lesson is the teacher's.

These themes, nourished on the compost heap of ages, have vitality more than most. But any work, if it is to nourish us as spectators as well as having a therapeutic value for its maker, must have an autonomous life of its own as art.

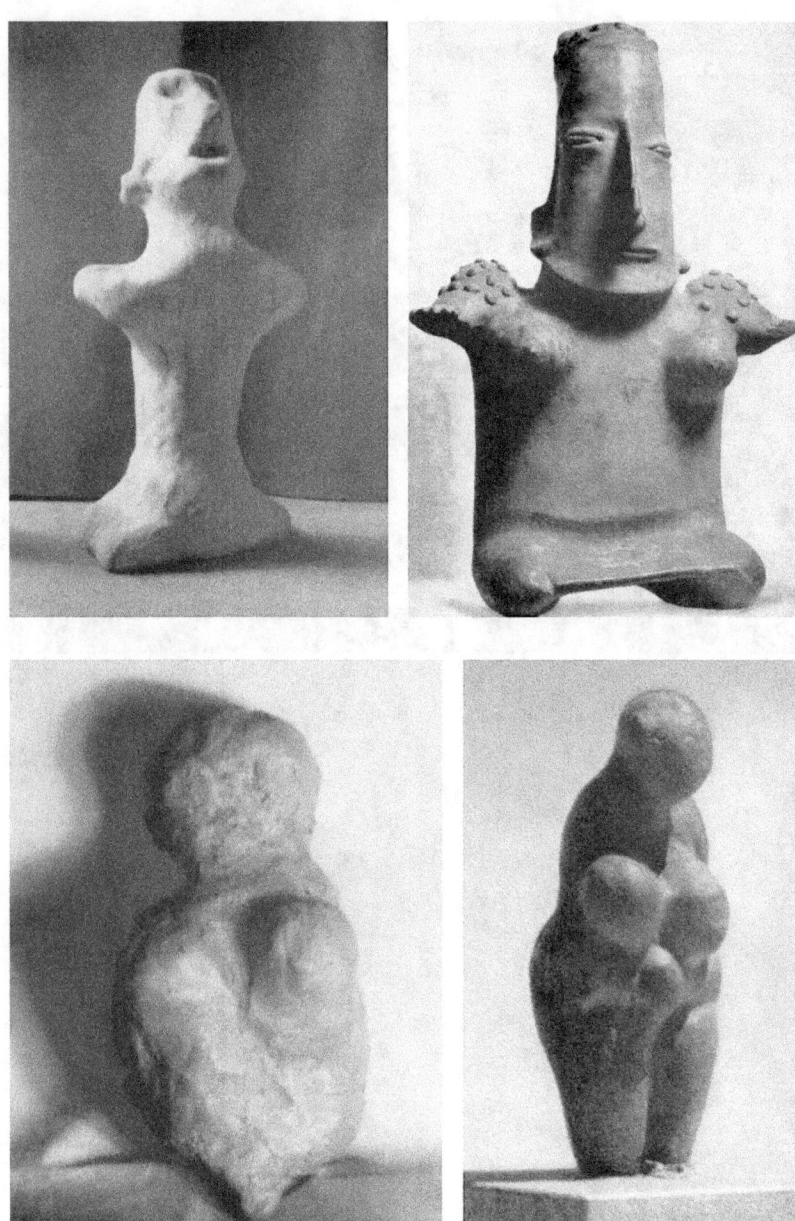

PLATES 25a-d (a) Figure with elongated face, rudimentary limbs (*Boy, age 11*); (b) Aztec figure;
(c) Mother-Image? (*Girl, age 11*); (d) Neolithic Mother-Goddess

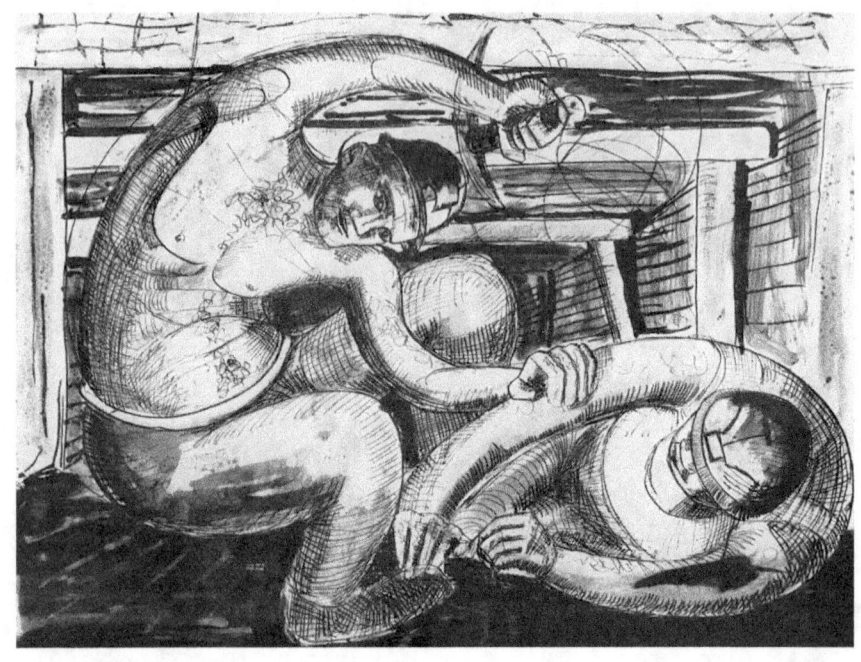

PLATE 26 "Miners." Paint and ink, made after the visit to a mine (*Male student*)

PLATE 27*a* "The Seawall." Wax and watercolor, showing symmetrical frontality (*Boy, age 14*)

PLATE 27*b-c* Bulls, showing frontal viewpoint (*Boys, age 13 and 12*)

PLATE 28*a* "Harvest Festival," in strong vermilion, orange, black (*Boy, age 15*)

PLATE 28*b* "Three Kings," in strong red, gold, purple, black (*Boy, age 14*)

PLATE 29a *Christ as the Good Shepherd,* in the Orpheus tradition, 5th century
Mosaic
Mausoleum of Galla Placidia, Ravenna

PLATE 29b *Emperor Justinian and his Train,* showing Byzantine frontality, before 547
Mosaic
Basilica di San Vitale, Ravenna

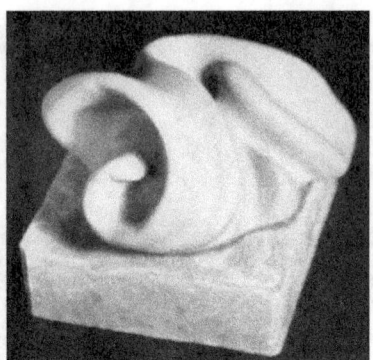

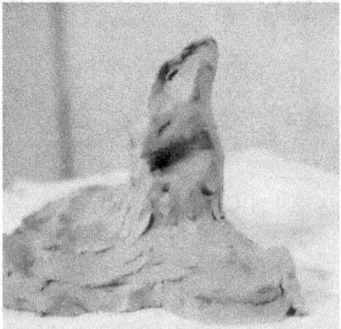

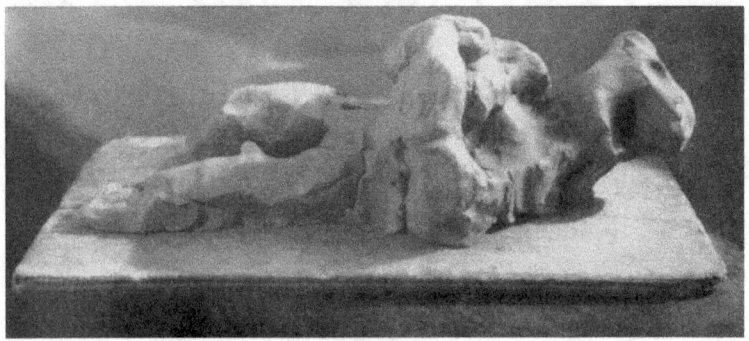

PLATES 30*a-d* (*a*) Shell-like model (*Female student, first clay experience, blindfold session*);
(*b*) "Whorl" (*Male student, begun blindfold*); (*c*) "Nose." Middle stage of a pillar
turned into a face (*Female adult*); (*d*) "Mother and Child" (*Boy, first clay
experience, blindfold session*)

PLATES 31a-e Stages of one model (*Female adult, blindfold session*)

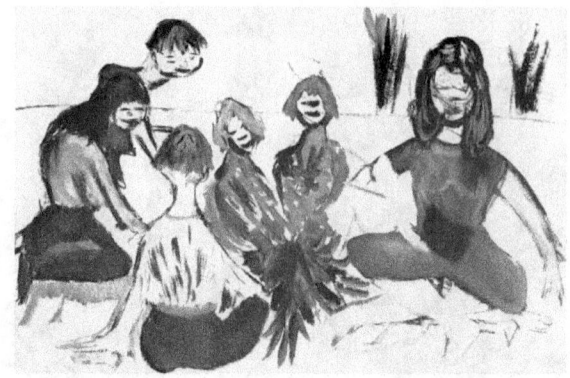

 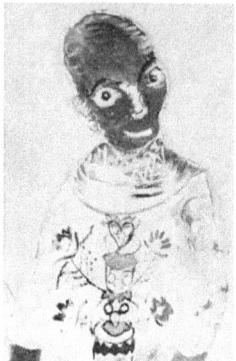

PLATES 32*a-e* Stages of Phyllis's work: (*a*) "People Round a Fire"; (*b*) "Oranges on a Dish";
(*c*) "The Eastern Princess"; (*d*) "Self-Portrait"; (*e*) "The Wise Old Man of the East"

XI

RELATIONSHIPS BETWEEN THE IDEA AND THE MEDIUM

Nothing can be sole or whole
That has not been rent,
— W.B. YEATS, "Crazy Jane Talks with the Bishop"

In the course of this study, in the painting classes but especially in the modeling classes I have described, I became interested in the way in which the first shape is modified in the course of creating even quite a simple work. Each of us with any experience in the medium brings to the act of creating the memories (with their overtones of the teaching), the frustrations and the satisfactions of former attempts. So each succeeding attempt becomes more complex to study. Therefore it appeared worth trying to study the *first* contact of students of different ages with a medium new to them, to catch the act of creation naked, as it were. I was taking many day and weekend courses at this time, where clay was new to most of my students and, an additional advantage, clay work is less likely to induce imitation of known masterpieces than painting is.

Those who start painting in adult life come with a stock of second-hand and often trivial images in which they try to clothe their individual feelings. Gifted teachers have shown that it is possible to bypass this difficulty by various means, but with clay there is much less preconception of what is accepted as "art." Therefore I chose studies in clay for this part of the investigation. Clay lacks the immediate attraction and seduction of color, and so relies completely on the form, and its apparently inert mass does not even limit and enclose the form as the rectangle of a paper or a canvas does. Precisely for these reasons, and because it is so responsive to the touch, it often gives rise to a very personal language at the first attempt.

The *disadvantage* of choosing a new material is that there is little opportunity to go far enough in the period under study to produce anything that has value as a work of art. For (though it is difficult to separate them) I was not interested primarily in clay as a diagnostic or therapeutic material but as one that could offer children and adults the experience of shaping, of creating coherent and expressive forms within the tradition of their culture.

In asking what exactly is experienced in contact with a material, I have used three sources of information: my own *experience* as modeler and potter;[1] *observation of the shapes* produced in the course of working and how they are modified; the *comments* of the makers. The comments on which I have chiefly drawn here were made immediately after completing a first piece of work in clay (when this is not so, I give the circumstances) by children, by students, by teachers (of all subjects), and by other adults. I introduced them to modeling when they were blindfold because I found they got a more immediate contact with the clay, that thus they concentrated more on the aspects of touch and three-dimensional form. Also, they did not get distracted by their neighbors or become self-conscious about their own products.[2]

Before trying to analyze this process, here is a description of the first experience of modeling blindfold by a Physical Education tutor who joined a students' session:

> I became completely absorbed in what I was doing and felt that being blindfolded isolated me from the other people in the room—although we were so close we were almost touching, and one could hear their breathing. One was aware of the intense absorption of everyone. As the students had settled down with their clay and got out their scarves, there was quite a lot of cheerful chatter and laughter as they blindfolded themselves or one another. I had expected that this would continue through the period of modeling, especially as one might expect some

1. I have written on this in *New Era* (April 1958).

2. But one sensitive adult has told me that she found it quite intolerable to be blindfold with the clay and that the shut-in feeling inhibited her. It is not necessary to blindfold the younger children—they work mostly by touch anyway.

> self-consciousness and embarrassment with so many people modeling for the first time—but the strange thing was that as soon as our fingers touched the clay we each became completely absorbed in our isolation with what we were doing, and there was complete silence for a long period.

What is happening during this initial meeting with clay? Two elements that must be paramount are the *tactile and kinaesthetic sensations*—though I am not suggesting that the experience is ever limited to this. Something of the importance of these emerged in the incidents of the little girl who did not want to get dirty and made nothing her first session, and of the two boys who said that they were making a mine but who, instead of adding convincing detail, just pushed their hands in and out of the holes they had made.

The first work with clay may be experienced by older students[3] as a thoughtful *exploration* of its qualities:

> The first thing I experienced was the amount of resistance or compliance of the clay to grasping and pressing, flattening and twisting.

Then there is *conscious pleasure* in plastic moulding:

> I did not start modeling with any particular shape in mind. I was only concerned with pressing, squeezing and twisting the clay, and thoroughly enjoying its plastic qualities.

And:

> This morning, being blindfolded, I spent some time just enjoying the feel of the clay. I am afraid I cannot recall any of my thoughts while I worked except perhaps that I was enjoying myself because no one could see what I was doing. I was more concerned with feeling than with thought: pleasure in the feel of the shape I could make by drawing the clay out with my thumb and first finger and the narrowness at the edge, in poking my fingers into the clay and in moulding the clay around my fingers.

Many other records describe such feelings.

Next, there are *body images* that arise very early in the process and possibly have associations with the texture and consistency of

3. These extracts are from accounts written just afterwards by three students of about nineteen.

the clay itself. For instance very many of the eleven-year-old group to which Margaret belonged produced pillar shapes, both boys and girls (but more boys), which may be seen as exploring how far the clay would pull up straight (if pulled up at an angle it often falls down), but which would be interpreted by most psychiatrists as penis shapes. There are also many scooped hollow shapes, e.g., the shell (PLATE 7a). A Movement student also speaks of finding she had made a shell. (The shell is, of course, an age-old symbol of femininity—Venus herself was born from one.)

Here is a different body image:

> I took the clay in my right hand and squeezed hard and found that I had made deep hollows and divided the clay into three parts. I then had the idea of a body with two listening ears and saw in my mind a picture of the internal auditory mechanism. This I tried to convey in the more central part through a tortuous series of communicating apertures. The outer parts I moulded as ears or at any rate spread appendages.[4]

A young woman student writes most vividly of evolving her model in another relationship to her own body:

> The clay is very cold, and I must work it, hold it in my hands, and move it quickly about until it becomes warm and living. I will work it into a smooth, smooth ball that fits into the hollow of one hand. I will push it thin in the middle like a big bubble that bursts and must be recaptured again by the larger mass. I will make of it a long thing that can be held in both hands at once.
>
> I like the feeling of the now warm and moving clay. I should like to have something that is held light in one hand but that is within the firm grasp of the other. I wrap my fingers caressingly around this thing that is mine and it in turn encloses my thumb with itself. It is a thing *made to be held by me.*

4. Three students in this group of twenty-four, to which this modeler belonged, commented on ear associations in their models, but they were students at the Movement Studio and would be conscious of sound and music. One of these writes, "It was an experiment of great interest and the assimilation of listening and imagination definitely influenced the resultant shape of the model."

In addition, there are the *ideas* that arise in the mind. We cannot of course separate any of these things in the act, they happen at the same time or they flow into one another, so that it is seldom possible to distinguish cause and effect, (e.g., it would be difficult to say whether the last excerpt was more of a body image or a mental idea). I suspect that some hint of the significance of the pleasure of stroking the pillar shapes was just on the verge of consciousness when some censor in the boys modified the representation to an "acceptable" object. One would not expect to have a verbal description of this moment from the children, but in several instances I saw them pause in the slow physical enjoyment of this shape, freeze still for a moment, and then start with a new directiveness to give the clay the distinctive features of the candlestick or lighthouse or another object that they named (e.g., PLATES 2*a-c*). One such that took shape in this way was turned into a head in a very pointed cap. On another occasion, a woman teacher who had been working with a literature group (in which she had been arguing with two of the men) rushed into the clay room, seized a lump of clay and pulled it fiercely, violently, into a pillar shape, which she after a moment turned into the nose on a face, pressing out a flat circle round it on which she added eyes and mouth. PLATE 30*c* shows the middle stage of this work.

Here are some descriptions of how an idea occurred from working the material (although these children and students had been told their final object need not represent anything at all). A boy of eleven in a grammar school, who made blindfold the model in PLATE 30*d*, when asked how he came by the idea said:

> I just stroked the clay beneath my fingers and I thought it was like a woman so I put a baby in her arms.

An older man student wrote:

> My first feeling was extraordinarily strong. I felt how brutally I was attacking the clay and how tense my hands were. I made a conscious effort to have a finer touch in my fingers that meant that my whole body carriage had to be altered, and I seemed to fidget about for a long while until I obtained a sufficiently calm position. All during this while I had simply pummeled the clay, squeezing and twisting it in a very rough way.

I was then conscious of an outward curve arriving. My thought was immediately "how typical of me and similar to my paintings and movement." My next conscious thought was that it felt like a flower, possibly an orchid, but I did not try to make it really life-like.[5]

And again, a woman said:

Earthy feeling—something from a riverbed that still had the smoothness from running water. Fingers poked into it and made hollows that could be smoothed into grooves and gave the idea of carving in church doors.

Then I had a new piece of clay. Again something from earth. Three long points came and then a tree-trunk entered my thoughts. Something that was more living came with playing and eventually I took off my bandage to reveal a primitive piece of prehistoric life.

This, of course, is quite different from starting either with an "idea" to represent (e.g., a woman, a foal) or an "idea" with practical considerations to fulfil as one might in pottery, e.g., a vessel to keep liquids hot or a wide bowl to hold fruit.

But the associations of the idea may draw the modeler (or painter) away from the work itself and become a monologue instead of a "conversation" between man and material. The works of the Movement students were characterized particularly by a sense of flowing and balanced forms. But one of them, who produced a trivial and cliché swan, wrote thus:

Almost immediately I felt the hollow of a swan's back emerging to a finely pointed tail, but then *I did not concentrate on what I was doing*[6] because swans are connected with the place I am happiest in the world—the Helford River—and I enjoyed the memory of the sun on the water and the tingling exhilaration of being alone on a bright summer's morning. I could not get its smoothness and roundness of form, and they are such graceful creatures.

5. A male Movement student. It is interesting to compare this with the flower of another man (PLATE 7*b*) and his comment: "I think it is the calyx of a flower but I was thinking of my wife all the time."

6. My italics.

It is interesting to compare this with the second long excerpt later in this chapter in which the modeler also tries to make a swan because of her strong associations of pleasure with the memory, but realizes later that they were literary associations. The whole genus of commercial pottery swans and paintings of swans with cloying sentimental associations are a bog from whose clutches only an innocent or a genius can rise to new forms.

In addition, there are considerations of "pure" or abstract form that may be unconscious in young children or beginners but are often an important consideration to the mature artist. Here are some comments on this from students of movement and dance, who I found developed nonrepresentational shapes more than most beginners:

> Never having done any modeling before, I first sensed a pleasure in the feel of the clay as I squeezed and pressed and moulded it into shapes with my whole hand. I was very conscious at first of the shapes that I was forming—having possibly a mental image of some before translating them into material form. Gradually I became less conscious of this and more fascinated by the feel of the material resulting from a different touch—a strong pressure of a smoothing action, a quick prod, or a rolling between the palms of the hands.
>
> From this sensation, I think, evolved the feeling that I wanted to make the model flowing while not forming it from one solid piece—but knitting parts together in different ways and in different directions.[7]

Again:

> I thought of making loops and feeling the shape of the holes produced. This idea led me to make deep hollows and smoothing out the surface I squeezed the edge of the hollow out as thin as possible.[8]
>
> As I began to model I worked consciously from the idea of movement and tried to achieve lightness, but soon I realized that the nature of the clay did not go towards lightness and I must accept its heaviness and solidity. I had the idea of a figure kneeling on one knee and began to develop this idea, but very

7. A female Movement student.
8. A female Movement student.

soon the shapes formed by the clay, curves, and hollows became more important to me than my idea, and I worked rather to develop those.[9]

Yet even when form is nonrepresentational, it is evocative. Henry Moore has written: "There are universal shapes to which everyone is subconsciously conditioned and to which they can respond if their conscious control does not shut them off.[...]The meaning and significance of form itself probably depends on the countless associations of man's history. For example, rounded forms convey an idea of fruitfulness, maturity, probably because the earth, woman's breasts and most fruits are rounded, and these shapes are important because they have this background in our habits of perception."[10]

One woman has written a simple but quite penetrating description of the emergence of forms:

I have frequently spoken about the clay and the model as if it were something that took on a life apart from the modeler. Yet this is only a way of speaking to convey the sense in which one's own thoughts and feelings are made conscious to one through a medium. I believe it is a mistake to imagine that something magical occurs between the artist and his material. It appears like this only because the unconscious of most of us is so far removed in everyday life from the conscious. Certainly I was aware most of the time of the origin of my forms in myself, but not until they had become defined far enough in the clay to recognize them. The ideas and conceptions are one's own—but they have to be *reclaimed* from the medium upon which we have impressed them. There is, as it seems to me, no mystique about creative art. It is one way of finding out about oneself.[11]

The most full accounts I have are from those I have known well personally. A sensitive and penetrating teacher of poetry alongside whom I had taken modeling groups suddenly wrote me this letter:

9. A female Training College lecturer.

10. *Henry Moore: Writings and Conversations*, ed. Alan Wilkinson (Berkeley: University of California Press, 2002), 195-97.

11. A female university lecturer. It will be apparent that I believe this account underestimates the part played by the material, but it is helpful to have such a clear account of one student's feelings.

Sunday

I must write and tell you what happened to me. I was in London last weekend and went just to look at the recreational groups.

I joined the modeling group and asked the leader for a lump of clay.[12] I was blindfold for a minute or two and then knew more or less that I was moulding a figure. So I took the scarf off and went on. In about half-an-hour (which was all I had) the rough shape was there. The teacher was very difficult about it—I had leapt too many of his stages—but I couldn't wait, the thing was pouring out of me! I had to leave it and go to the meeting and I thought that was that. But all through the lecture on the secondary modern school—this piece of clay was at me. I wondered if they had destroyed it and rolled it up—I didn't wait for the discussion—but just until the clapping started and took the bus back to Highgate. They had saved it for me, and now I have finished it. It really is something most tremendously important to me—and I couldn't say, like some others, I know how it's done—because I don't. I'm going to save it for you to see—and some day to get your advice on firing it. Will it keep all right or do they crack when they harden? It's a strange mixture of the symbolic and the representational—and it's strangely arresting.

But what I really want to say to you is—what an experience it is, and how now I know so much of all you have been saying about clay. Now I know that I must go on. I never thought clay was my medium—but I had never tried modeling, and now I feel I must go on and on.

Some time later this teacher had her second experience of clay in a modeling group with me and wrote the following full description. Photographs of her model at various stages are attached.

12. This leader had worked with me, and he also had found blindfolding helpful with beginners. I do not mean to suggest that it is the general practice or the right approach for all teachers or all students.

AN ACCOUNT OF A CLAY MODEL IN THE MAKING
(PLATES 31*a-e*)

Blindfold I took a large lump of clay and began to squeeze and press it—bang it—and generally feel round and through it. Then the lump divided in my hands. I began to mould it as a divided thing. An idea of it sprang into my mind and I turned to S.R. and said, "I see it already finished. It is an abstract shape—two spirals—then both twisted into a third complicated spiral at the top." The urge to take off the scarf and mould what I was seeing in my mind's eye was very strong. Very gently she persuaded me to go on a little longer blindfold. Then slowly I felt human forms under my hands, and I knew certain things about them:

1. That they had a common basic structure.
2. That one was gaining in size and stature above the other.

Again I desperately wanted to take off the scarf—and again she persuaded me to go on a little longer. I went on mould-ing—but now I felt I was wrenching the clay—the two figures seemed to be in some kind of a struggle together—and I was solving a problem with the clay of how to keep them together making a group—yet bringing them apart to define a relation-ship. It was an awareness partly of the clay as material, partly of an idea of what the clay was saying. The two were there together. Then S.R. said if I wished I could take off the scarf. I caught the suggestion from the form that one figure was reclining, another was seated upright upon a large rock base.

Then I worked for some time in a leisurely way developing a reclined female figure and an upright male seated one—facing each other. The rock was built up and out partly to support the figures and partly to vary and make more interesting the circu-lar design which had developed. At this point I had to plunge my hands into the center of the model to dig out the clay that I did not want—so that the figures could gain their space field as it were. I discovered that in doing this I had formed a pattern not unlike the original spiral idea, but flattened out because it was a floor pattern. It was a kind of maze threading its way round the limbs of the figures and the rock, but in the shape of a broken circle—joining together again.

I was aware of a struggle going on here inside myself—an urge to keep a circle with unbroken contacts—an urge to break the circle and lose some contacts. I found these two urges producing

a struggle inside me that often made decision very difficult. Then I wanted a break caused by outside circumstances—I tried to cause one by chattering or going over to someone else working. It was as if I was saying of the forms—"They must be joined up to keep the interest alive—or the continuity must be broken in order to keep it alive." The problem was how to recognize that breaking and joining were part of the same drama. A similar problem emerged about the space in the middle of the figure. It appeared menacing very often—and I kept thinking: "How shall I bridge that gap—which looks so ugly?" Then S.R. would say, "When you have decided what the male figure is doing—then probably the problem of the space will be resolved." This was true to some extent but the space still remained a problem—and the finished model shows that I have not solved it satisfactorily. I can see that it is part also of the problem of the broken and unbroken lines.

Then came the need to know more about the human figure—I began to look round the room and study the other people working in the room—the set of shoulders—the crook of arms. At this point I asked S.R. to pose for me. She lay on the table and floor—sat on a chair and so on. Placing herself as I wanted the figures in the model to be, she got me to feel her bone structure and my own. Then I saw the importance of bringing together the imaginative feeling of the forms and a sense of the structure of the human body. But this landed me in another conflict—because one sense could so easily overcome the other before a resolution had taken place. Either what I wanted to say got lost in not being able to say it, or by concentrating too far upon the anatomy I began to lose the impulse of what I wanted to say. It seemed to me that if only these struggles between thought and feeling and structure and design could be resolved, then a very satisfactory composition would result.

An example of this: There was a long uninteresting stretch on the rock between the two figures. The man's arms had not been put on but already the lean of the body suggested that one was resting on his right knee and that the other, whatever it was doing, was held in a restful position. The woman's arm reclining on the rock was reaching out, but again in a non-urgent way.

The idea that this was a family group kept coming and going. Finally I knew that there was a baby to be placed somewhere. If I placed him on this dull patch on the rock there was the problem of how he was to be connected with the father and mother. This

was a very difficult moment—chiefly because I could not make the child look anything but a tadpole from the waist downwards—though the head part and shoulders had come off quite well. I felt a kind of despair, which made me discredit everything else I had done. Then I appealed to S.R. who with the smallest touch of clay just clapped the legs on—so that an alive and kicking baby was there in an instant. I could not bring it to that point of space at that point of time. Once the baby was there the mother's right arm knew what it was doing—tickling one of the baby's legs. Then came the strong urge for an unbroken circuit. I would let the father's left arm lightly touch the child's head. But the arm was not proportioned for the span it had to make to do this with ease, and the hand kept breaking off. Moreover the long line of the mother's arm, baby and the father's arm seem to need breaking; yet if it was broken—what was to happen to this left arm? Was the father to seem quite uninterested in the child? I never solved this problem. I am quite certain that it was solvable in this model, and that the breakdown—which showed itself as a flagging interest, which I rationalized in many ways, was something in me—some effort I could not make whilst the clay was still soft and workable. My indecision about continuities and discontinuities lasted too long for the model to be rescued at that time. Just before I reached that breakdown point I had thought I could work at the model for days—then I knew that I couldn't. In any case I was nearly at the end of what I wanted to say—or could at that time say. Artistically it had failed—but the reasons for its failure were partly due to a failure to solve problems of line and space—but also a failure to solve problems in myself in relation to the line and space of this model.

However, in one important respect the model had succeeded. It was dimensional. At every turn of the group a new angle of meaning unfolded. And one big change emerged. Looked at from one side Mother and Father were talking to each other and attending to the baby with a kind of loving subsidiary care. Their gaze is directed to each other. On the other side of the model they are both turned to the child. In the first position the child appears fully formed, enjoying a life of his own, in the second he merges into the rock face, as a shadowy form. When this became apparent and was remarked upon by others I knew that however much I had failed in many ways I had conveyed the meaning that was developing as the work went on—and which at one point I stated quite consciously as my aim—that I should

convey an idea about children and parents belonging to each other and yet being apart. The idea that thus came to light in the end was there in conception in the idea of the two spirals that met to make a third spiral—it was there in embryo in the idea of the two pieces of clay as human figures which I was finding out how to group together and yet to give a separate entity to. This notion of togetherness and apartness was there then in all stages of the model and expressed itself in one struggle after another through changing forms until it culminated in a family group where a sense of confirmed domesticity and tender concern was linked with the suggestion of conflict expressed in the nobbly forms of the rock and the complex interweaving of bodies and limbs. It would be easy to imagine a sea washing up around. I wonder how far the tellingness of a composition can be judged by its power to call forth many interpretations but at the same time to resist them and subdue comment to its own intention.

Another thing that this work brings home to me convincingly is that the problem of what is often called technique is this problem of understanding human feelings in terms of a medium. Once the facts about a medium are known—e.g., the porous quality of clay—then the problem is how to say all one wants to say within these terms. I believe there is a great deal of truth in Robert Frost's remark that a poet has nothing to think about but the subject and afterwards nothing to boast about but the form. His intention is truly to think and feel through his material, then the form will bear witness to his success or his failure.

Working this way has also brought home to me the force of Keats's utterance: "I am convinced of nothing but the holiness of the heart's affections and the truth of imagination."

<p style="text-align:center">* * *</p>

It seems rather presumptuous to comment on an experience that is described with such honesty and insight by the modeler herself. But it is perhaps worth pointing out how the first forms that emerged were, as so often, pillar shapes drawn up from the body of the clay itself and a hollow form—later deepened by the writer plunging her hands into the center to dig the model out. The symbolic nature of the activity is clearly brought out on many levels; the writer describes it in terms of space, "the urge to break the circle and lose some of the contacts,"

and in terms of human relationships—these two shapes had already taken on characteristics of male and female. As she says, "breaking and joining were part of the same drama."

The problems of art education are summed up admirably in her comment:

> Then I saw the need for bringing together the imaginative feel-
> ing of the forms and a sense of the structure of the human
> body. [...] Either what I wanted to say got lost in not being able to
> say it or by concentrating too far on the anatomy I began to lose
> the impulse of what I wanted to say.

Clay is an extremely valuable material just because it can be reshaped in a moment as ideas develop or feelings become clear in one model.[13] This writer says frankly, "However much I had failed in other ways I had conveyed the meaning *that was developing as the work went on*" (my italics).

Some teachers today are anxious lest the current use of draw-ings and models by the psychiatrists, and perhaps even that kind of humanist relationship of art education to the life of the individual I have tried to describe, should result in the values of art itself being held of no account. But to convey—not only to express—one's feelings demands just those absolutes of tension and balance between variety and the harmony of the whole, or between light and shade in many senses, which are the underlying concepts through which the artist's thought is conveyed. This particular model was an early effort by one skilled in the discipline of words rather than clay, the next model to be described goes further as a work of art.

After taking a few days of modeling with this adult group at a sum-mer conference, I told the students that if any of them wished after they left the conference to write down their impressions of our ses-sions together I would be very glad. Among others, I received this from a woman painter and training college lecturer, the only person in the group trained in art.

13. For the same reason it can be a dangerous one.

MODELING BLINDFOLD
(PLATES 32*a–e*)

I had heard vaguely of modeling blindfold, and was faintly scep-
tical, and inclined to think of it as just another "stunt" teach-
ing method. I was therefore surprised at the completeness with
which it shut out my usual world—even though I paint a little
I'd not realized how narrowly my reactions were limited to the
visual. I had also worked a bit in clay before, but again was sur-
prised how much having to rely on touch made its character
evident and pleasurable—a reveling in the feel of it, and a sort
of responsibility and tenderness towards it. I thought, this is
what I feel for Hugh (my seven-year-old nephew)—and I found
my hands making a curved and sheltering shape, and I was not
much surprised when I saw what I'd made.

Now we had lovely new silky clay with an elasticity of its own.
I got a nice large lump and blindfolded myself in a kind of glad
surrender and started to work the clay and was at once struck,
no, there came to my consciousness a feel of the tension in the
clay and how, as I pulled it left and right with my two hands, it
was opposing and yet indissolubly one like love (and I had a sort
of flashback to a student who was modeling last term the heads
and shoulders of two boxers, and how I said to her, "Your prob-
lem is to make them separate and opponents, and yet united in
one.") The two pieces of clay in my two hands were a man and a
woman, both drawn apart but returning each to the other —and
the main forms were modeled fairly distinctly before I took my
blindfold off. I remember being surprised that I'd made the man
so large, but otherwise it was pretty much as I'd expected.

I worked open-eyed the rest of Saturday and Sunday morn-
ing. Main parts of figures were very little altered—I was awfully
pleased with it and felt it had expressed a bit of me, and was
ridiculously pleased that people liked it. I didn't know what to
do with the arms, especially the man's left arm that led away
rather indeterminately. S.R. said, "Would you try a clean cut
with the wire and see perhaps if it wants to go in this direction?"
So I cut it with the wire and saw at once that thereby the feeling
was returned into the model. I don't know whether she or I said
her hand might need to be turned in too, and it was so.

Later, considering their faces, I began to model them in a too
obvious way, relying on accidents of light and shade rather than

on the actual form of eyes, etc. But as soon as it was suggested to me this was happening I saw it and rescued it. Also with the arms and hands, I began to make them too anatomical and too strongly disengaged, but clay is lovely—you can have second feelings—and this was put right. People said very nice things about it, and I lapped that up, but as well as this I felt a great deep satisfaction, and even now (a month later) the model sits on my mantelpiece, and I love it ridiculously dearly.

On Monday morning I was to start something new. We'd been at Bosham on Sunday, and I had been much moved as always by that lovely place, by the sense of ambient, pervasive light, the quiet, the feel of its being old, and I thought, oh, I could paint this. And then I watched the swans sailing so serenely, one especially, the large rounded form of her breast pushing gently into the water and making little shallowed hollowed ripples, but so much did they belong to each other that one hardly knew which caused which. I said I had an idea I wanted to try, though I felt very doubtful about it and was pretty sure it might fail, and we agreed I'd try. I knew that "in my right mind" I'd never try a swan—the idea is too obvious and overblown and sentimentalized, and I'd have discouraged a student from attempting it and I knew all this—but one part of me strongly wanted to try. I didn't work on it for very long and when I looked it was horrible, quite horrible, and I knew I couldn't do it and squashed it sadly. (Now, a month later, I just wonder, I just wonder if I could have satisfied myself by an abstract of the shapes, or better, by dancing it out; or whether it wasn't really a formal idea at all but a kind of day residue, and I wonder why I clung so desperately to an idea that I knew deep down wouldn't work. Learnt a lot about teacher-pupil relationship, S.R.'s gentle acceptance both of the desire and the failure.)

Then I was a bit sad and lost, and she suggested that I should try a blindfold model of a head with the face turned away from me. I began and quite soon felt happy with the clay, and the head began to grow, and I felt my own head and tried to get the right relationship of parts. It was difficult, but I can't remember much about its coming or what I thought. In fact, I didn't really think very much about who it was, and when I unblindfolded, it was quite a complete head, though rough, and I didn't know she was like that. (Someone said after that it was rather like me, but I can't see it.)

I worked on it—same thing over, making the eyes too photographic (funny to do this not in paint), but rescued it quickly. I didn't know what to do about the back of her head and her hair. I tried long locks over her shoulders to emphasise the peasant-primitive feel of her, and then someone mentioned the horsetail, and I got a lump of clay and stuck it on very roughly to get the effect, and it just seemed to balance happily and to be right and give the youthful inexperienced yet wise (? slight feel of ancient Greek) feel of her. She's now a bit like a fifteenth-century Italian painting—I must look up the one I mean. And we had to stop and she's sitting patiently in a biscuit tin in the kitchen waiting for me.

* * *

These two modelers give us valuable insight into the relationships between three things: the qualities of this material that results in its "naturally" assuming certain shapes; the thoughts or ideas that arise in the mind of a particular person; the forms that are actually found possible to a disciplined control of the medium, which arise from the other two. Both these students found or were seized by a theme—the human family—so rich in itself that in interplay with the clay, it soon involved them in philosophic musings: "There came to my consciousness—a feel of the tension in the clay, and how as I pulled it left or right with my two hands, it was opposing and yet indissolubly one, like love." The other modeler finds herself quoting Robert Frost and Keats. For her, only the words of a poet can describe her experience, and it in turn illuminates her understanding of Keats.

Anything whatsoever may serve as an inspiration for the artist, and the most unlikely object may be illuminated by his personal vision. But it is no accident that from the earliest times and still today, artists—sculptors such as Moore and Giacometti, poets, dramatists, and even unusually responsive architects—continue to find repeated inspiration in this and other universal themes. They are the basic stuff of our lives, and in shaping our statement about them—however individual—we are in some sense one with the artists who have done so and with all men.

When Margaret made her "rosegarden," with its walls and narrow entrance, its fountains, rose trees, and "lovely smells," which she

described in that dreamy haze, she was unconsciously aligning herself with the long tradition of the "idealized garden" of our culture. When she put a labyrinth around it, she protected it by the ancient symbol of conditional entry.

I am not losing sight of the fact that all Margaret actually produced in that art lesson were some sausages and pillars of clay on the desk. Her idea or theme, while it had the basic formal structure of the traditional garden, was yet not worked out to the extent that could communicate to others, though *acceptance* seemed to satisfy her and send her off gaily to her next lesson. Obviously, there is a temperamental difference here—some people are more easily satisfied—as well as a difference in stage of ability to express thoughts and feelings in that medium. I think the mood gives us the clue as to how, as teachers, we may discern the point each has reached.

I believe that the mood of immersion that I noticed also when I too rudely interrupted Bert modeling his miner, and which had to be dispelled in the group returning from the coal mine, is usually the stage of *not* having worked through to a resolution, a statement (to oneself or others) that communicates the experience. Margaret did not come to me nor draw my attention to her "rosegarden"; it was the end of the lesson that brought a termination to her musings. This contrasts with the sense of relief and satisfaction shown by the painters of so many of the cave paintings and the two adult modelers who modeled a family. It is not a question of achieving a real work of art—few of us ever do that—but of having found an expression fitting to our command of the medium at the moment. The girl who modeled the "ancient Mother-Goddess" ran up to me to share her pleasure in it.

Even though that model communicated hardly more than the rosegarden, she showed very clearly that she felt a sense of release and joy in having made it. Eddie, who said "I've done it" before he broke up his woman, had a further kind of satisfaction. The students who, on the day after we returned from the coal mine, went away and painted, modeled or danced their experience, were able later that evening to meet and talk quietly and more objectively about it, showing that they had reached a new position through their creative work.

There are therefore two different levels of release and satisfaction. The primary, and educationally the more important, is the shaping of a form that draws the experience into a state, into a "gestalt" that makes it acceptable, digestible *to that person*. Otherwise experience is simply chaos, and we are confused and overwhelmed, never coming to that point of rest and stability. Young children can manipulate shapes and colors earlier than language, and so paint and clay and other materials are vitally necessary for them to have always to hand.[14] This shaping, which defines a form and both releases the maker from the chaos of unresolved experiences and nourishes his nature through the now digestible material, can do this even when he does not realize consciously what he has made—as the little girl did not know the form that pleased her so much resembled a Mother-Goddess, and as few of us are fully aware of the implications of what we have made. It mediates between the different levels *of the maker*. It goes on being necessary, after communication with others is well established, for secret and personal experiences that do not call for immediate sharing. Communication brings the second level of release.

But communication to others is a different matter—that depends not only on sufficient command of the chosen medium to shape it but also on the other's ability to interpret. Just as the history of art for four hundred years shows repeatedly a rejection of what proved to be valid for a later generation, so the history of art teaching, in spite of sincere goodwill, had been too often a rejection of the children's communications to us. One who tries to communicate is dependent on a certain responsiveness in his recipient. Having said that, I still believe that helping each individual towards his own language of communication is a great part of the art teacher's job. Between the phantasy ramblings of childhood and the wrought steel of poetry, between some of these strange clay shapes illustrated here and the formal precision of

14. Even later, when more command of language is gained, there are still many experiences that cannot be communicated in verbal language, and feelings can be communicated much more directly and precisely in shapes and colors and sounds.

sculpture, lies not only the pain of maturity but the discipline of the art. To have the emotions and the desire to express is not enough. Marion Milner has written of another little girl of eleven who made a mess of her consulting room out of sheer affection:

> She was trying to deny the discrepancy between the feeling and the expression of it; by denying completely my right to protect any of my property from defacement she was even trying to win me over to her original belief that when she gave her messes lovingly they were literally as lovely as the feelings she had in the giving of them. In terms of the theory of symbolism, she was struggling with the problem of the identity of the symbol and the thing symbolized. [...]
>
> But was this struggle to make me see as she saw in essence any different from the artist's struggle to communicate his private vision? [...]
>
> The battle over communicating the private vision, when the battleground is the evaluation of body products, has a peculiar poignancy. In challenging the accepted view and claiming the right to make others share their vision, there is a danger which is perhaps the sticking point in the development of many who would otherwise be creative people. For to win this battle, when fought on this field, would mean to seduce the world to madness, to denial of the difference between cleanliness and dirt, organization and chaos. Thus in one sense the battle is a very practical one; it is over what is suitable and convenient stuff for symbols to be made of; but at the same time it is over the painful recognition that, if the lovely stuff is to convey lovely feelings, there must be a lot of hard work done on the material.[15]

Crazy Jane, Yeats's female tramp, playing the part of the wise fool who, as in Shakespeare, mocks our pride, our self-righteousness, our intellectual solutions, and who is more than ever necessary in an age of cellophane-wrapped specialisms, reminds us

> 'Fair and foul are near of kin.
> And fair needs foul,' I cried. [...]

15. "The Role of Illusion in Symbol Formation" (1952), in Marion Milner, *The Suppressed Madness of Sane Men: Forty-Four Years of Exploring Psychoanalysis* (Hove and New York: Brunner-Routledge, 2002), 79-80.

'A woman can be proud and stiff
When on love intent;
But Love has pitched his mansion in
The place of excrement;
For nothing can be sole or whole
That has not been rent.'[16]

Echoing Stanley Spencer's "spiritual union between what in me has been revealed and what outside myself revealed it,"[17] Wilson Knight has written, "All poetry celebrates a divine creation by marriage of humanity and nature."[18] But the visual arts, and especially perhaps pottery, sculpture, and architecture, celebrate this in an inescapable way; the raw material is the stuff of the earth—which must be rent if it is to be impregnated by human ideas, and the human partner receives as well as implants in that reciprocal rhythm.

For Margaret, the path may lie through the discipline of pottery and the study of the garden theme in our culture. No adult, however much one wished to, can bring her fulfilment, but it is perhaps possible to show her what real fulfilment is, and to set before her—to

16. "Crazy Jane Talks with the Bishop," in *W. B. Yeats: The Poems,* ed. Richard J. Finneran (New York: Scribner, 1997), 264. It is not, I think, that we must take the fool as the ideal to follow, to set up as a model for us all, but that we must never despise and underestimate his wisdom, nor cease to be grateful that some are called to be fools, to live out their intuitions about the nature of life in these extreme ways. We have enough sane, calculating, compromising mentors, and, if we do not have the living advocates of the other ultimate (the rebels, the earthy, who enjoy instead of trying to turn their backs on our physical nature) as a counterforce, how shall we each find our own point of balance on that tightrope, a liveable philosophy?

Nor should we forget that the material that was used for Margaret's "rose-garden" and Eddie's "woman" is the material of Sung dynasty pottery. Moreover, without the physical labor of stamping clay and getting smoke in one's eyes and dirt in one's hair stoking the kiln, Sung dynasty pottery could not have been produced.

17. Stanley Spencer, from *Sermons by Artists* (London: Golden Cockerel Press, 1934).

18. G. Wilson Knight, *The Christian Renaissance: With Interpretations of Dante, Shakespeare, and Goethe, and a Note on T.S. Eliot* (Toronto: Macmillan, 1933), 374.

offset the tawdry that she will meet in cheap adolescent literature—
the different paths to fulfilment, of Isolde, of Dido, of Hermione,
of Beatrice.

If then there are moments to urge a student to disciplined study,
moments to draw his attention to the works of the masters and other
moments to leave him alone with his own creating, how are we to
avoid doing the wrong thing? We can only prepare ourselves to rec-
ognise these "moments of creation" by an observation of moods and
a sensitive awareness to atmosphere; by using in humility our own
experience-as-an-artist to relate to his.

XII

ROSEGARDEN AND LABYRINTH

The rose in a mystery, where is it found?
Is anything true? Does it grow upon ground?—
It was made from earth's mould but it went from men's eyes
And its place is a secret.
—G.M. HOPKINS

We had the experience but missed the meaning,
And approach to the meaning restores the experience
In a different form.
—T.S. ELIOT, "The Dry Salvages"

The Cretan labyrinth design, it will be remembered, has no blind
alleys. Every part of the figure has meaning, and even when a path
is apparently going in the wrong direction, it leads to the center. The
labyrinth, a widely used form for initiation, may certainly symbolize
education, for it is the type figure of *conditional entry*. He who traces
its path aright wins through. I had been puzzled for a time by the fact
that there seemed to be two main types of labyrinth, those in which
one had to reach the *center*[1] (the Cretan maze, carried by Bronze-Age
settlers across Europe) and those in which one had to find one's way
through (the Malekulan mazes through which a man found his way
beyond death). For us Europeans, the labyrinth is indissolubly asso-
ciated with Crete. Now Daedalus was a Cretan, and Daedalus gives
us the clue to this puzzle—as Ariadne gave Theseus her clew to *his*.
When on their flight from the angry Minos, Icarus's wings of wax

1. Perhaps it is a matter of temperament whether one sees this or the
"closed" Kafka labyrinth as a symbol of life itself.

melted, and he fell into the sea, Daedalus bereaved, landed in Sicily and afterwards built that temple with the Cumaean gates where, Virgil tells us, Aeneas descended to the Underworld for illumination and guidance. But Minos wished to pursue his vengeance, and knowing the intricate mind of Daedalus (as well he might who had lost his wife to a bull through Daedalus's artifact[2]), he offered a reward to whoever would pass a linen thread through a Triton shell. Though in hiding, Daedalus could not resist the challenge: "Fastening a gossamer thread to an ant, he bored a hole at the point of the shell and lured the ant up the spirals by smearing honey on the edges of the hole. Then he tied the linen thread to the gossamer and drew that through as well."[3] Then Cocalus, the Sicilian king with whom he was hiding, produced the problem solved, claiming the reward. Minos, assured that he had found Daedalus's hiding place, demanded his surrender—but Daedalus finally outwitted him. So, when seen in *three* dimensions, the spiral of the labyrinth can lead to the center (honey on the hole!) and at the same time lead out at the other end—Yeats's "perne in a gyre."

The labyrinth has served as an apt image of life's confusions. Dante, at the springing point of European poetry, has described his journey, which was certainly tortuous, starting from the Dark Wood, to

> That valley's wandering maze
> Whose dread had pierced me to the heart-root deep.[4]

He goes by way of that wilderness echoed in Blake's

> Till the wild desert planted o'er
> With Labyrinths of wayward Love
> Where roam the Lion, Wolf, and Boar.[5]

2. I am aware that there are other constructions that can be put upon this strange story.

3. Robert Graves, *The Greek Myths: Complete Edition* (London: Penguin, 1992), 313.

4. Dante Alighieri, *The Divine Comedy: Hell,* trans. Dorothy Sayers (London: Penguin Books, 1949), 71.

5. "The Mental Traveller," in *The Poetical Works of William Blake* (Oxford: At the Clarendon Press, 1905), 278.

This is the closed labyrinth from which there is no way out—the hell of endless repetition of forbidden indulgence. Dante descends—with, for a guide, Virgil, who described for us that labyrinth wrought on the gates to the Underworld by Daedalus—and he goes into the womb of earth herself—the traditional place for initiation and illumination. As Dante searched in the coils of the Inferno, and on the slopes of Mount Purgatory, so Donne pictured the search for enlightenment

> On a huge hill,
> Cragged and steep, Truth stands, and he that will
> Reach her, about must and about must go.[6]

In our own day, the *Four Quartets* use constantly the language of labyrinths

> Trying to unweave, unwind, unravel
> And piece together the past and the future. [...]
> And the way up is the way down,
> the way forward is the way back.[7]

And the whole spiritual journey of the poet is summed up in a slow revelation of the labyrinth nature of life:

> In order to arrive at what you do not know
> You must go by a way which is the way of ignorance.
> In order to possess what you do not possess
> You must go by the way of dispossession.
> In order to arrive at what you are not
> You must go through the way in which you are not.
> And what you do not know is the only thing you know
> And what you own is what you do not own
> And where you are is where you are not.[8]

In *Ash Wednesday,* the apparently closed labyrinth, the "endless journey to no end," is seen to have a center, a heart in Grace, personified in Mary, *rose hortus conclusus* and conclusion, Christian inheritrix of many of the Great Mother's attributes:

6. "Satire III," in *John Donne: Selected Poems* (London: Penguin, 2006), 110.

7. "Dry Salvages," in T.S. Eliot, *The Complete Poems and Plays, 1909-1950* (New York: Harcourt Brace & Co. 1971), 131-34.

8. "East Coker," in ibid., 127.

The single Rose
Is now the Garden
Where all loves end
Terminate torment
Of love unsatisfied
The greater torment
Of love satisfied
End of the endless
Journey to no end
Conclusion of all that
Is inconclusible
Speech without word
Word of no speech
Grace to the Mother
For the Garden
Where all love ends.[9]

The search this book describes began with a young girl's putting a labyrinth round a rosegarden. Now the rosegarden has long been the symbol of fulfilment. Aucassin, the poet king James I of Scotland, the hero of the *Roman de la Rose* and countless others first saw their life's love in a rosegarden. In a rosegarden, according to tradition, the Persian lovers sway in each others' arms. A rosegarden often surrounds a castle or a keep where the loved one is held (though Henry II chose to keep his love at the center of a maze!). Mary, who is Rosa Mundi herself, is also "the enclosed garden," and the rosegarden and the paradise garden finally fuse in one symbol of joyous fulfilment; so I began to understand something of the antiquity of the images in *Four Quartets,* from the first exploration of past experience, "disturbing the dust on a bowl of rose-leaves" and the echo

down the passage that we did not take
Towards the door we never opened
Into the rose-garden.[10]

T.S. Eliot's garden, too, has the traditional elements of the formal pattern, the alley, the pool filled with water, the birds calling in response to the music in the shrubbery.

9. "Ash Wednesday," in ibid., 62.
10. "Burnt Norton," in ibid., 117.

> Only in time can the moment in the rose-garden, [...]
> Be remembered.[11]

The interaction of the timeless moment with time's moment of remembrance is in a rosegarden—itself a timeless symbol, but a fragile one, for what fades more quickly or reverts to weeds more wholly when left untended? It is man's courageous and pathetic effort to enclose the experience of romantic love, to isolate and intensify it through the delight of the senses enriched by every refinement of cultured humanity, so that in this love we are not only ourselves but the inheritors of and trustees for all great lovers. Nor must we narrow the concept of love to a complacent heterosexuality, remembering Sappho, Leicester, and the central image of Family Reunion contained in the line

> And I ran to meet you in the rose-garden.[12]

The garden image, which enshrined this profound concept of ideal fulfilment in European culture, also contains that which reminds us of mortality—the yew tree, which came into the garden by way of the "gardens of death" of the ancients.

> The moment of the rose and the moment of the yew-tree
> Are of equal duration.[13]

The other gardens of death were the gardens of Adonis, baskets or pots of swift-germinating herbs tended by the women of Egypt and Syria, and when they as swiftly withered, consigned to the river to be carried away while they sobbed and mourned for the dead youth, lamenting his death and singing of his resurrection.[14]

Moreover, the zenith moment of love in the garden is juxtaposed not only to the moment of mortal death but, in another dimension, to human suffering, the fire that burns up the desert:

11. Ibid., 119.

12. "Family Reunion," in ibid., 277.

13. "Little Gidding," in ibid., 144.

14. Jessie Weston gives one of the many accounts of this in *From Ritual to Romance.*

> Then I must freeze
> And quake in frigid purgatorial fires
> Of which the flame is roses, and the smoke is briars.[15]

But divine suffering, as Pentecostal fire, illumines inwardly but consumes not—echoing the crown of roses and crown of thorns: the saints "standing in God's holy fire" glow like the gods in Persian miniatures, blaze like the burning bush. We are allowed to glimpse the true moment of fulfilment,

> When the the tongues of flame are in-folded
> Into the crowned knot of fire
> And the fire and the rose are one.[16]

Thus, as I understand it, the desert, the symbolic opposite of our garden, is one of three things: it is the uncultivated barren place that has yet to be tended and cared for ("the desert shall blossom like the rose"); it is the state of a formerly flourishing land that has been blighted by plague or fire ("the Waste Land"); and it is also the symbol of renunciation ("the saints in the desert").

Education as I see it should itself be a *fulfillment* of human aspirations at different stages of development: the physical coordination and pride of skills; the training of intelligence and the discovery of intellectual satisfactions; the directing and strengthening of the emotional life and the anticipation of romantic love. It should also be a preparation for the later fulfillments of adult life unknown to adolescence. But it should not ignore the *renunciations* that every life calls for, stressing rather the quality of that which is worth sacrifice, and the possibility of a final synthesis, "for the fire and the rose are one."

Great poems of "almost eternal durability," fine buildings in which man encompasses space to house his spirit, even a simple pot—implying the still center around which movement eternally spirals—all these embody the great symbols that carry their meaning for every level of the personality as to every age of childhood or manhood. These are for us, as teachers, paths that lead out to the profound achievements of other ages and back into the deeper recesses

15. "Fast Coker," in Eliot, *The Complete Poems and Plays,* 178.
16. "Little Gidding," in ibid., 145.

of ourselves. But they are also—because they do not rely on intellectual comprehension alone—meeting grounds where we find ourselves alongside our pupils as persons involved in life's problems. Contemplating together such archetypal symbols we meet simply as human beings, sometimes finding our roles reversed—as Margaret led *me* (tracing with her finger the path into her "rosegarden": "You have to come along this way"), and as her model led me into this study. Although I tumbled on them "by accident," the rosegarden and labyrinth seem to me, among others, peculiarly illuminating symbols of adolescence. We would be sentimental to see that phase of life only as the first, and cynical to see it only as the second, but the double image reflects the yearning for real fulfilment hedged about with the difficulties and renunciations of growing up.

Such symbols, which are strange to us "yet we have known them always," are our common ground. In making our own image of them, the isolation (which might result from the development and definition of each personality for which I have pleaded) is averted in the consummation of the individual and the family into the whole human race seen in the light of eternity—Dante's Royal Rose in which he saw the whole scattered leaves of the universe bound up into one folio or one flower turning towards the Light.

Pursuing the study of the labyrinth that a young girl put around her rosegarden led to Eleusis, and in the Eleusinian Mysteries the individual's consummation is revealed:

> The idea of the original Mother-Daughter goddess, at root a single entity, is at the same time the idea of rebirth. [...] The principal thing in Eleusis was not metempsychosis but birth as a more than individual phenomenon, through which the individual's mortality was perpetually counterbalanced, death suspended, and the continuance of living assured. [...] The ear of grain in Eleusis sums up a certain aspect of the world, the Demetrian aspect [...] budlike summings-up and goddesses in all their perfection form a single, unequivocal, coherent group. [...] Through all of them, through the grain of corn and the Mother-Daughter goddess, the same vision opens [...]. Every grain of wheat and every maiden contains, as it were, all its descendants—an infinite series of mothers and daughters in one. [...] What we see in Eleusis—not, however, broken up in this way but summed up

in clear figures—is something uniform and quite definite: the
infinity of supra-individual organic life. [...] The Eleusinians ex-
perienced a more than individual fate, the fate of organic life in
general, as their own fate. [...]

In this wordless knowing and being the first two elements of
this paradox—having a supra-individual fate as one's one fate,
and all being as one's own being—are not really contradictory.
As organic beings we do in fact possess both.[17]

T.S. Eliot put it another way:

That the past experience revived in the meaning
Is not the experience of one life only
But of many generations—not forgetting
Something that is probably quite ineffable.[18]

I have been pleading for a kind of teaching of the arts that presents
a worthy material—both in the sense of the physical medium and of
the stimulus presented to the pupils, for we have seen how one inter-
acts with the other—and constantly links it to profound work of the
past that draws on the same sources. This is not, let me say again, the
only aspect of teaching necessary, but it is that in which we may hope
for complete personal involvement, that "leap into the sea" of Keats,
that immersion in the aesthetic moment of Berenson, from which we
emerge renewed, even reborn.

The moments of contemplation and the moments of creation fer-
tilize one another. We must give every single person the opportunity
to be themselves, at the zenith of themselves, which is the experience
of the artist:

As kingfishers catch fire, dragonflies draw flame;
[...] *myself* it speaks and spells,
Crying *What I do is me; for that I came.*[19]

17. C.G. Jung and C. Kerényi, *Essays on a Science of Mythology: The Myth of
the Divine Child and the Mysteries of Eleusis* (Princeton, N.J.: Princeton Univer-
sity Press, 1993), 123-54.

18. "The Dry Salvages," in Eliot, *The Complete Poems and Plays,* 133.

19. Gerard Manley Hopkins, "As Kingfishers Catch Fire," https://www.poet-
ryfoundation.org/poems/44389/as-kingfishers-catch-fire.

In such moments the intellectual awareness (though intellect is not uppermost), the bodily coordination (free from self-consciousness of body), the intense aliveness of heightened emotion, are apprehended as an exquisite sensation of *wholeness*. Any child who has known such a moment, in however limited a sense, shares with the artist the knowledge that experience is not just something that happens to you. It is something you take—perhaps literally—in your hands and shape it; and the shape you make stands out there in the world and stares back at you, shaming or delighting you, or challenging you to shape it better. Then it may come home that art is a way of extending and coming to terms with experience itself. Long after he has left school and probably painting and the writing of poetry behind him, one who has known this will look at the work of an artist or a poet, and, with this understanding built into his being by experience, recognize the image another human being has made of tragedy or of ecstasy. Then he will know with certainty that no man is an island: that for us the bell does not only *toll,* but we can also share in the peal for a wedding, or a birth, or a rebirth.

PHYLLIS'S PROGRESS

A brief account of the course of one adolescent over the two years I knew her may make the progress I intend clearer. Phyllis, twelve years old when I met her, was a rather pale, plump, cockney lass of mediocre intelligence, who obviously got pleasure from paint splashing and had a sense of color and a natural gift for getting down quick impressions. Her paintings, or rather sketches, were always of people, either rapidly roughed in with charcoal or painted directly in quick strokes, never finished off but laid aside as soon as a problem presented itself. While the individual figures have life and are related in groups to one another, they are not related to the background—usually just left as gray paper—and the light and dark tones are used in a pleasant conjunction but not with any idea of representing solid form or light and shade.

At this time Phyllis went with her class teacher to visit the Tate Gallery. Out of all the near-contemporary paintings she saw there she fastened on Paul Cézanne and could not leave his paintings once she had seen them. Who would have guessed that Phyllis, so lazy, slapdash, easy-going as she was, would have found her "master" in Cézanne, one of the most precise and persevering of all the modern masters? The aspect of Cézanne's work that fascinated her was the way in which he represented three-dimensional form by changes of color so that one sees the curved plane swinging away round a limb or a tree by the variation in color rather than by tone, as had been the practice with most of the post-Renaissance painters. Now Phyllis was a girl of limited intelligence and very little experience of art, and she grasped only this one facet of the complex art of Cézanne—but this fascinated her.

In the first art lesson after this visit she set up for herself in the art room—as these children were accustomed to do if they wished—a group of oranges on a plate. In painting the oranges she tried to show the shape of the sphere by varying the color and she put it on with careful dabbing strokes. She did this with concentration. To persist in this over the whole painting was more than she was capable of (PLATE 32): the dish and table cover are treated more in her former style, and the background is filled with a rather facile decoration. But she *had* filled in the background and covered the whole sheet, which she had not done until this time.

When the class did the "Family Group" subject, Phyllis chose to work with them. In this painting she reverted to her former style of a quick brush sketch, but she again used the whole paper and composed the picture pleasantly within the space. The rug in the foreground shows similar decorative pattern as in her former work, but there is no attempt here at representing three-dimensional form. Was the subject too complex for her, or too near her emotionally? It is as though she, like some painters, must work out her technical problems in a restricted area such as the still life, which narrows down the problem to a relatively simple set of shapes. In the next study, however, she herself chose the subject, a group of nudes, and here she further explored her technique for representing plastic form by changes of color. In fact, in her excitement, she has exaggerated this; the color ranges from a very pale pink through a deeper pink, to a strong raspberry, but she has been fairly consistent in using this gradation on the different curves of the women sitting on the grass. The drawing is weak and the whole is rough and unfinished, but that is quite what one might expect.

In Phyllis's next picture—a street scene—the technique as developed in the nudes is used not only for the standing figures but in the trees, and the whole painting is carefully composed within the picture space. True, the houses are rather flat, but she has made strides in maintaining a coherent style over the whole. She is beginning to use consistently the language she has chosen.

The next significant picture of Phyllis is called "An Eastern Princess," and the head and neck of the princess fill the whole sheet. It is

a completely blatant and luscious female with enormously enlarged black eyelashes and a huge red sensual mouth. The earrings are much larger than was the fashion at the time when this was painted, and the princess wears a great assortment of elaborated jewelry on her elongated neck. Her coloring is south-sea brown, and her jet-black hair is piled on her head. Phyllis worked rapidly on this painting. It is interesting that it shows none of the technical achievement that she had reached in the last studies of three-dimensional form. The face is painted almost flat in a return to her earlier decorative style. Obviously her mind was fixed at this moment not on technique but on something explosive inside her that must be said. This was confirmed when she showed it to me, saying in a manner both cheeky and defensive, "Do you think it is like me. Miss?" Now Phyllis had a pleasant neck, but her face was rather pasty white, and her hair was a mousey color. The long black eyelashes and the great red mouth could not have been further from any potential good looks she had. One can't build on a complete unreality. By this time I felt that I knew Phyllis well enough to treat her frankly, and I said, "No, Phyllis, I don't think it is very like you. The princess has your neck, and it's a very nice neck; some time you must choose a blouse to show it off, but your hair and your skin are fair, and I like the way your hair falls simply and straight round your head. For you to wear such enormous earrings would pull people's eyes away from the way your nose wrinkles up when you are pleased. Your eyes are gray, and gray eyes can be most attractive because they reflect the colors that you are wearing and they change color in different lights and different moods." We looked again at the princess, Phyllis perhaps a little crestfallen, and then I laughed and shook my head, "No, Phyllis, it's not like you, it's fun, it's exciting, it's exotic, but I like you better."

After this Phyllis worked on three studies for self-portraits, using a mirror. One of those was in charcoal, one in oil paint, and one in tempera. By observing her own face in the mirror, and drawing directly from that, she did arrive at something like a self-portrait. True, it is still idealized; the neck is elongated and the face is moulded into an oval shape, but the coloring, although the hair is more yellow than Phyllis's mousy coloring, is fair and natural. There is no attempt to

dress it up in an elaborate style and to add those exaggerated, flapping eyelashes. Phyllis worked with great concentration, as the fact of three self-portraits, almost identical, bear witness, and the final study on greenish paper in those soft yellows and fawns is a lovely piece of work.

The last picture that I have of Phyllis's is called "The Wise Old Man of the East." The Orient is again her source of inspiration; here is the brown skin that she used in the "Eastern Princess" and dark eyes that look out from a hollow face. But it is a thoughtful, contemplative painting rather than an idealized one. The wise old man is wearing a yellow garment, with embroidery on the front, showing her love of pattern (that was apt to overrun the earlier pictures), but here limited to the tunic in unusual colors of blue and petunia on the gold. The whole picture is thoughtfully composed within the picture space, and the background is subtly related to the coffee-brown of his face, dark hair, and yellow robe. When I asked Phyllis what had made her paint this subject, she looked at me—almost shyly—and said, "I've been reading a book about Buddhism and the wisdom of the East." I was not able to pursue the subject at that moment, for all I know it may have been a romantic novel or an astrologer's "handbook," but I felt that in this picture Phyllis had achieved a real moment of vision, a moment of wholeness, in which she had brought together so many elements that had been disparate in her former work. She had modified her exotic idea of the East shown in the "Eastern Princess" to something a little more genuine; she had related subtle colors and resisted the temptation to use wild, hot contrasts to achieve an exaggerated effect; she had restrained the decoration to a place where it contributed to the whole theme; and she had caught within the face of the wise old man himself something that was gentle and genuine, in an appreciation, not of blatant, physical charms but of frail old age.

Phyllis enjoyed art, but as she left school near this time I have no idea whether she went on with her painting or not. Yet looking back from the first slapdash, uncomposed, unfinished paintings to the last group, I am sure that it mirrors her advance towards a coherent personality in coming to terms with her own appearance—which is such an important facet of the adolescence of girls—and in her yearning

for something a little wider than her limited London East End life. "Mirrored" is not adequate because I hope that the paintings themselves were experiences that contributed to this development.

The figure of a spiral with its oscillation and wheeling suggests how such progress is far from being in a straight line. Phyllis, using paint to express her ideas about the world and her phantasies about herself growing up, is seen to find a course that pulls out on one side to work out a technique of painting (inspired by Cézanne) and on the other to her interest in people linked to her own romantic longings.

No diagrammatic image is adequate for the complex operations of human development, but this spiral may at least remind us how neither the "purely objective" study of an object or a technique nor mere subjective self-expression can be a final aim for our students. Such works are only halting places (if they become more one gets held there immobile) from which one wheels back, and perhaps occasionally, like Phyllis with her "Wise Old Man," I feel, achieves a work that unifies these extremes and gives a point of equilibrium.

Objective studies have not formed any part of this book because they are not its subject, but, as a teacher, I must confess that there are children who, during the years I have known them, have been deflected from their own way of painting, neither by the works of the masters with which I have carefully littered their environment, nor by the direct visual experiences to which I have tried to entice them in observed studies. They have pursued their own way self-motivated, sometimes not improving their power of visual representation one whit, but unerringly creating their own world of images. Such a one was Bobby—skinny pale child of slum parents—winning his way through school, not by charm or fisticuffs but by avoiding the occasion of conflict and smilingly producing each week a halcyon world out of his humdrum experiences. One week his parents took him

to an East End Chinese restaurant, and there it appeared on paper: purple walls, cyclamen pink background peopled by black-pigtailed Chinamen and with decorations of his vague transcription of Chinese letters. Even when the class went to look at the red brick Victorian chapel in the neighborhood, and several of them made delicate, careful studies of its precise brickwork and its sombre smoky colors, Bobby's version was a slapdash haze of red and gold looking like a Baroque cathedral. An earnest teacher who insisted on Bobby's drawing from observation and practicing careful skills would have taken away from him what was perhaps his only protection in a harsh world through which he, physically delicate, emotionally vulnerable, must move—his own transfigured version of it.

While for young children and the occasional Bobby, phantasy is an important way of exploring the world and of trying out and combining ideas without the responsibilities of "real" action, adolescents must bring their phantasies into some relationship with reality. This will not be a steady progress but one that veers, sometimes wildly, between one and the other. With wise teaching in the arts, they have the opportunity to come to terms with experience, as Phyllis modified her phantasy portrait to something nearer reality and grew in the process of doing so.

APPENDIX II

A BRIEF SUMMARY
OF THE ARTS OF EARLY MANKIND
RELEVANT TO THIS STUDY

When this book was written, Johannes Maringer's *The Gods of Pre-historic Man*[1] had not been translated into English, so that its information on recent finds was not available to me. In this, a brief and necessarily superficial summary of the chronology of various early forms of European religion and art that may be known to the reader, I am indebted to that book from which the quoted passages are taken. Maringer stresses that our knowledge of these remote ages is very incomplete.

The earliest traces of religion we have are those of the hunters of the last great interglacial period, and these are preserved only because they occur in caves over 8,000 feet up in the Alps accessible in these distant short summers but later cut off for perhaps fifty thousand years by the descending ice cap. The undamaged head and long bones of the captured cave bears, which they climbed so far to hunt, were preserved—sometimes in a stone coffer in the bare recesses of the cave—and the brain and the marrow seem to have been an offering to a "divine dispenser of good fortune." The deliberate placing of these bones in relation to one another may be a first feeling towards human art in "arrangement" and "composition." Present-day circumpolar peoples practice a similar rite, and "it is always bound up with the concept and veneration of a supreme being."

This may have been only one facet of the religion of these interglacial people, but no traces have been found yet of other religious practices.

1. Johannes Maringer, *The Gods of Prehistoric Man*, trans. Mary Ilford (London: Phoenix Press, 2002).

The hunters of the upper Paleolithic period relied on reindeer; and peoples of Eastern Europe and Northern Asia submerged young does as offerings in lakes or pools, which points to a belief in a deity in or of the earth. Others whose principal prey was the bear seem to have used a ceremonial killing that shows a religious awe, and this bear cult has survived in Northern Asia to the present day.

However, most of the hunters who moved into Europe during this period brought magic practices from other ancient cultures, which flowered into Western European Ice-Age art. Animals were the staff of life and the hunters and hunted belonged, as it were, together. In imitating the animals (by assuming animal masks, skins, and mimic dancing) the hunter, but particularly the shaman or magician, believed that he could have power over the animals. Sculptured animal forms, particularly the bear, were obviously covered with the actual head and skin of the animal for ceremonies, and cave rites would take place round this effigy. Above all, the walls of deep recesses of the caves—often reached by the labyrinthine windings of "conditional entry"—were decorated with painted and scratched representations of the beasts, of magicians performing rites, and of pregnant women. "Whatever the explanations, what took place here, deep in the bosom of the earth, must have been connected with fertility magic."[2] Maringer goes on: "Recent anthropological studies have[...]questioned the purely magical interpretation of Ice-Age art. A. E. Jenssen, for instance, observes that many practices characteristic of hunting peoples which have been regarded as 'magical' are in 'fact, genuinely religious.'"[3]

It is during this last Ice Age that the Mother-Goddess figurines are first found, and they are specially prevalent during the Aurignacian (earliest period of the late Paleolithic age), whereas the animal paintings on cave walls reach their peak during the Magdalenian period (the latest period of the late Paleolithic).

During the succeeding Mesolithic and Neolithic ages, after the ice had retreated for the last time, hunters' practices were preserved only in the extreme north, and very similar practices exist today in

2. Ibid., 100.
3. Ibid. 107.

the arctic territories. Among the farming peoples further south, the cult of the Mother-Goddess can be traced without break and is reinforced, especially in South-Eastern Europe, by ideas about her complex nature from the Near East and Egypt. Her last great stronghold was in Malta where her great temples are still extant. In Neolithic times, her function as goddess of Death (and rebirth?) is stressed by her association with tombs, and this is the great age of dolmen tombs and menhirs. The menhirs, single standing stones, were often carved with signs, one even representing a mother and child, and appear to have been thought of as a resting place for the soul of the dead person underneath when it emerged in bird form from the grave. The cave-like dolmens (post-and-lintel hollow constructions heaped over with earth) and menhirs (single upright stones) may have some sexual analogy.

As the Bronze Age developed, the cult of the Sun gained strength and the chthonic cult of the earth, caves and moon-mother waned. Though there are objections, Arthur Hatto suggests an interpretation of Stonehenge that links the two. Stonehenge, the greatest of the European monuments extending over parts of both periods, was built in three phases: the first, by Neolithic peoples making ditch and ramparts enclosing a great block; the second, by beaker folk erecting the famous blue stones brought from a great distance; the third, by Bronze-Age peoples erecting five great trilithons in a horseshoe shape open towards the sunrise at midwinter.

Hatto proposes that the concentric arrangement of stones represents the position of male and female dancers in a dance that was part of the fertility ritual.[4] Even the orientation of the opening of the horseshoe towards the point on the horizon where the sun rises at the midwinter solstice was related to this ritual; the interior of the horseshoe was a symbolic womb into which the rays of the sun penetrated. Certainly many dances and children's games today—"Here we go gathering Nuts in May" and "The Grand Old Duke of York"—seem to be faint echoes of immemorial rituals.

4. *Eos: An Enquiry into the Theme of Lovers' Meetings and Partings at Dawn in Poetry*, ed. Arthur T. Hatto (The Hague: Mouton & Co., 1965), 56.

www.ingramcontent.com/pod-product-compliance
Lightning Source LLC
Chambersburg PA
CBHW070435180526
45158CB00018B/1337